Beauty
Photography
in Vogue

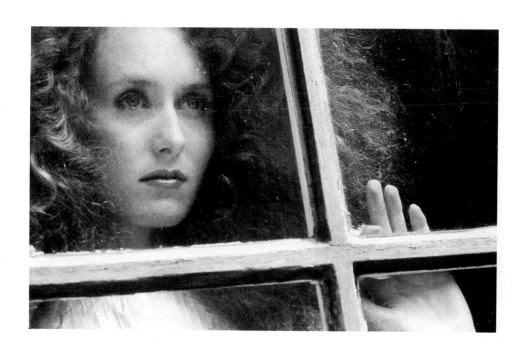

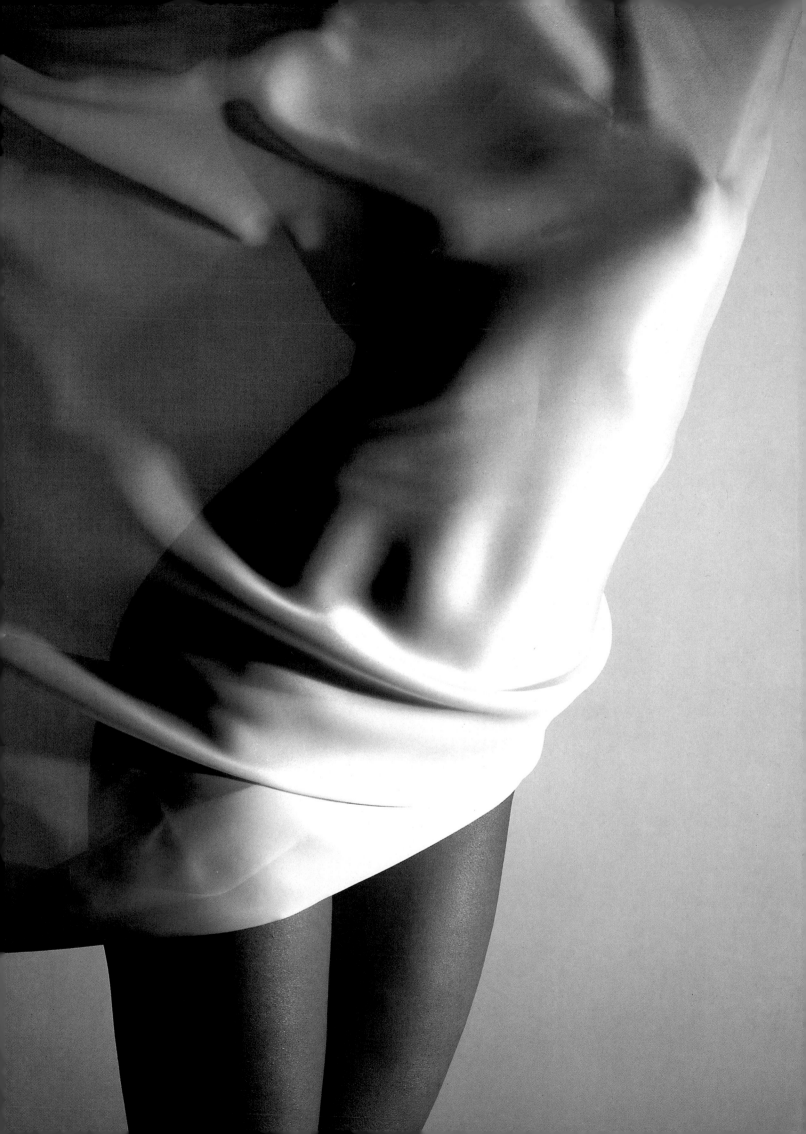

Beauty Photography in Vogue

By Martin Harrison

OCTOPUS BOOKS

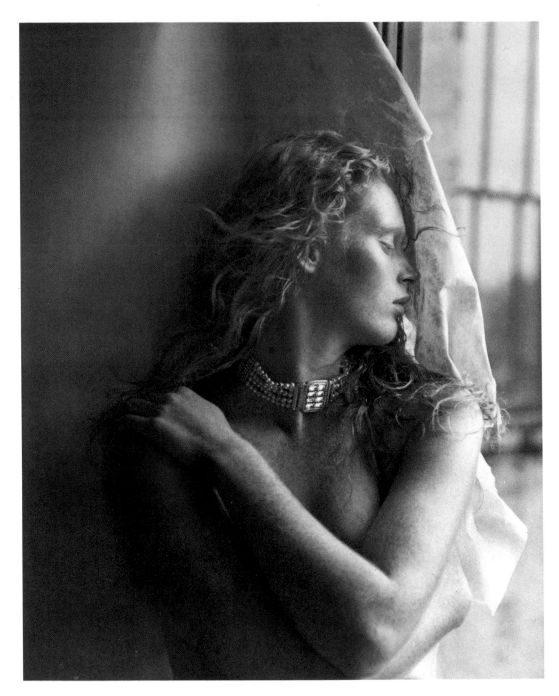

Page 1, Deborah Turbeville 1983; *Page 2*, Butch Martin 1984; *Above*, Steven Meisel 1984

To Irene

Editor: Marilyn Inglis
Designer: Steve Kibble
Production Controller: Maryann Rogers

First published in 1987 by
Octopus Books Limited
59 Grosvenor Street
London W1
© The Condé Nast Publications Limited
ISBN 0 7064 2859 5

Printed and bound in Hong Kong
by Mandarin Publishers Limited

Beauty Photography in Vogue

Contents

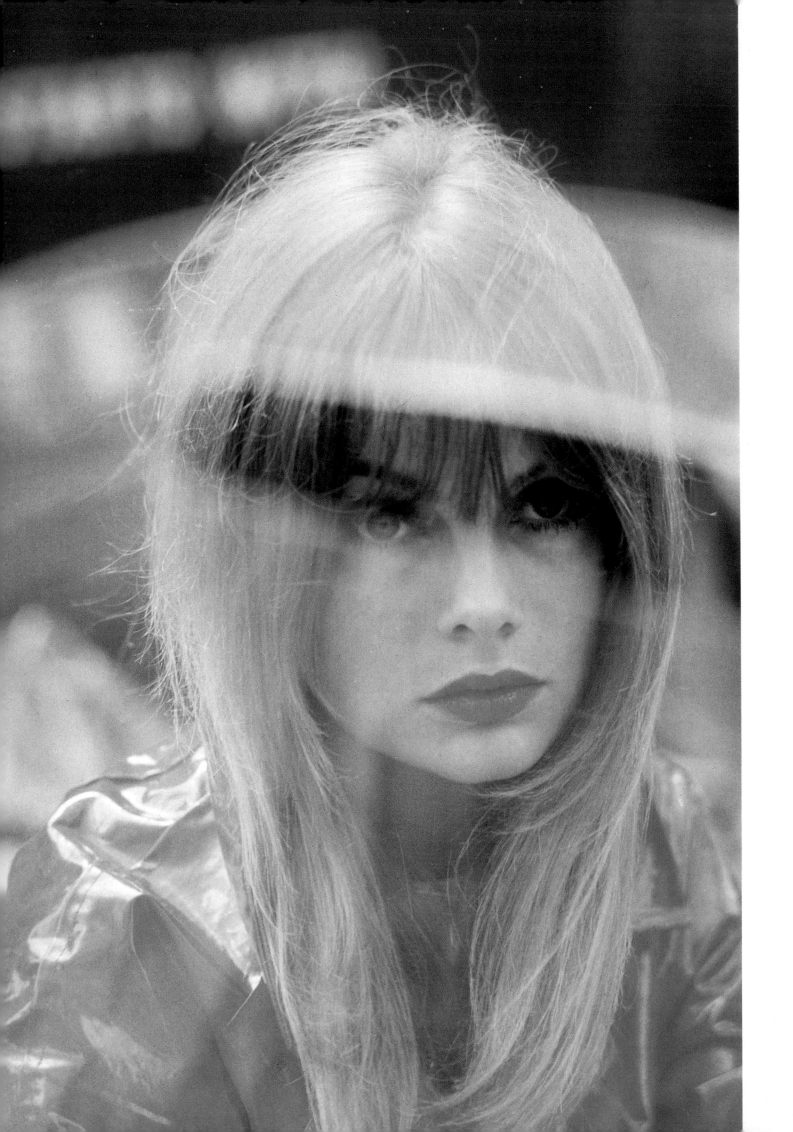

Introduction

Most of the fashion photographs to have graced the pages of *Vogue* also told us something about beauty. But it is a different – though related – phenomenon with which we are concerned here – the beauty photograph. Strictly speaking there have never been beauty photographers, only fashion photographers who sometimes specialised in beauty. But for more than fifty years *Vogue*'s editorial policy has made a clear distinction between the two categories, and it is their definition of what constitutes a beauty photograph that has been followed in this book.

In this context a beauty photograph signifies a concentration on the appearance of the woman herself, as opposed to what she might be wearing. For sure she may be shown displaying a covering of outlandish make-up, or be half-hidden under lush Pre-Raphaelite curls, but in general a beauty photograph is primarily concerned with a woman's bodily well-being. Health and exercise are an integral part of this regime, and indeed the beauty photograph first appeared in *Vogue* at the beginning of the 1930s, when it was felt a new kind of woman was emerging, symbolised by a love of sun, fresh air and exercise. In 1932 a prophetic *Vogue* headline ran *The Undressed Life and How to Live It*; it was precisely the kind of feature which the first beauty photographs were called on to illustrate. Alexander Liberman, *Vogue*'s Editorial Director, observed, 'We can no longer think of beauty without motion. These human beings, these women who fascinate, hypnotise us, are rendered more desirable by their mobility, their energy'. The body – and the way it moves – were thus established as major preoccupations

of the beauty photographer. The question of how best to convey movement is a recurring theme in this type of photograph; throughout its history there is a constant to and fro between the polarities of snapshot action realism and the carefully composed studio photograph.

George Hoyningen-Huené, a Baltic baron who joined the staff of French *Vogue* in 1926, spanned both extremes in some of *Vogue*'s earliest beauty photographs. Best known as the master of cool, static, neo-classical elegance, Huené also provided eloquent visions of sun-worship and exercise – both practices he advocated for himself. Initially such photographs, even those by Huené, were reproduced quite diminutively in the magazine – an indication that they were still considered less important than the fashion coverage – but by the mid-1930s they had claimed full

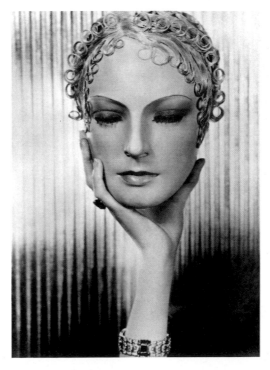

Far left
Saul Leiter 1966
Left
George Hoyningen-Huené
1933

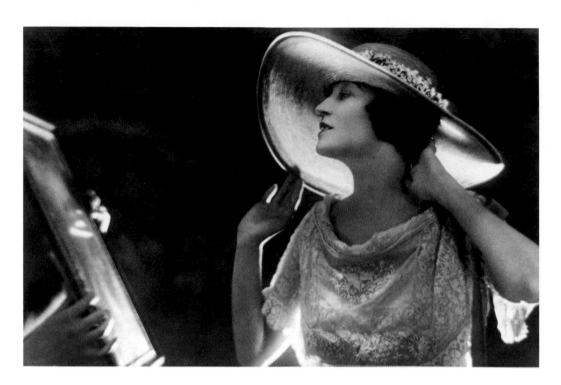

Right
Baron de Meyer 1919
Below
Edward Steichen 1932

pages. One reason for this change was undoubtedly Condé Nast's growing acceptance of the new realism in *Vogue*'s photography; committed earlier to the studied elegance of Baron de Meyer and Edward Steichen, *Vogue* now made room for a more natural approach.

Vogue's leading practitioner of the 'snapshot aesthetic' was *Toni Frissell*. Following an unsuccessful spell as a copy-writer at the New York office she was persuaded to take up photography in 1934. The credit for introducing action into fashion photography rightly goes to the Hungarian ex-sports photographer *Martin Munkacsi*, but Toni Frissell's use of roll-film cameras gave her greater flexibility and a clear advantage over Munkacsi's cumbersome plate camera in terms of capturing movement (page 112). Her own philosophy of a vigorous, active lifestyle must also have given her a special empathy with this kind of picture. *Vogue*, incidentally, had some commitment to women taking up photography at this time; in 1939 the redoubtable Dr Agha (*Vogue*'s Art Director from 1929 to 1941) contributed a feature along these lines entitled *A Woman's Place is in the Darkroom*. Writing in *Vogue* in 1941, Frank Crowninshield (Editor of *Vanity Fair*) discussed Frissell's

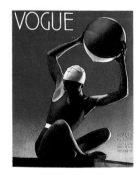

work with special insight, referring to her 'beautifully animated shots . . . photographing young girls for *Vogue*, informally and *en plein air*; showing them at race-tracks, country clubs, swimming pools, horse shows, golf-links and tennis courts . . .'

The beauty photograph, which might at first sight seem a limited area of expression, in fact rapidly proved to offer an intriguingly wide range of graphic and dramatic possibilities. Hoyningen-Huené, who had collaborated with *Man Ray* in the 1920s, brought a surrealist sensibility to what could have been a mundane hairstyle photograph by shooting Antoine's curls on a dummy head held aloft in a real hand. When Huené left *Vogue* in 1935 his close friend *Horst P. Horst* filled the gap left by his absence admirably; during the following decade he supplied some of the most distinguished and imaginative of *Vogue*'s beauty photographs. His powers of composition were the equal of Huené's – possibly a legacy of his training as an architect (he studied briefly with Le Corbusier) – and he was less inclined to view his women solely in terms of abstract geometry. He appeared to revel in the kind of beauty preparation shot where he could add a little wit to his formal qualities (pages 87 and 172).

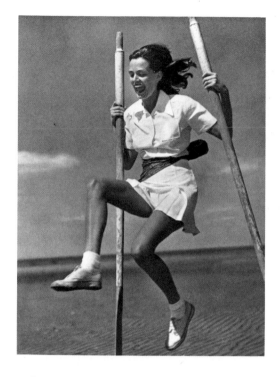

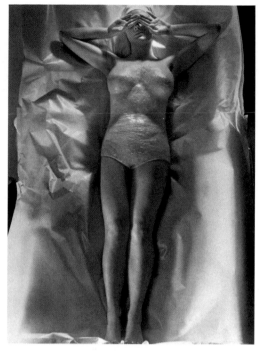

Edward Steichen, Vogue's chief photographer since 1923, contributed studio beauty pictures of flawless elegance, but occasionally also made successful forays into more informal modes (pages 55 and 124). By the time beauty photographs had become an important component of *Vogue*, Steichen was a much less frequent contributor to the magazine, and his output was small, though consistently brilliant.

Concurrently with the marked increase in the use of beauty photographs, for both editorial and advertising purposes, a new generation of photographers was emerging in the 1930s, some no doubt attracted by the expanded commercial opportunities. Another important factor in the development of fashion magazines was the improvement in the colour reproduction processes. *Anton Bruehl* is justly recognised for his pioneering colour photography for *Vogue*, which, in Frank Crowninshield's words '. . . marked a new boundary in pictorial illustration, with a new process involving great technical difficulties and reaching a new high in printing costs'. Bruehl's technical achievements have tended to overshadow his other talents as a photographer, but these were considerable, as his excursions into black and white underline (page 114).

As magazines became increasingly competitive, innovatory approaches to photography were actively encouraged by *Vogue*. The Swiss photographer *Herbert Matter* had originally (like William Klein who became a *Vogue* star some twenty years later) studied painting under Fernand Léger. Not prolific as a photographer, he seemed able to bring a fresh eye to all of his sittings. His range was wide, from the informal outdoor work of the late 1930s to the enigmatic studio beauty shots of the 1950s (pages 59 and 178). The young Russian photographer *Arik Nepo* joined the Paris *Vogue* studio in 1934. Less consistently inventive than Matter, he nevertheless produced some particularly original beauty pictures during his early days in Paris, including what was perhaps the first of many combined 'before and after' beauty treatment photographs.

The 1940s – in New York especially – were in many ways the golden decade of magazine photography. The advent of Kodachrome film in 1935 had made one-shot colour photography practicable and not prohibitively expensive; in addition experimentation to produce eye-catching images was now wholeheartedly endorsed by *Vogue*'s editorial policy. The most inventive photographer of them all was

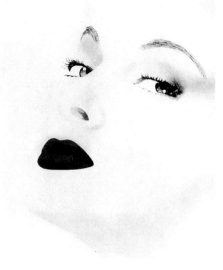

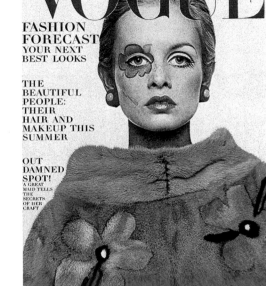

Right
Erwin Blumenfeld 1950
Far right
Richard Avedon 1967
Below
Erwin Blumenfeld 1950

unquestionably *Erwin Blumenfeld*, who pushed commercial photography further along the path of a Man Ray inspired surrealism. Dutch by birth, he could in fact claim a direct link with the Dada movement, for he and his cousin Paul Citroën were made leaders of the Amsterdam branch of Dada, although the gesture was merely a Dada joke since there were no other members. Blumenfeld arrived in New York in 1941, having fled war-torn Paris, where he had already made extraordinary beauty photographs for both *Vogue* and *Votre Beauté*. The best known of all his New York *Vogue* work is surely the 1950 cover shot of model Jean Patchett showing a pair of lips, one eye, and – coup de grâce – a beauty spot. This was very much a collaborative effort with *Vogue*'s art department; Blumenfeld's original shot was made in black and white, using harsh spotlights to bleach out all the unwanted detail, the colour being added at the printing stage. It is instructive to compare this example with a slightly later beauty shot, which was run in black and white with only the lips tinted.

An experimenter along different, more technical, lines was *Gjon Mili*. He was a pioneer of the stroboscopic light – a pupil of *Harold Edgerton* who had invented the electronic flash in 1932. The ability of short-duration flash exposures to capture movement was an important scientific advance, although Mili preferred to think of himself as an artist. If his photographs now tend to appear rather gimmicky, he was certainly highly regarded by his contemporaries. Jean Paul Sartre wrote in 1946, 'Mili is without resentment: he likes everything, eating, drinking, dancing. . . . He is happy. He does not want to kill you – far worse, he wants to catch you alive.' The multiple exposure stroboscopic picture of a naked woman in motion (page 24) was an ideal application of the technique for *Vogue*'s purposes, and the windswept hair covered in shampoo (page 143) has a striking vitality. But there was another school of thought which believed that the most effective way of conveying the impression of movement in a photograph was to record it as a blur, rather than completely freezing time and motion. *Richard Avedon* was clearly of this persuasion, and wrote in 1949 '. . . a subject blurred through motion will have a plasticity and flow that frozen motion cannot express. . . . People, women particularly, are almost continually in motion. The aliveness, the realness of people can best be captured by capturing some of this motion'.

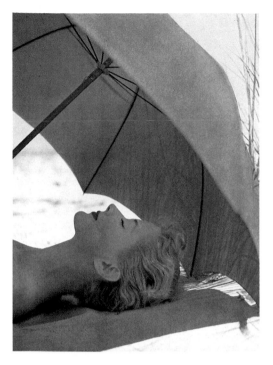

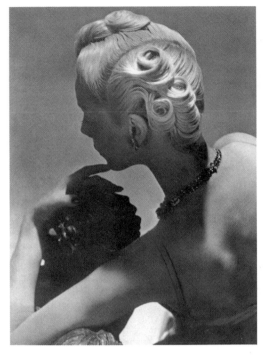

Richard Avedon and *Irving Penn* were the two pre-eminent magazine photographers of the post-war period, and although Avedon did not move to *Vogue* until 1965, Penn took his first photographs for the magazine in 1943. Happily, both continue to work for *Vogue* today. Penn initially specialised in complex but carefully composed still-lifes, his mastery of fashion and beauty achieved only gradually. But soon he had raised these areas of photography to new levels of perfection and professionalism. The seemingly effortless stream of pictures for which he has been responsible, all sharing the same graphic economy and directness, were in fact the result of a painstaking and intense application to the task. Many of his early beauty photographs remain undiminished masterworks of the genre, their appeal timeless (page 31). Those who would emulate Penn have often thought he employed tricks or secrets unknown to them, mistaking the value of the rigorous devotion he brought to each sitting. The *Girl on the Beach*, for example, was made on a standard Rolleiflex camera and lit by ordinary sunlight – the light was diffused by the umbrella and the model's face pink because that was the colour of the umbrella. Equally Penn's other photographs illus-trated here have shared the same basic equipment and techniques as any of his contemporaries; the clarity of his vision has determined the superior results.

When Penn began to work for *Vogue* in New York he was able to use the facilities offered by the magazine's own in-house studios and darkrooms. By this time the London and Paris offices ran flourishing studios too. The migration of European artists and photographers to New York during the war resulted in a situation after 1945 where the British and French editions of *Vogue*, were feeling starved of photographic talent. Harry Yoxall, former managing director of British *Vogue*, wrote 'Until the arrival of Cecil Beaton and Norman Parkinson our London studio was lamentably short of native aptitude; and even when they arrived they were constantly being whipped off to Paris and New York. So we were very dependent on imported talent. . .'. Patrick Matthews, for many years manager of the London studio, recalls, 'We were always looking to find someone here of the stature of Penn or Blumenfeld'. So began a system of loaning photographers from New York to the less well endowed European studios. In fact the process had started just before the war, when *John Rawlings* was sent to the aid of

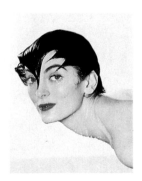

11

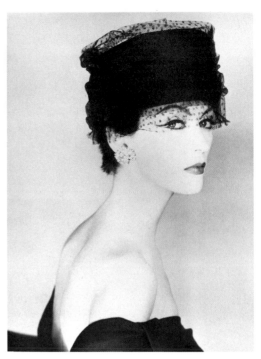

the London studio. He had come up through the ranks in New York, having served as assistant to Cecil Beaton and Toni Frissell. Competition at home was so fierce that it was felt Rawlings would have more scope to mature as a photographer in London – where *Vogue*'s studio was in any case desperate for someone to fill the gap left by Beaton's prolonged absences abroad. Rawlings worked in London from 1937 to 1939 and was able to return to New York fully fledged, carrying on a highly successful career at *Vogue* until the 1960s. During his London period he became increasingly assured and professional, if not exactly adventurous, but back in New York he blossomed, some of his beauty photographs in particular showing real originality (page 70).

Clifford Coffin was one of the first American exports after the war, being sent to the London studio in 1946. One of his most intriguing beauty pictures involved re-photographing a black and white print of a woman's head with styled hair laid over the print – a disorientating but eye-catching ploy (page 146). Short of stature, Coffin was nevertheless striking in appearance, dressed completely in black and with crew-cut hair; his acid tongue and bohemian habits (he would be discovered in the

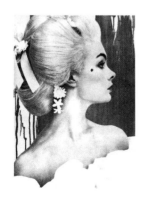

darkroom taking drugs) meant that relations with *Vogue*'s editorial staff would often be strained, and after two years he left for Paris, eventually returning to New York. A fine photographer, Coffin was responsible for a notable innovation in lighting techniques. This was the ring-light, literally a ring of tungsten lamps held by a stand around the camera lens, which gave an even, shadowless light on the subject. Electronic flash versions of this light were used by several photographers in the 1960s, and its aggressive frontality was revived to record punk fashions in the 1970s.

Another American posted to the Paris studio in 1949 was *Richard Rutledge*. A seriously underrated photographer, Rutledge showed a subtle understanding of light and his handling of daylight in particular could be exquisite. He described his fine solarised nude as 'another trick that turned out rather better than expected. Coloured lights were thrown on the model: the colours in the picture are the complementary colours, as a result of solarising with white light'. *Robert Randall* was not sent by *Vogue* to Paris but elected to go there courtesy of the GI Bill after the war, ostensibly to learn French. Born in California, Randall was a child-

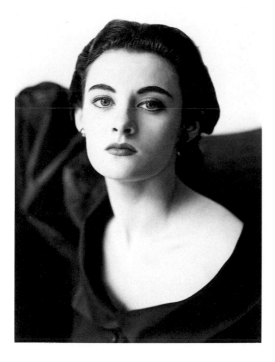

hood friend of *Henry Clarke*; fascinated by films, they would borrow disused Hollywood backlots to use in their own amateur movies. Later Randall became a technician in MGM's laboratories and during the war worked as an assistant in John Ford's war reportage film unit. Once in Paris he soon gravitated to working for French *Vogue*, where he would quite frequently be called upon to take beauty photographs. Henry Clarke himself is best known for the opulent elegance of his fashion photography, and only rarely supplied beauty illustrations. The most peripatetic of *Vogue*'s photographers, Henry Clarke worked mostly from Paris and continues to live in France.

British *Vogue*'s own chief photographer in the 1940s and 1950s was *Norman Parkinson*. He was especially interested in bringing a kind of realism – and often humour – into his pictures. As Parkinson said 'My women behaved quite differently – they drove cars, went shopping, had children and kicked the dog . . .'; he was adept at injecting such informal, tongue-in-cheek qualities into his beauty pictures.

John Deakin worked for British *Vogue* from 1947 to 1955; his forceful and perceptive portraits were generally more successful than his fashion photographs, the shot illustrated here (the point of which was to show eye make-up) being so striking because he was able to approach it as a portrait. Czechoslovakian *John Sadovy* worked for British *Vogue* briefly, having won a photographic talent contest run by the magazine in 1954. One of his first commissions – for *Vogue Beauty Book* – was a dramatically lit and highly effective interpretation of a hair treatment (page 141).

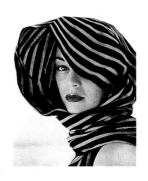

The beauty photograph can be read in the same way as a fashion photograph, insofar as it is in constant fluctuation between the formal and the informal. At one pole of informality in this context might stand the completely unposed, 'from the hip' reportage style of photographers such as *Robert Frank*, whose book *The Americans*, first published in 1958, had a profound influence on contemporary photography. Of course some degree of artifice is always necessary in a fashion or beauty photograph, but it is fascinating to observe how beauty photographers have attempted to reconcile a realistic, reportage approach with the demands of magazine illustration.

A key factor in the development of the reportage style was the gradual acceptance of the 35mm camera – initially frowned on

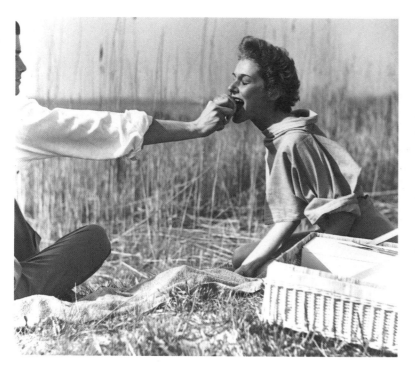

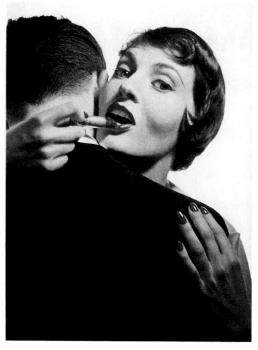

Above
Frances McLaughlin-Gill
1950
Above right
William Klein 1955

by fashion magazines. Its flexibility, light weight and ease of use greatly assisted informal picture making. As early as 1949 *Frances McLaughlin-Gill* was using a 35mm camera on sessions for *Vogue*; initially there was some resistance, since editors objected to having to select from such small contact prints, but she overcame this by having the whole sheet of contacts enlarged to 20 x 16 ins. Much of McLaughlin-Gill's inspiration came from films, particularly in the sense that she preferred to create a story-line as an underpinning for her features for *Vogue* and its junior magazine *Glamour*. To this end she always tried to find models who could act out her mini-dramas, rather than simply hold a pose. For the 1949 feature *Beauty through a Man's Eyes* she actually used an actress, Nan Martin, to produce a marvellous series of pictures – vibrant and spontaneous, they look astonishingly modern today. In 1951 she wrote about what she was trying to capture in a photograph '. . . motion or reality, the feeling of a moment passing, the fleeting glimpse of recognition, a gesture, a smile then and gone . . .' adding '. . . the theatre can be compared to photography in that it presents an illusion of reality by artful contrivance, producing for the viewer the

image of true life'. This statement neatly sums up Frances McLaughlin-Gill's approach, one which she has continued to develop up to the present day and which she brought to all of her beauty assignments (page 115).

Paul Himmel was another photographer who pioneered the reportage method in fashion and beauty. He was much more closely associated with *Harper's Bazaar* than with *Vogue*, but the one beauty photograph he did take for *Vogue* – in 1953 – is worth looking at more closely since it is an illuminating and early example of a reportage type conception. The brief was to illustrate a new way of washing, and Himmel opted to photograph the model doing this through the cabin window of a sleeping coach on a railway train (page 60). His first choice of picture showed waiting passengers on a station platform reflected in the carriage window, but this extra touch of realism was rejected by the magazine since they felt that the woman looked as though she were being spied upon. The photographer argued that this was hardly possible in a train travelling at 60mph, but the less contentious version was the one ultimately published.

By the mid-1950s the concept of an haute couture aimed specifically at a

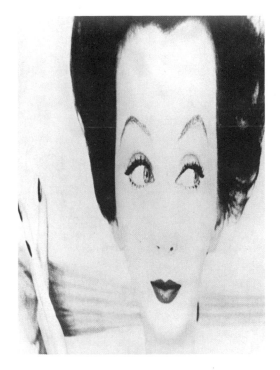

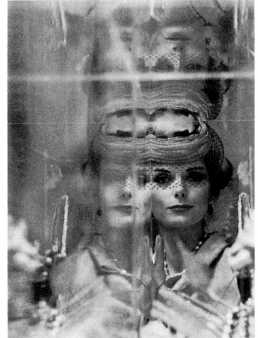

narrow, rich elite, was declining. Fashion entered what was, certainly to this observer, one of its dullest periods. Concurrently with this change fashion and beauty photographers became increasingly preoccupied with illustrating something quite different from a dress or make-up. Though dress and make-up might have been the nominal subjects of their pictures, what they were really concerned with was evincing a new lifestyle. Such thinking was already apparent in the work of Paul Himmel and Frances McLaughlin-Gill, and a new breed of fashion and beauty photographer was emerging for whom fashion as such held relatively little interest, but who could provide photographs which vividly reflected the changes in contemporary society.

When Alexander Liberman signed photographer *William Klein* to a *Vogue* contract in 1955 it was in tacit acknowledgement of the magazine's need for someone who could articulate this new mood visually. Having lived in Paris since 1948 Klein returned to visit his native New York in 1954. So powerful was the impact that the changes in the city made on him, that he immediately started to record his response with a camera. Said Alexander Liberman, 'Those pictures had a violence

I'd never experienced in anyone's work. The prints were harsh and uncompromising, yet Klein made the everyday fit into a new aesthetic. There was a wonderful iconoclastic talent, seizing what it saw. I thought it should be let loose. In the fashion pictures of the fifties nothing like Klein had happened before. . .'. It was difficult for Klein to translate a beauty photograph into an iconoclastic image, but he managed to come close with his distorted heads and the aggressively smoking woman (page 161). The girl drinking through a straw is closer to kookie than anarchist, but perfectly sums up a particular late fifties type – the acceptable face of the beat generation.

By commissioning *Bruce Davidson* in 1960, *Vogue* continued to take risks with its photographers. Like fellow American Klein he had shot no fashion or beauty previously; Davidson's background was also in reportage – notably in his case a pithy story on the infamous Brooklyn Gang. He made few concessions when working for *Vogue*; his photographs were raw, grainy in quality, full of movement, but must be regarded as successful in spite of – or perhaps because of – Davidson's lack of compromise. His more regular beauty photograph shows clearly his pre-

Left
Bruce Davidson 1961
Far left
William Klein 1955
Below
William Klein 1957

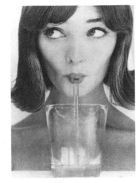

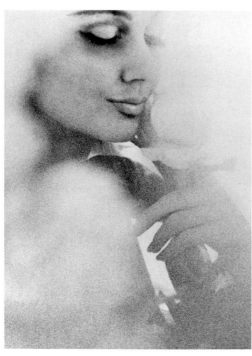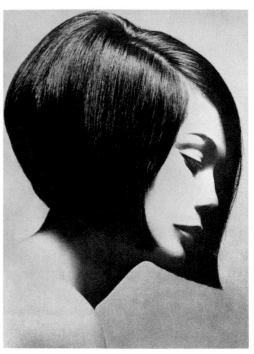

Right
Terence Donovan 1961
Far right
Terence Donovan 1963
Below
David Bailey 1985

ference for pushing 35mm colour film to the limit of its exposure range, which resulted in moody, dramatic images, while the exercise picture is pure documentary.

By the early 1960s the social changes that had been foreshadowed in the previous decade had spread much wider in their impact. One of the repercussions in the world of fashion and beauty photography was that London and Paris emerged to challenge the long established dominance of New York. The large scale borrowing of American material by British *Vogue*, for example, virtually ceased, as a group of young English photographers arrived on the scene who could supply exactly the kind of material British *Vogue* needed. Pre-eminent among this group were *David Bailey, Terence Donovan* and *Brian Duffy*, three Londoners later nicknamed 'The terrible three'. Duffy's line that 'Before us fashion photographers were tall, thin and camp, now they're short, fat and heterosexual' gives a clue as to how earlier stereotypes of a *Vogue* photographer were being adjusted. Separating myth from reality in the Swinging Sixties can be a difficult proposition, but it is clear from the evidence that nobody worked for *Vogue* simply by virtue of having the right kind of haircut – Bailey, Donovan and

Duffy all turned out to be accomplished and highly professional photographers. The most prolific *Vogue* photographer up until the mid-1970s, Bailey was responsible for many beauty photographs. The strength and immediacy evident in his recent shot illustrating teeth care (page 94) is already apparent in photographs dating from two decades earlier. Similarly the romantic, dramatic portrait of Penelope Tree from 1968 (page 166) does not lose by comparison with a highly effective recent shot of Victoria Lockwood. Terence Donovan proved to be an equally intelligent and adaptable photographer. Two very early beauty shots exemplify this; the softly romantic shot of Celia Hammond (1961) and the harsh shadows and high contrast of a 1963 picture emphasising the clear-cut geometry of a Vidal Sassoon hairstyle.

It was in Paris, where he had moved in 1962, that *Helmut Newton* began to steer fashion and beauty photography away again from a preoccupation with formal visual qualitites. References to films abound in his photographs of the sixties, particularly to the new spy films and to the New Wave cinema in France and Italy. It was clear that Newton was more interested in creating an exciting atmosphere in his

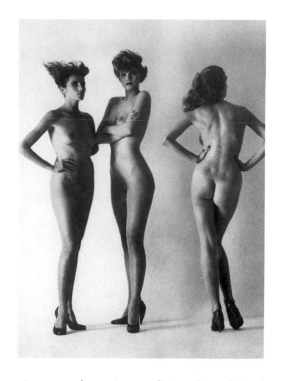

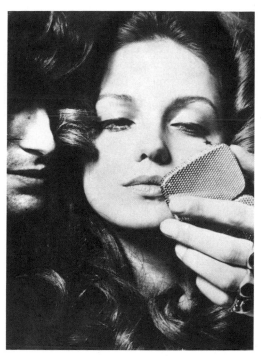

pictures than in traditional technical perfection. He became one of the most successful post-war photographers, and from 1976 began a series of books devoted to erotic photographs. He had always tried to push magazines in the direction of accepting increasingly erotic pictures, and after 1976 the gap between his private work and commissioned photographs narrowed even further. Thus most stages of Newton's development are illustrated here, from his sci-fi interpretation of a slimming machine in 1967 (page 62) to the three nudes (1983) which relates directly to *Sie Kommen* from his book *47 Nudes*. An even more recent interest in extreme close-ups is foreshadowed in another 1983 beauty picture of green fingernails.

Others in the 1960s moved photography further from its illustrative role in favour of an obsession with narrative. This was easier to pursue in fashion than in beauty photography, where there was more opportunity to have pictures spread in a sequence of anything between four and eight pages. Despite this the two individuals most committed to story-telling, *Saul Leiter* and *Bob Richardson*, both managed to take beauty pictures for *Vogue* in which a possible narrative was at least hinted at. Photographing his favourite model,

Donna Mitchell, for French *Vogue*, Richardson introduced a man (photographer Alexis Waldeck) intimately overlooking her make-up procedure. Placing a man in such close attention may be quite commonplace now but it was much more unusual in 1967. Saul Leiter's photograph of Jean Shrimpton with the red lips was for a special issue of British *Vogue* in which the colour red was the linking theme (page 6). Leiter's deceptively simple, but brilliantly successful solution was to photograph Miss Shrimpton wearing a red plastic mackintosh reflected in the window of a red London bus.

With Jean Shrimpton we arrive at the era of the model as personality. She was of course most closely associated with David Bailey. Similarly, Verushka, the exotic 6ft 1in German baroness, was linked with photographer *Franco Rubartelli*, though in her case her striking appearance was thought to be a greater asset than the talents of the photographer. This was perhaps a harsh judgment on Rubartelli, although his fashion photographs were certainly more dynamic than his beauty heads.

Guy Bourdin's first photographs for *Vogue* date back as far as 1955. In the 1960s his work was chiefly concerned with

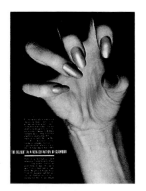

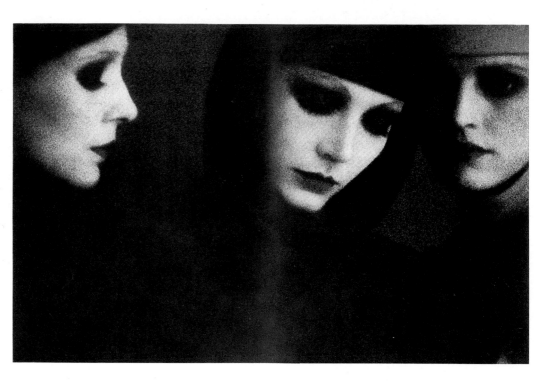

Right
Sarah Moon 1973
Below
Albert Watson 1985

geometry and formal values, but by the early 1970s he was giving free rein to psychologically complex sexual fantasies. He was given considerable freedom by French *Vogue*, both in terms of subject matter and layout – nearly all his photographs latterly have been double page spreads. The 1978 picture ostensibly showing face powder and perfume shows, in its sexual ambiguity, the revolutionary changes in Bourdin's photography since the previous decade, and also represents an extreme in *Vogue*'s depiction of beauty (pages 76).

Since first working for *Vogue* in 1968, *Barry Lategan* has become one of the magazine's most important beauty photographers. Never liable to go to the same extremes as, say, Guy Bourdin, he has remained a careful and professional craftsman, achieving qualitites of elegance and repose which have been especially effective in his beauty photographs. A typically lovely example is a 1975 skin care picture (page 71); Lategan was equally capable of producing a witty hairstyle photograph (page 148) or an informal scene in a sauna (page 66) and in recent times has proved to be perhaps the most versatile of all *Vogue*'s beauty photographers.

Sarah Moon, by contrast, has consist-

ently pursued a single type of beauty; she has described her interest in showing women who were caught in a state of suspended animation – waiting – as she puts it. Certainly her models all conform to a specific type, passive, dreamy, fin-de-siècle in spirit. Her 1973 make-up shot of three veiled women for French *Vogue* is a beauty classic and a fine example of Sarah Moon's considerable talent – a tightly cropped but subtly balanced composition, the coarse grain of the colour film invoking a suitably romantic, ethereal mood.

In spite of the occasional exceptions already noted, such as Bob Richardson and Helmut Newton, most fashion and beauty photography in the 1960s tended to be clean, formal and studio-orientated. Around 1970 a group of photographers based in Paris spearheaded a reaction against this trend, again attempting to re-establish the dominance of outdoor location realism. The leading member of the group was the American, *Arthur Elgort*. He advocated a laissez-faire approach, allowing his models to react as naturally as possible to the camera. More recently he has returned to the studio, and has experimented in different directions, for example with TV monitor images (page 176). Beauty photography in the last ten

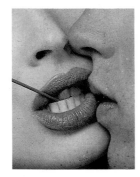

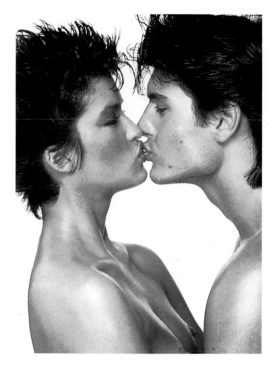 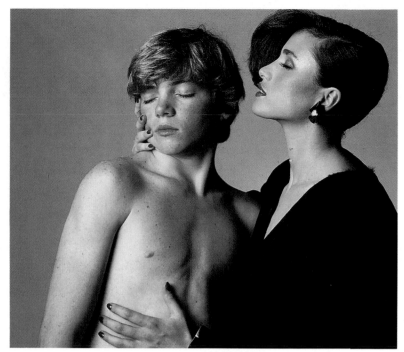

years has reflected the extreme variety of styles evident in fashion photography, a situation where it is no longer possible to point to a single dominant approach. The Italian edition of *Vogue* has afforded certain photographers a degree of editorial freedom that has not been otherwise available. The pictures by *Deborah Turbeville* they have published since 1982 are a case in point. Her work goes greatly against the current tide as Alexander Liberman observed, 'At a time when health and energy were being stressed she brought a mysterious reminder that everything in life in not health and happiness' (page 46 and 174). Turbeville's moving and poignant photographs are the product of a distinctly female point of view. Their acceptance appears to have paved the way for other women photographers on *Vogue*, whose work has in common with hers a specifically female empathy. Notable recent examples in this category are the beauty photographs by *Sheila Metzner* (page 34) and *Joyce Tenneson* (page 51).

The opportunities for developing a strongly individualistic photographic signature are at present rare on fashion magazines. Consequently *Vogue* uses many photographers who are flexible and highly professional but who must usually forgo the inclination to make an uncompromisingly personal statement. Nevertheless worthy examples of the genre have been made by *Vogue*'s current stars, as the photographs by *Albert Watson* (pages 105 and 165), *Denis Piel* (page 82), *Patrick Demarchelier* (page 119) *Bill King* and *Steven Meisel* (page 4) amply testify. The most influential figure to emerge in the 1980s has undoubtedly been *Bruce Weber*; ironically though, his single-minded belief in his own photography, his unwillingness to compromise, have resulted in a very in and out career with the high fashion glossies. His work is complex and ambiguous: it is at once innocent yet sophisticated, carefree but sexually charged (page 20).

Today, when the emphasis on health and exercise as essential components of beauty is greater than ever, beauty photography occupies a more important role in magazines than at any time in the past. One can confidently anticipate that *Vogue*'s photographers will continue to create further brilliant solutions to beauty photography's special challenges, adding to the variety and excellence of past achievements.

MARTIN HARRISON

Above
Denis Piel 1983
Above left
Bill King 1983
Overleaf
Bruce Weber 1982

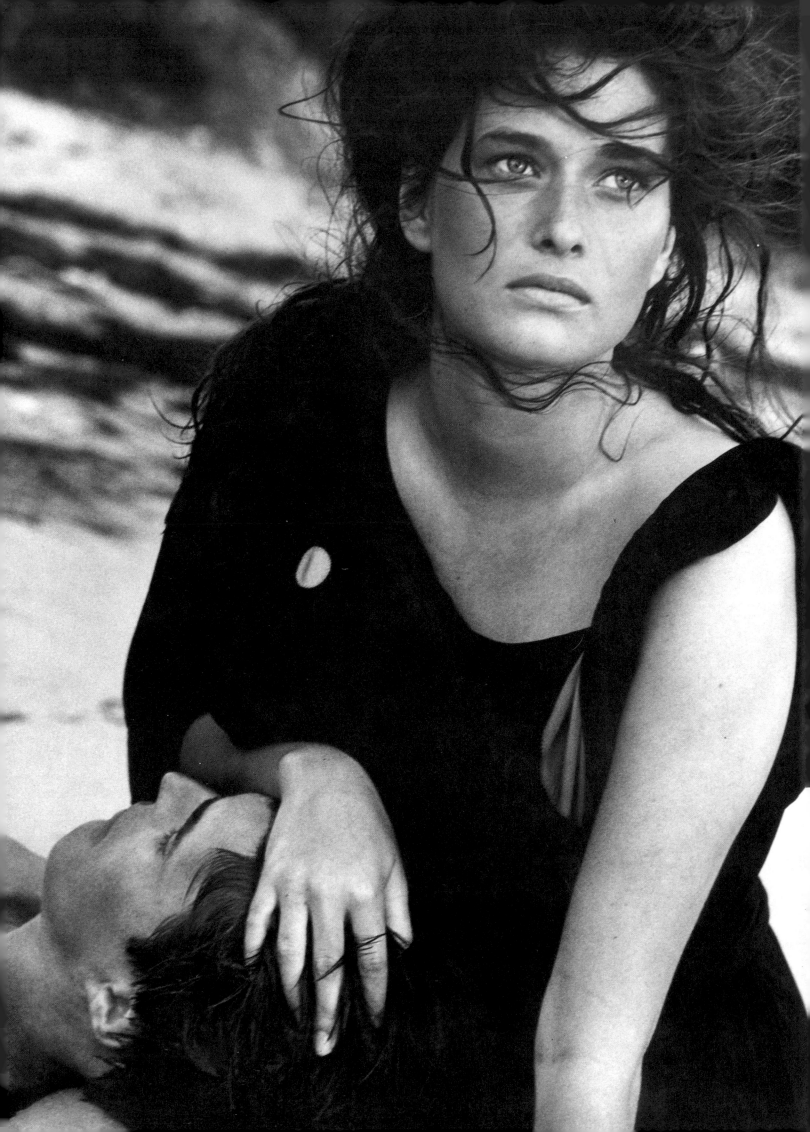

Plates

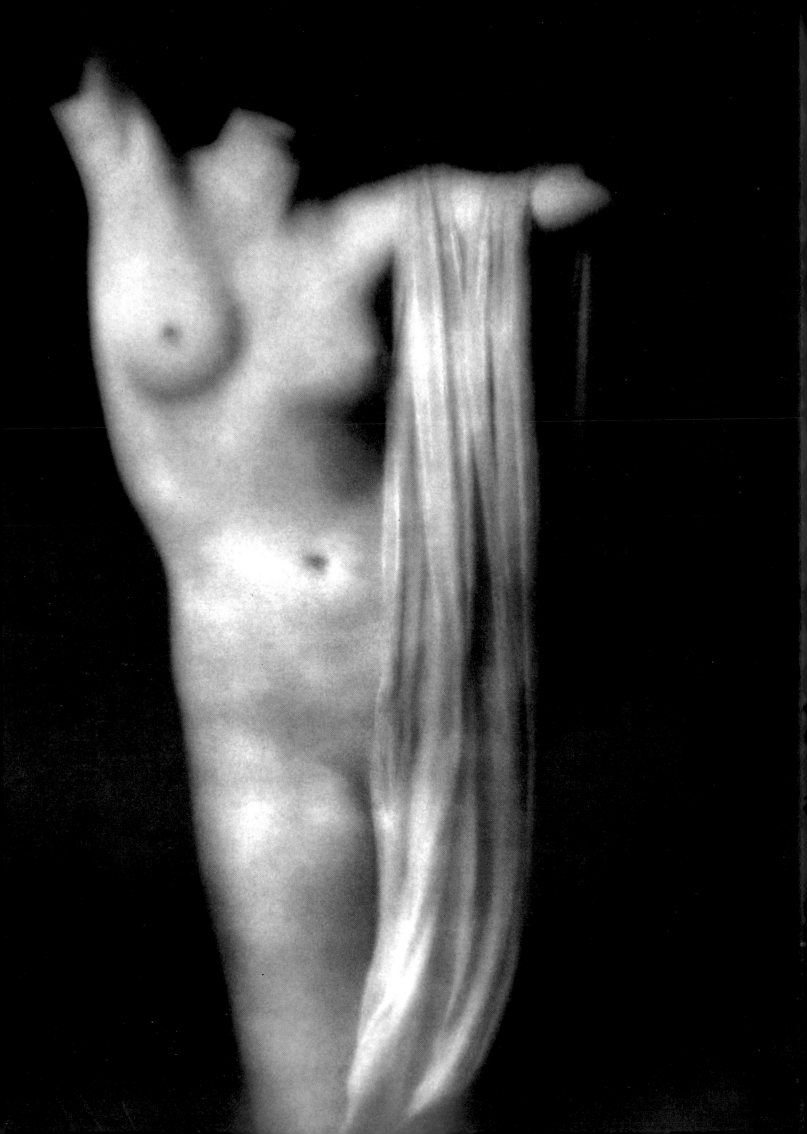

Basics

'How imperceptibly, but quickly, our views on beauty fluctuate! Even in two years the ideal can undergo a complete change! . . . It is a curious phenomenon that the demand for a certain new type of beauty is always supplied.' Cecil Beaton, 1967

The physical fitness and condition of our bodies is the basis for all beauty, a fact that has been consistently acknowledged and reflected in beauty photography. Nudity in fashion magazines is by no means a recent phenomenon – Steichen's earliest *Vogue* nude here dates from 1934; it will be apparent though that this was a back view and fairly dimly lit – some degree of modesty was clearly considered prudent in *Vogue* at that time. Frontal nudes were manipulated in various ways to avoid causing offence. Blumenfeld overlaid a screen of black and white parallel lines in 1944 and Coffin's nude of 1948 was optically distorted in a way which recalls André Kertesz's famous series of the 1920s. Similarly Rutledge's colour nude is solarized and Gjon Mili's stroboscopically multiplied.

It was not until the 1970s that the nude made its next major impact in beauty photography. By then a relaxation in moral codes meant that frontal nudity was acceptable. Franco Rubartelli contrived to have natural forms partly submerge the body in his 1972 photograph, but seven years later Mike Reinhardt had banished all false modesty in his depiction of a half-naked woman. Bruce Weber's recent work has demonstrated his increasing interest in exploring the nude as his principal subject matter, and his investigation spilled over into his pictures for *Vogue*; this development was already foreshadowed in one of his first *Vogue* photographs, the uninhibited and joyful picture made in 1980.

Left
Arnold Genthe
1938

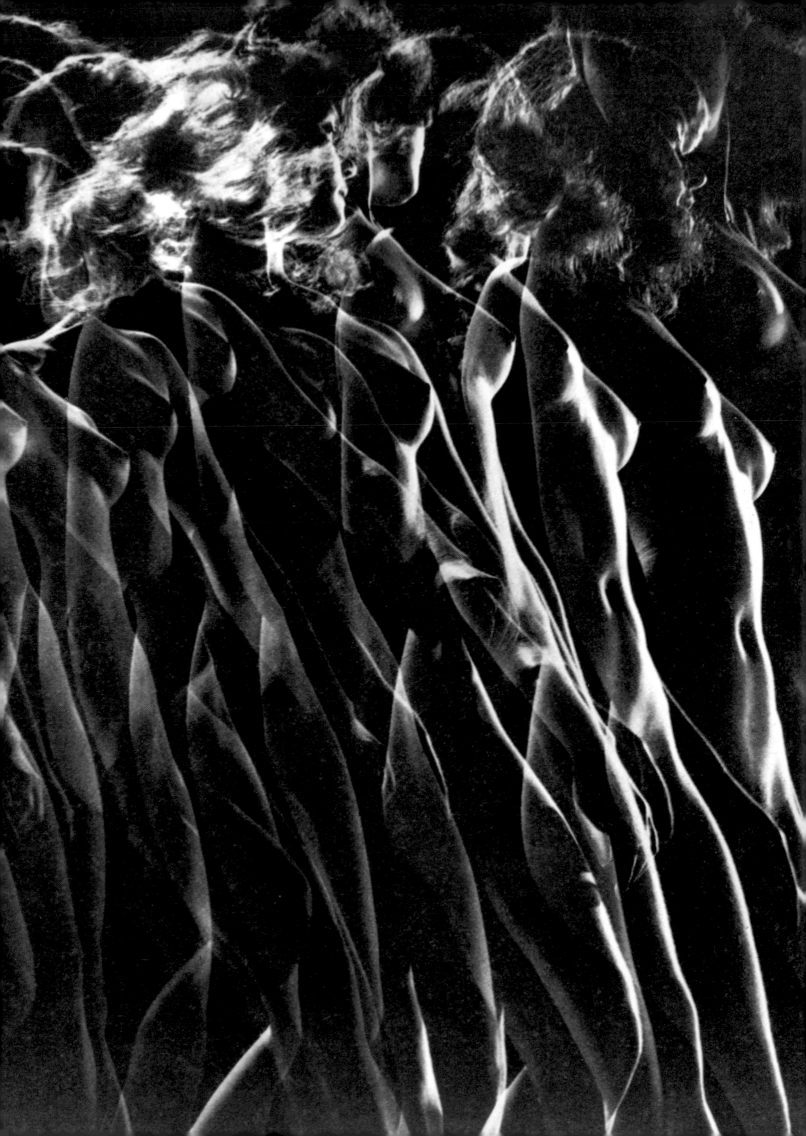

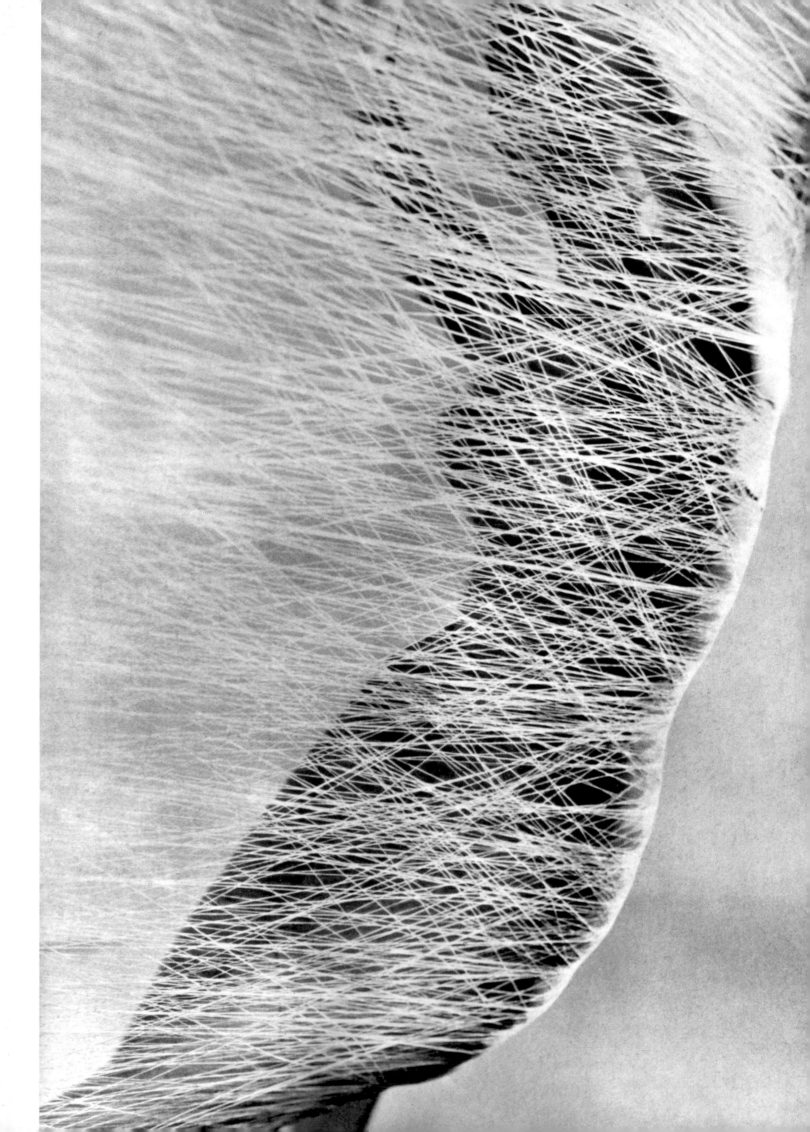

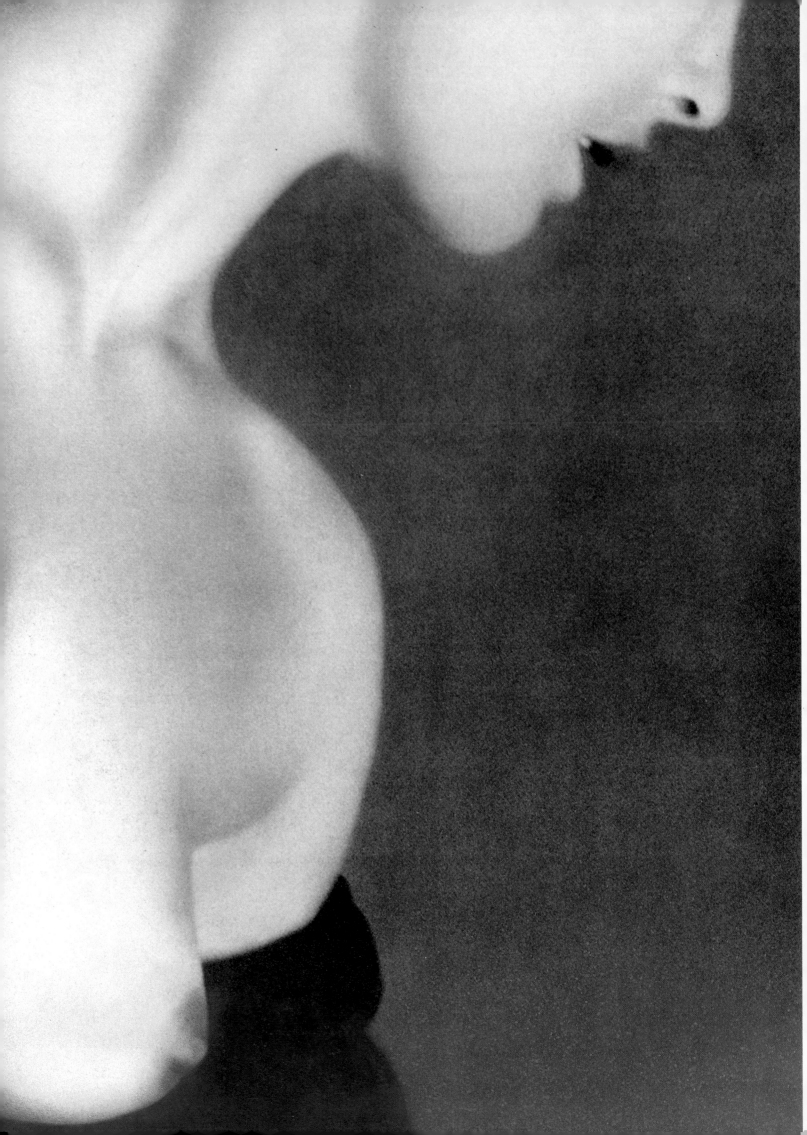

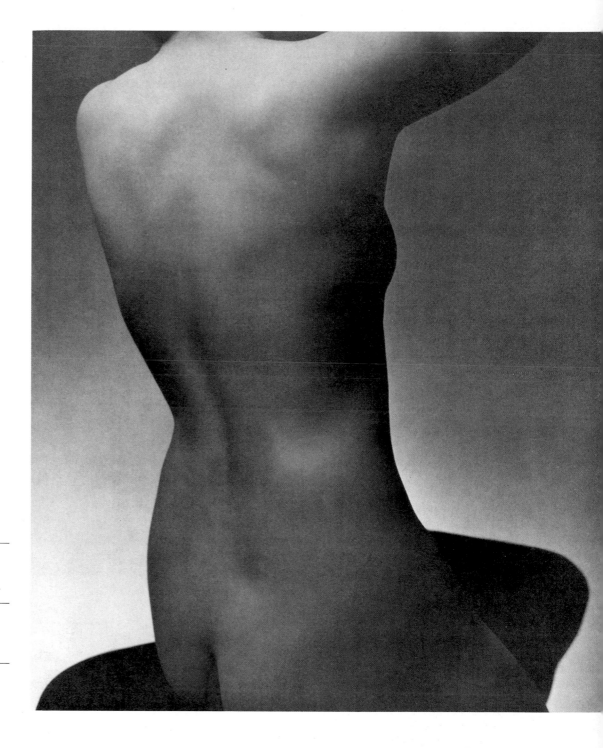

Previous page left
Gjon Mili
1944

Previous page right
Hans Hammarskiöld
1956

Left
John Rawlings
1959

Right
Edward Steichen
1934

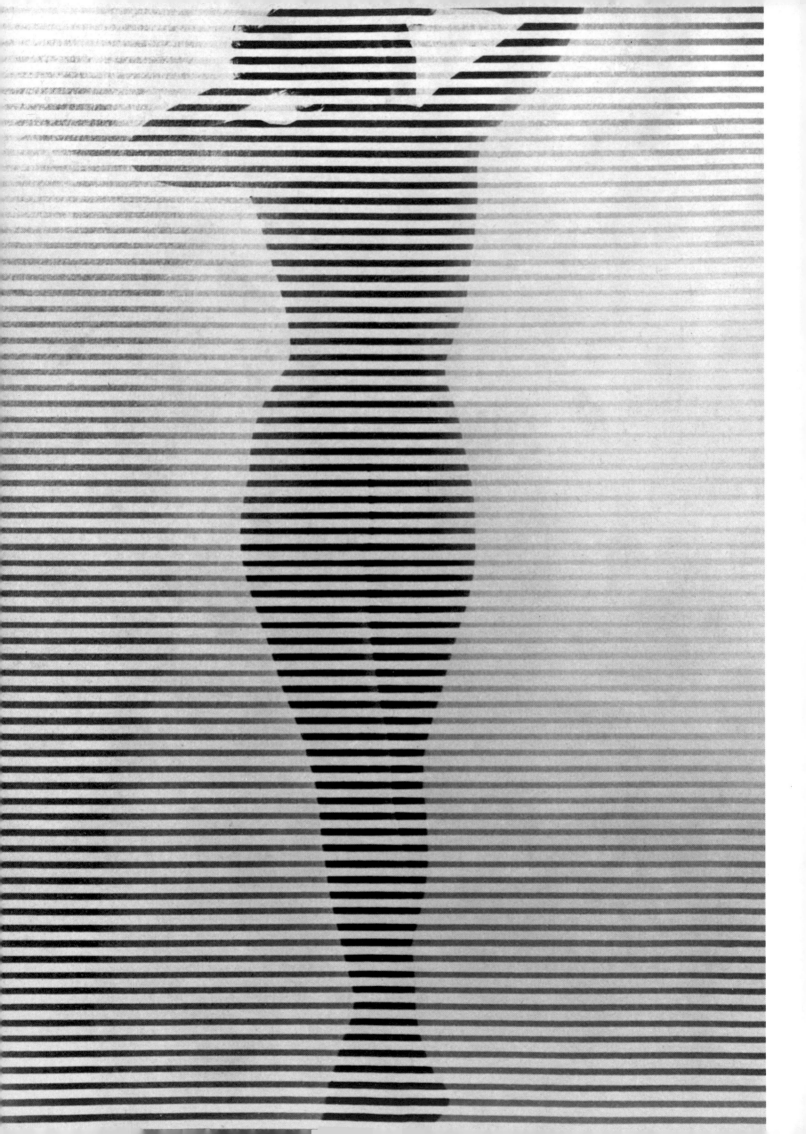

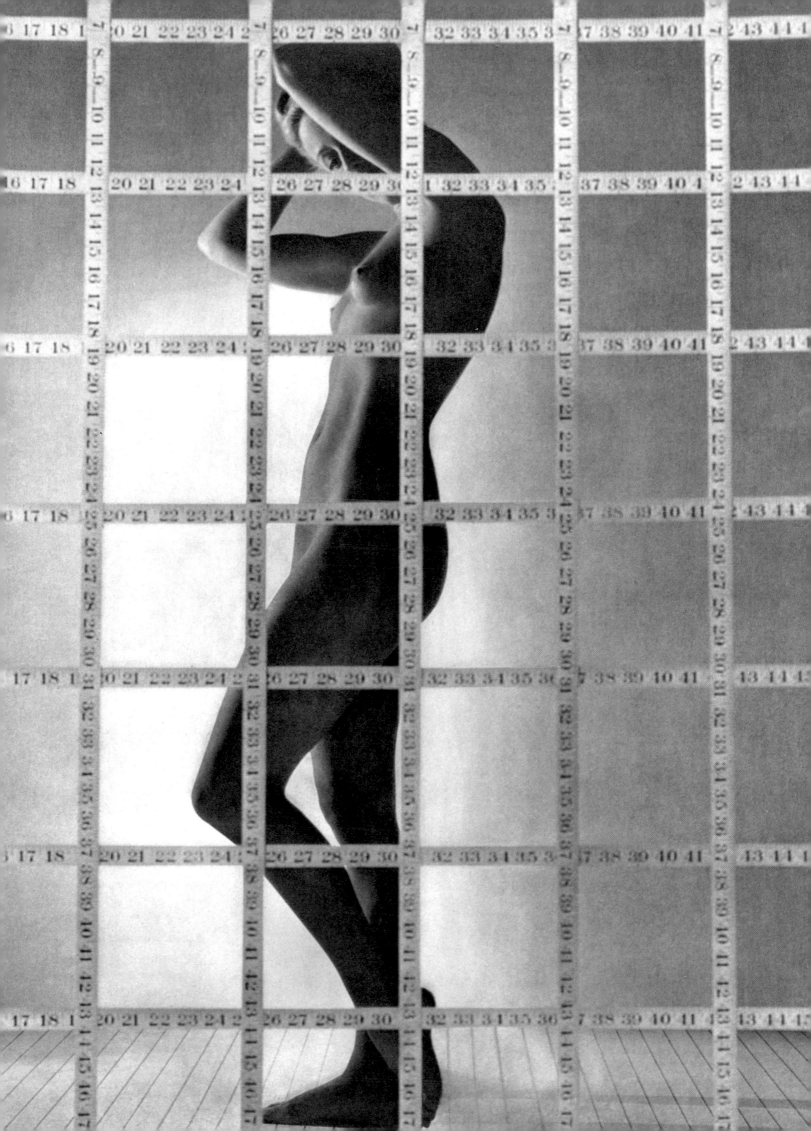

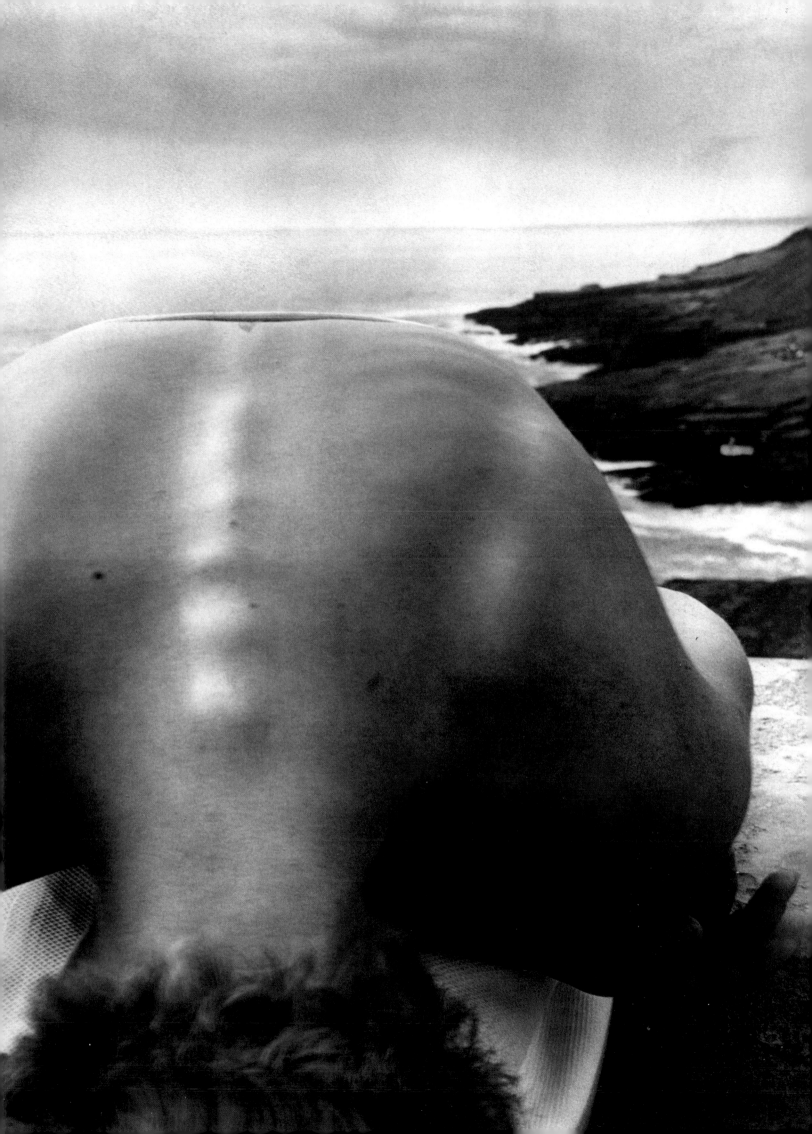

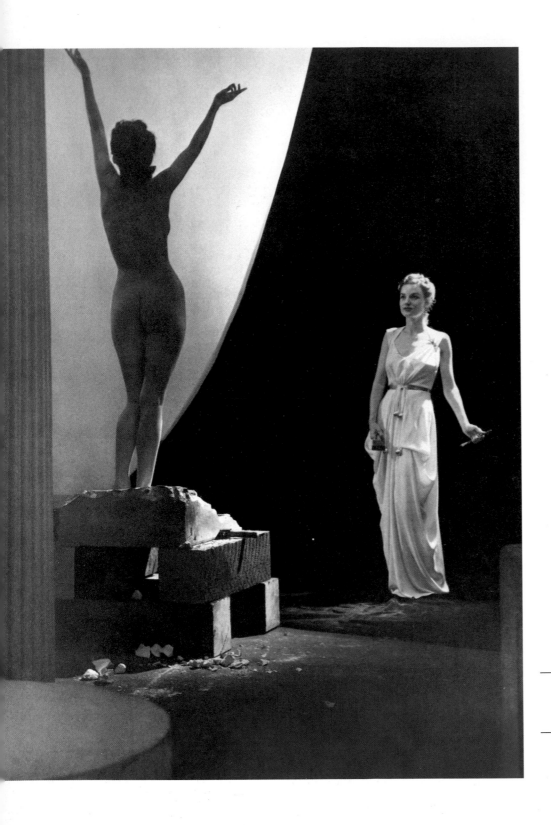

Left
Edward Steichen
1941

Right
Clifford Coffin
1948

Overleaf
Sheila Metzner
1986

32

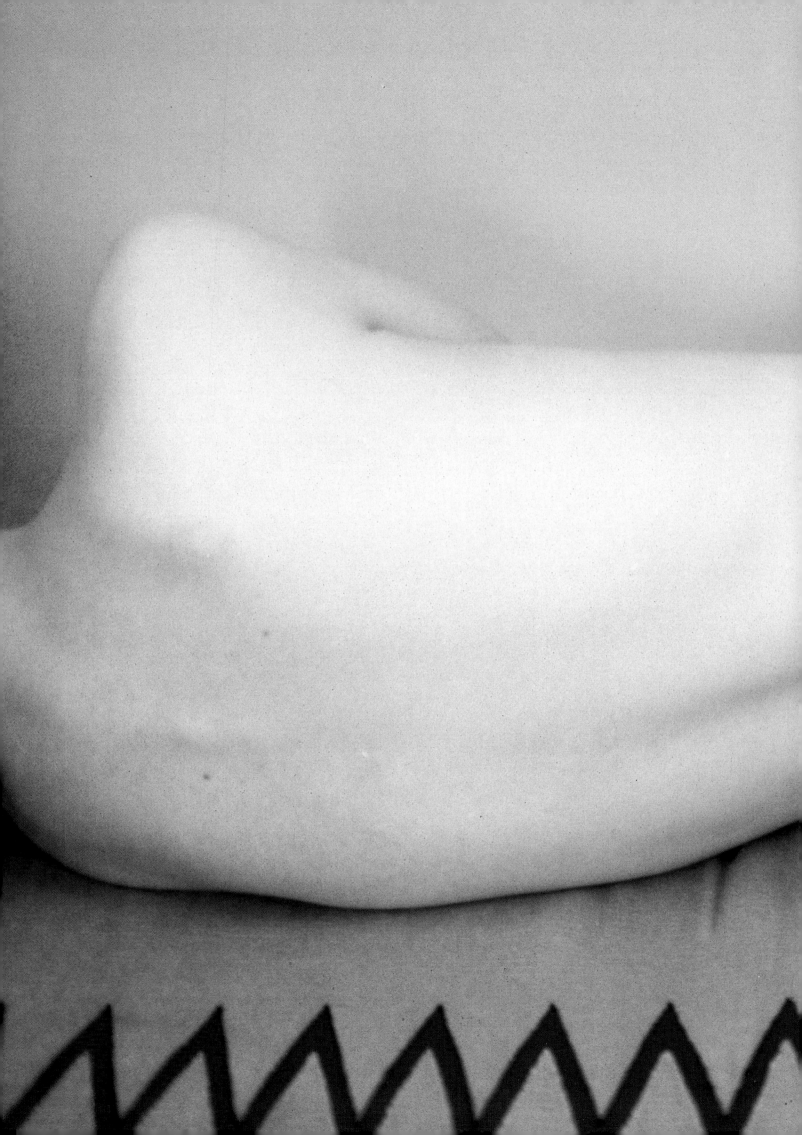

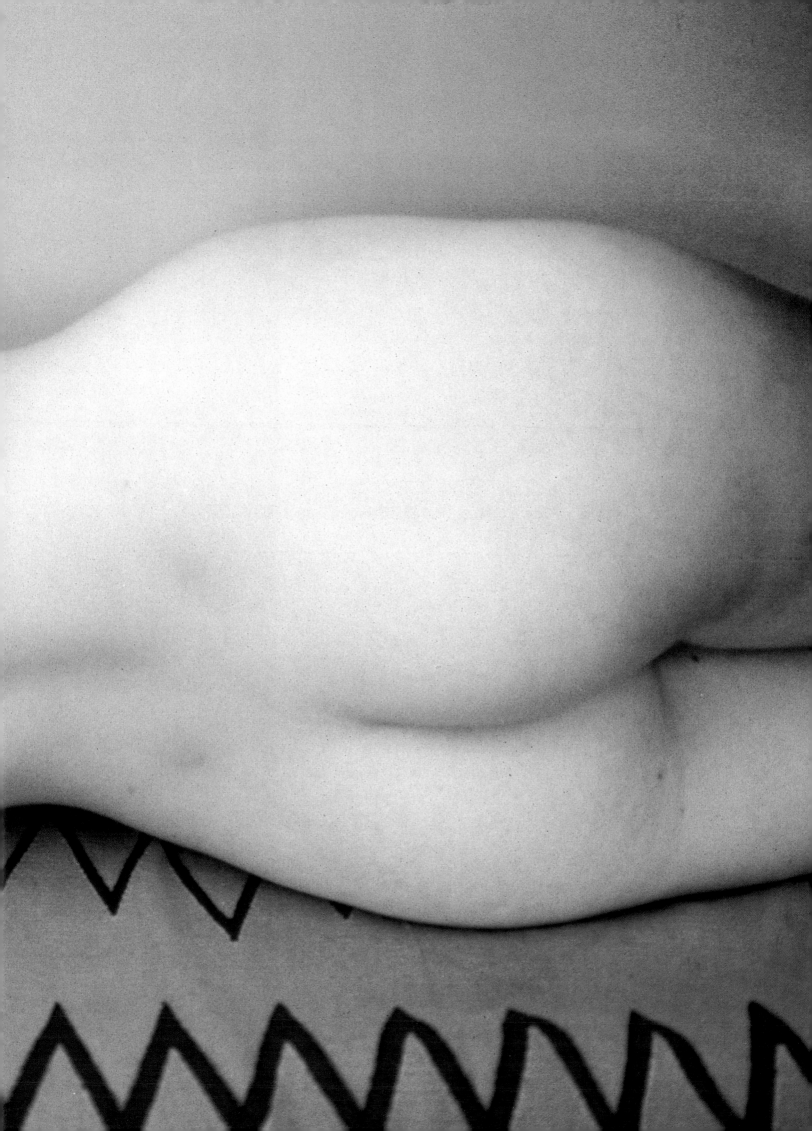

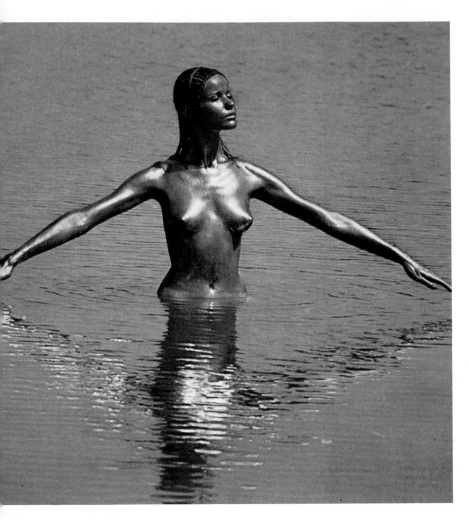

Above
Franco Rubartelli
1968

Right
Guy Bourdin
1969

Overleaf
Franco Rubartelli
1972

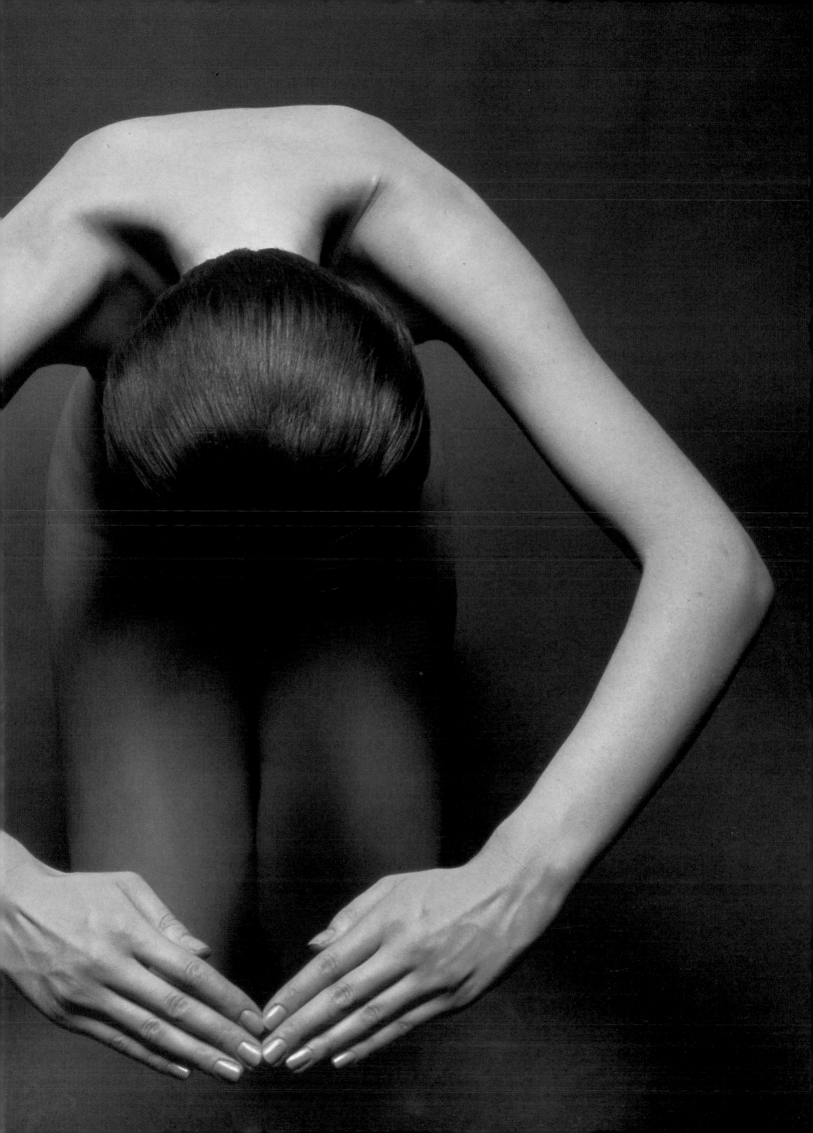

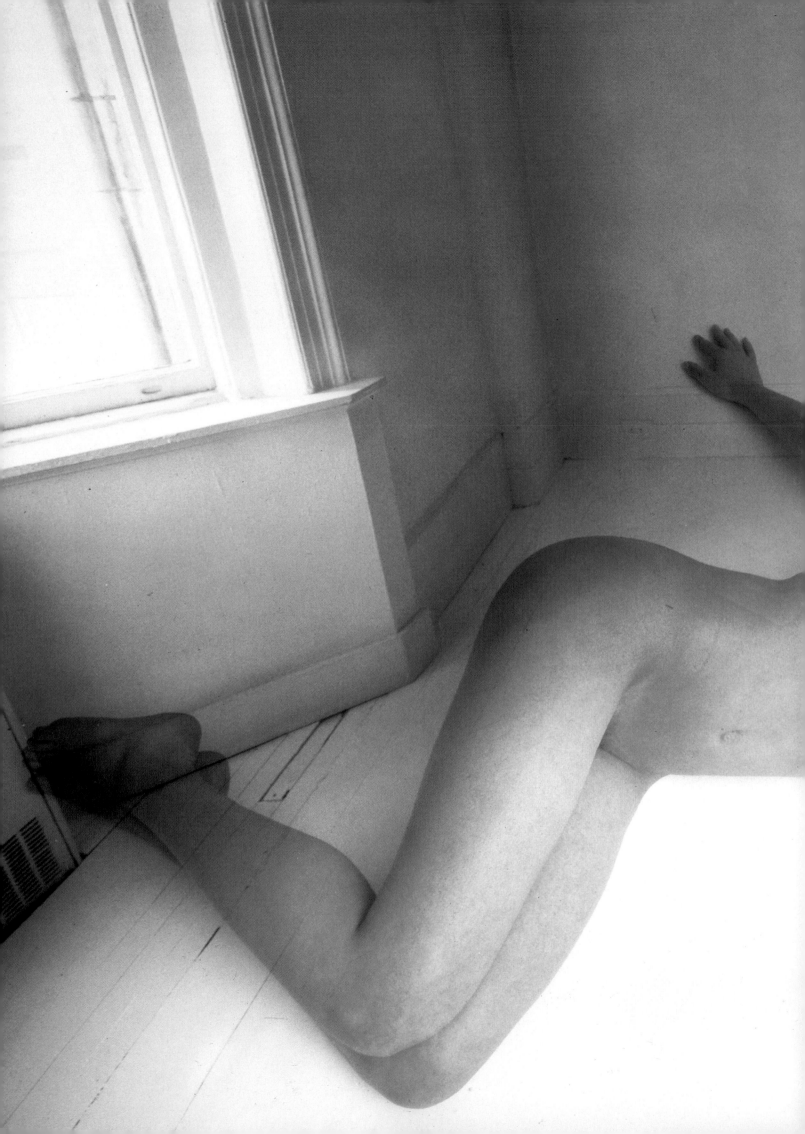

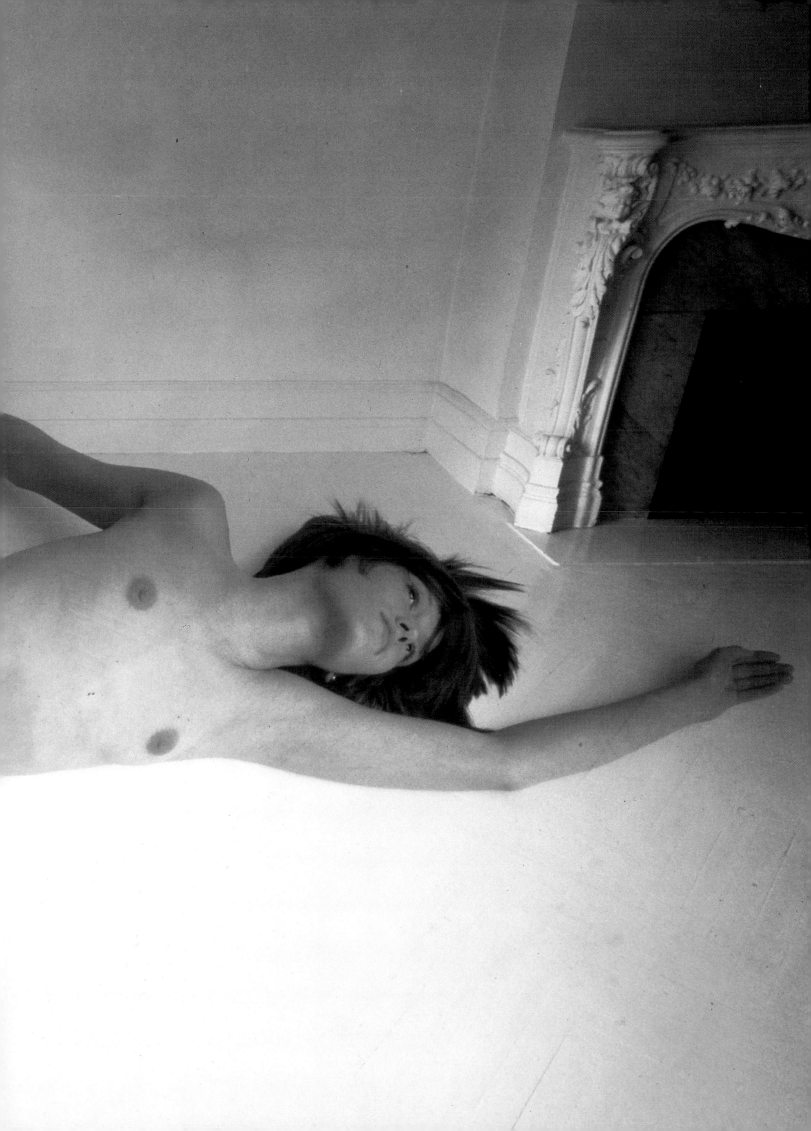

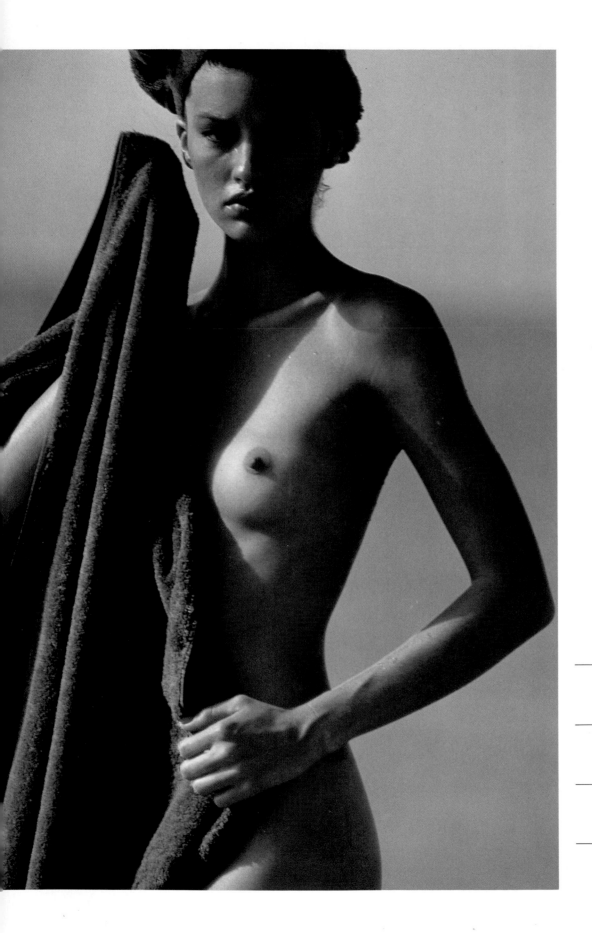

Previous page
Art Kane
1984

Left
Mike Reinhardt
1979

Right
Peter Lindbergh
1984

Overleaf left
Alberto Rizzo
1972

Overleaf right
Alan Turnbull
1978

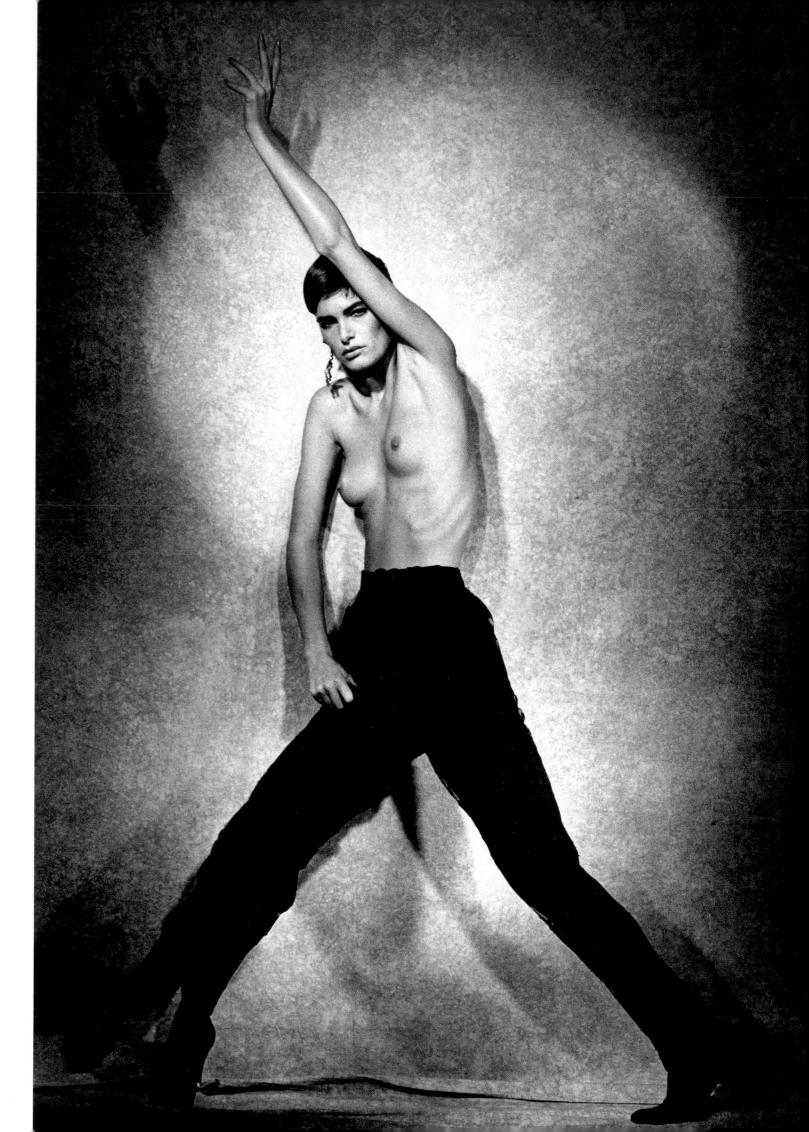

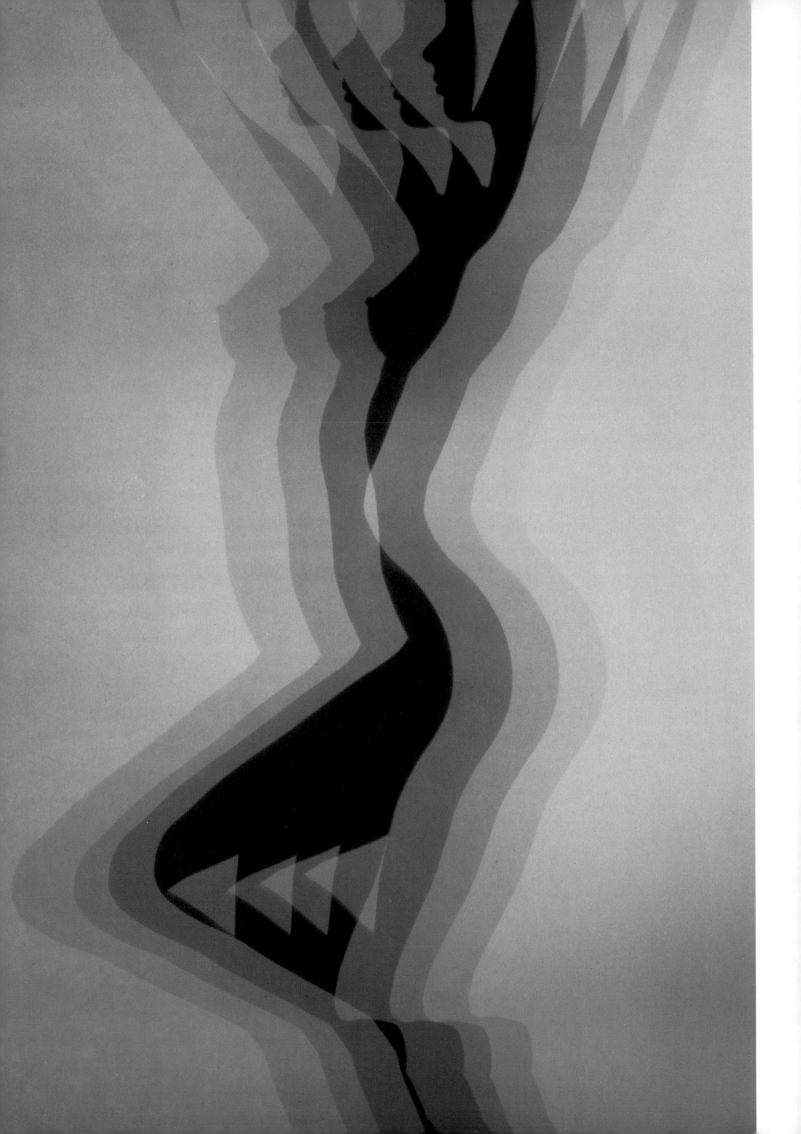

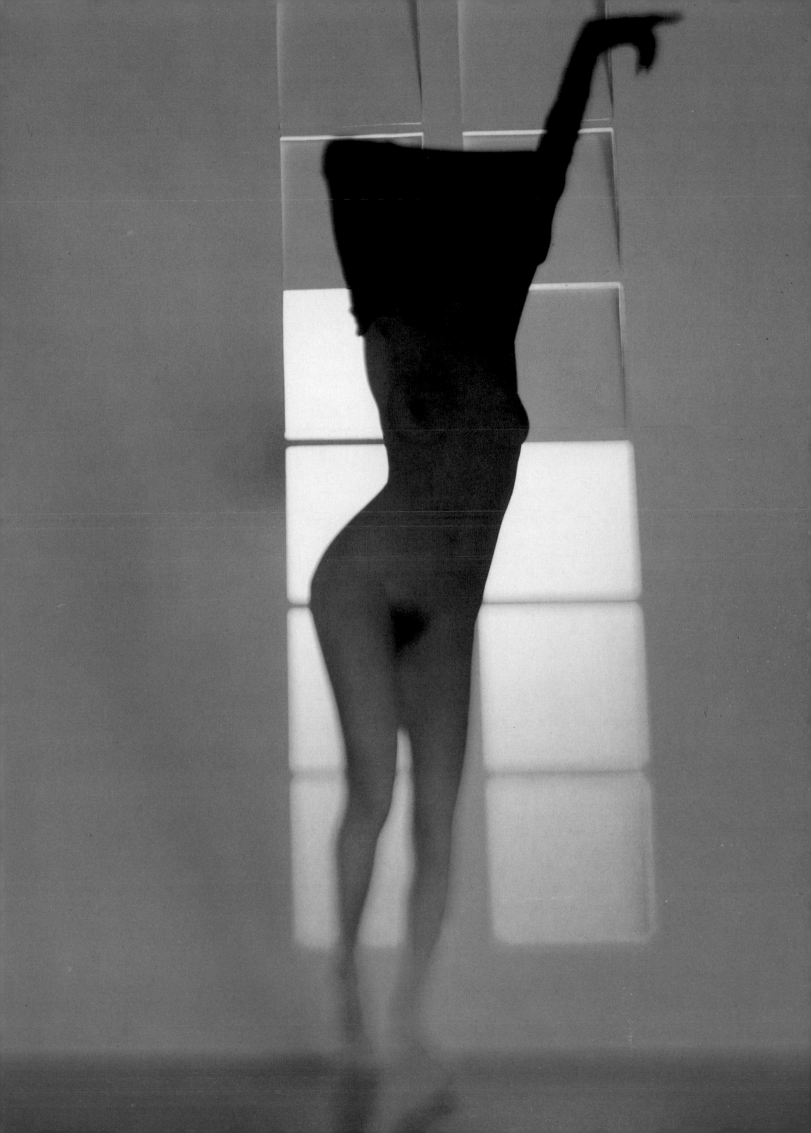

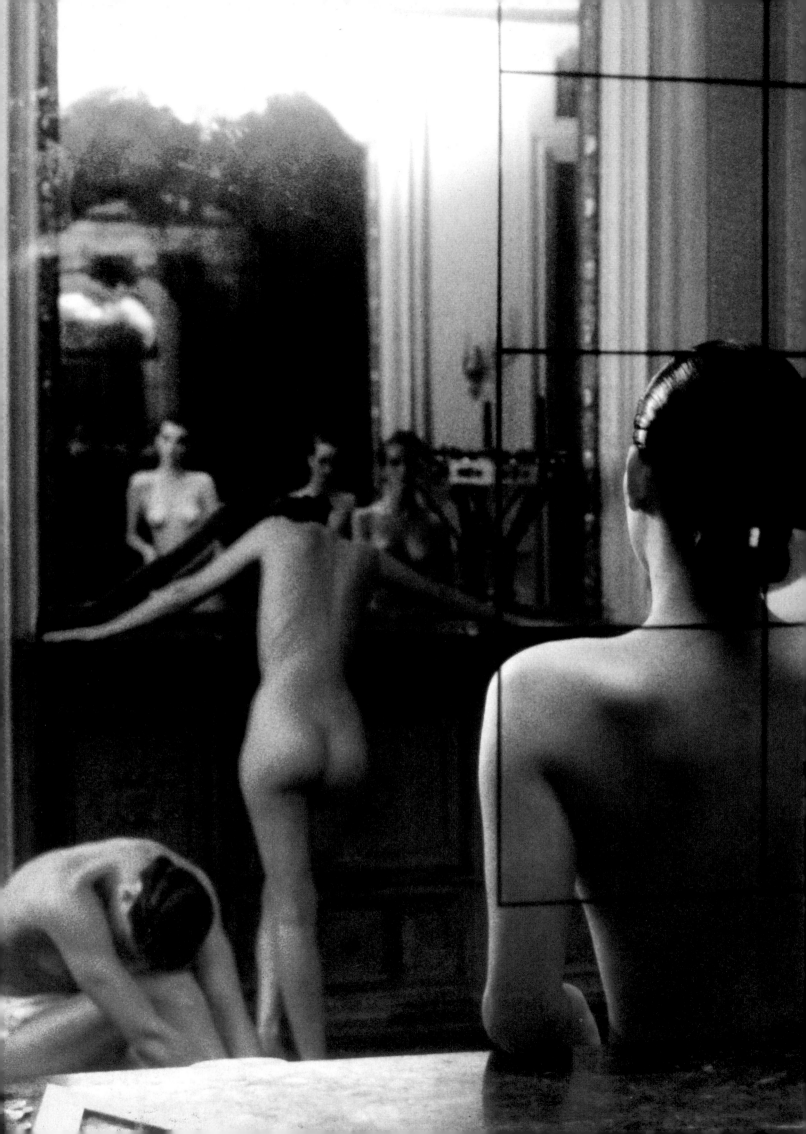

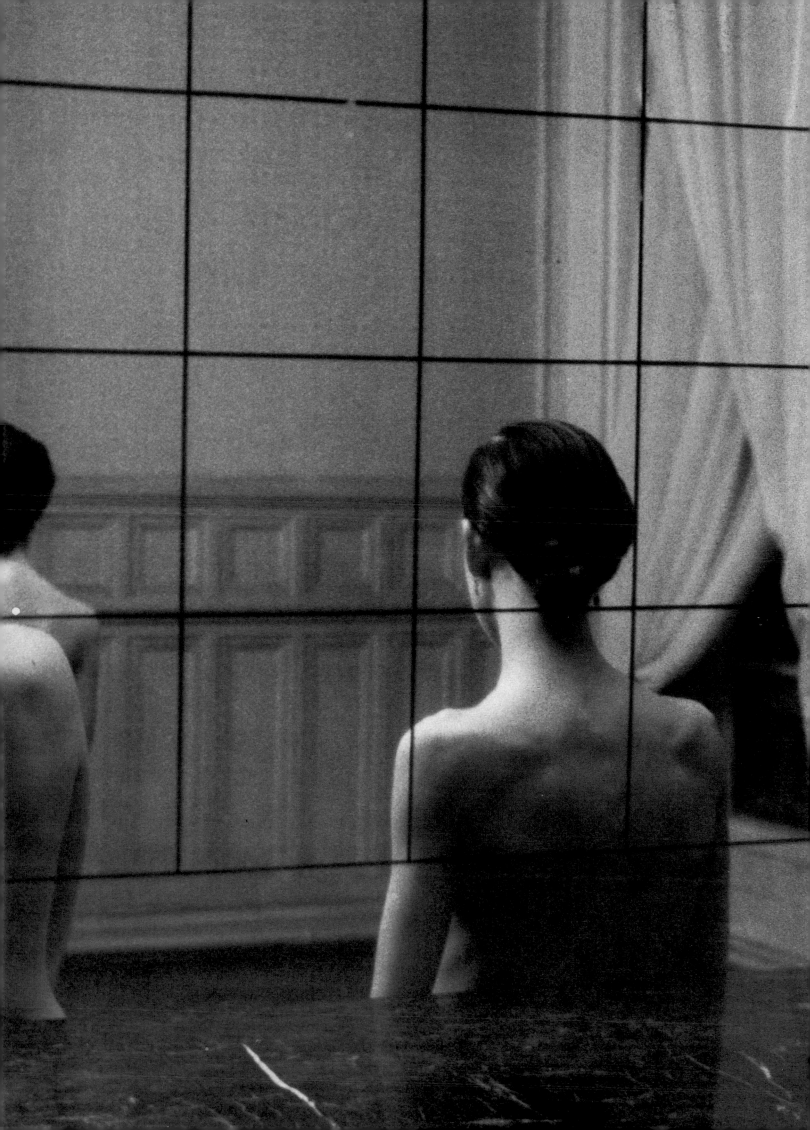

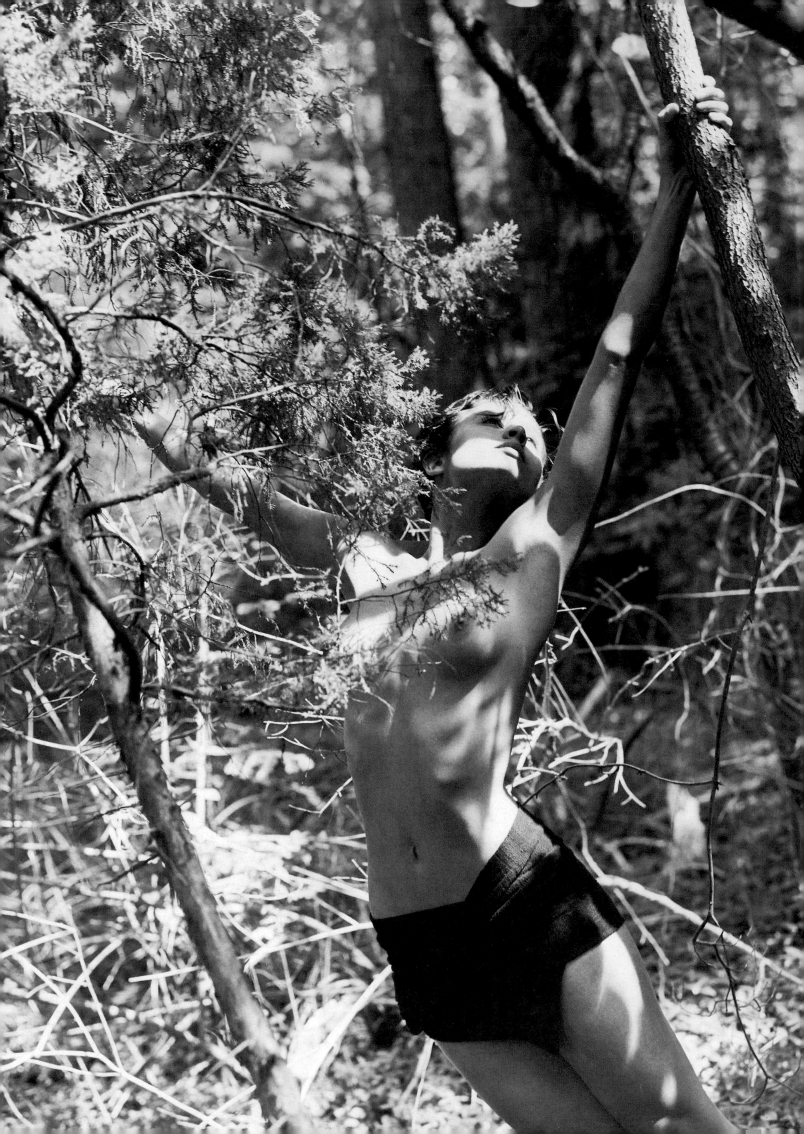

Previous page
Deborah Turbeville
1982

Left
Bruce Weber
1983

Right
Deborah Turbeville
1981

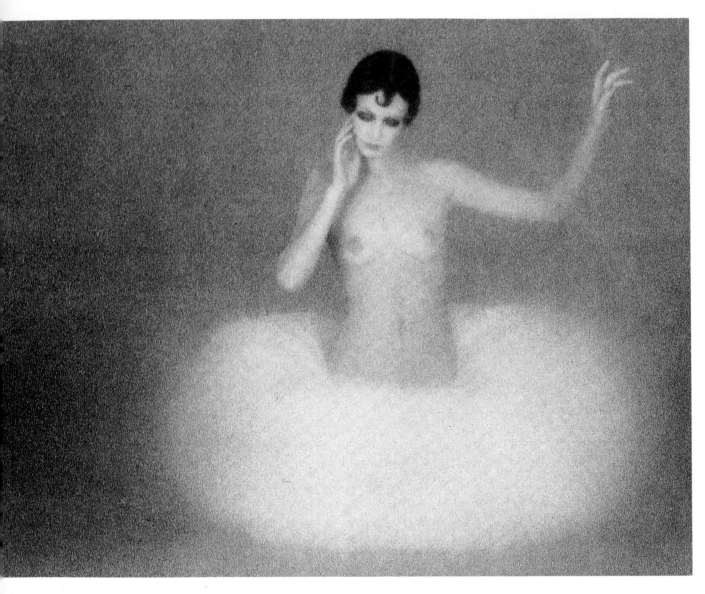

Above
Sarah Moon
1974

Right
Joyce Tenneson
1986

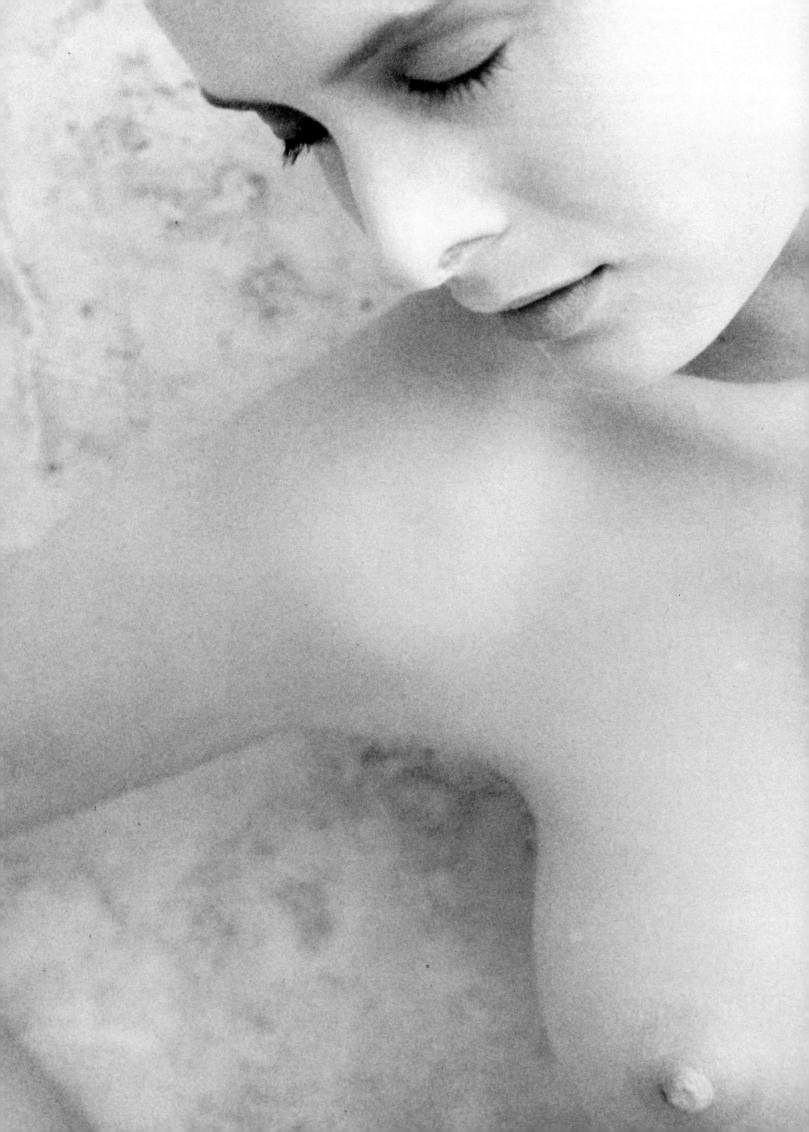

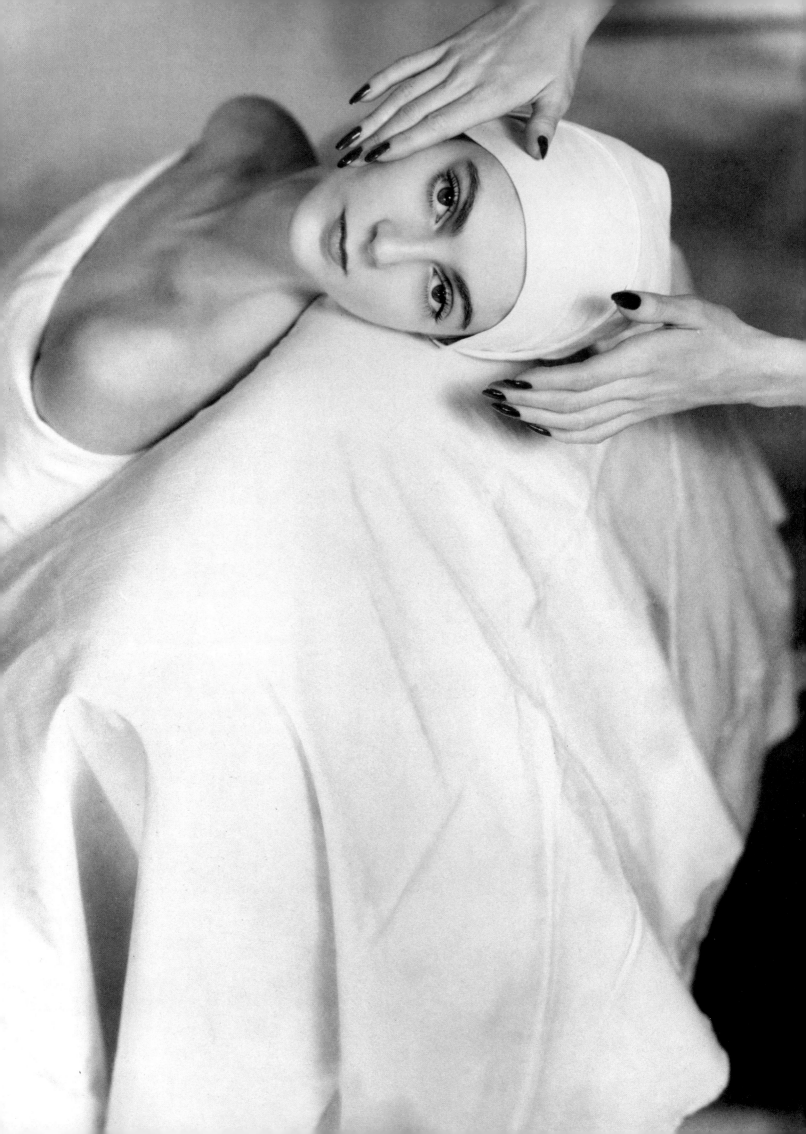

Preparation

'The whole history of the human face may be summed up in two words, the mask and the face. The latter is that which nature has endowed us with, the former that to which we wish to approximate.' Roy Strong, 1969

While recognising the importance of health and fitness, *Vogue* has always been concerned to point out that to achieve real beauty a woman needs help. 'Beauties are made, not born', *Vogue's Beauty Book* told us in 1938, adding: 'Believe us, the women you think of as beautiful have *worked* to make themselves that way'. It would be disingenuous to pretend that this advice was not at least partially connected with encouraging and reassuring the growing cosmetic industry. In the same year the American edition of *Vogue* revealed some interesting statistics: 'When foreigners flatter us by saying that American women are beautiful by nature, they couldn't be more wrong. American women *make* themselves beautiful, and they spend $261 million every year in the making.'

Beauty preparations have offered a vast range of stimulating challenges to photographers' imaginations. Irving Penn's recent pictures of skin mask preparations will intrigue those who follow Penn's work, since his approach to the subject embraces many of the categories which his work has explored – beauty, still-life, the nude – and the end result looks perhaps most like one of his famous anthropological portraits of New Guinea Mud Men. Helmut Newton recognised the science-fiction implications of the woman wired into a slimming machine and took the picture a stage further from everyday reality by printing in reverse tones. Denis Piel, Hans Feurer and Barry Lategan are all represented here by informal reportage type photographs, and it is instructive to note how Guy Bourdin has moved from being primarily graphic to wittily sexual in his interests.

Left
Horst P. Horst
1946

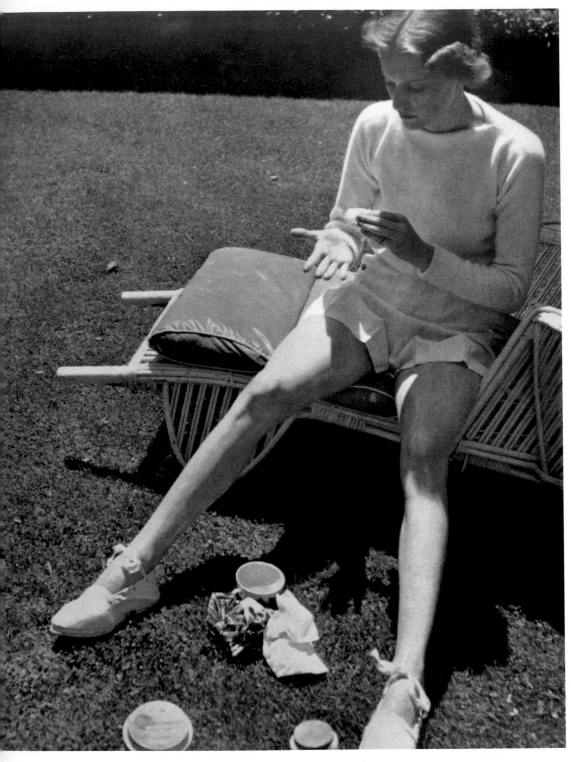

Above
Herbert Matter
1937

Right
Edward Steichen
1937

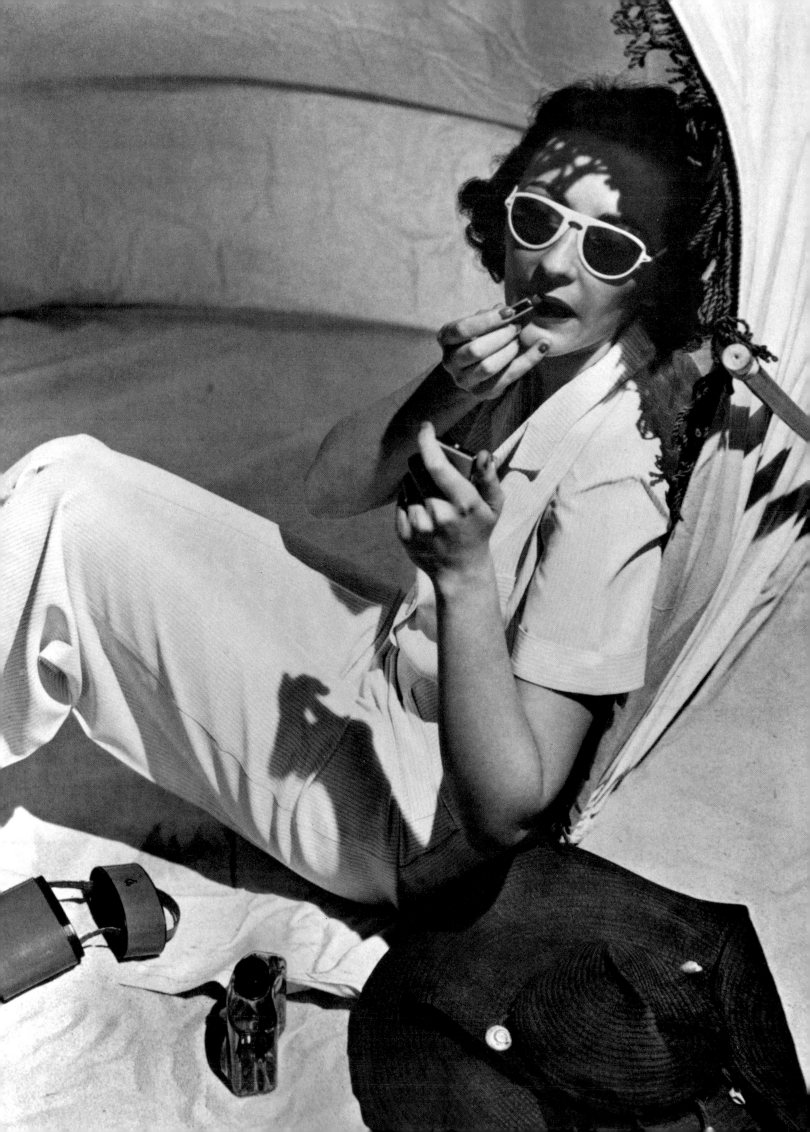

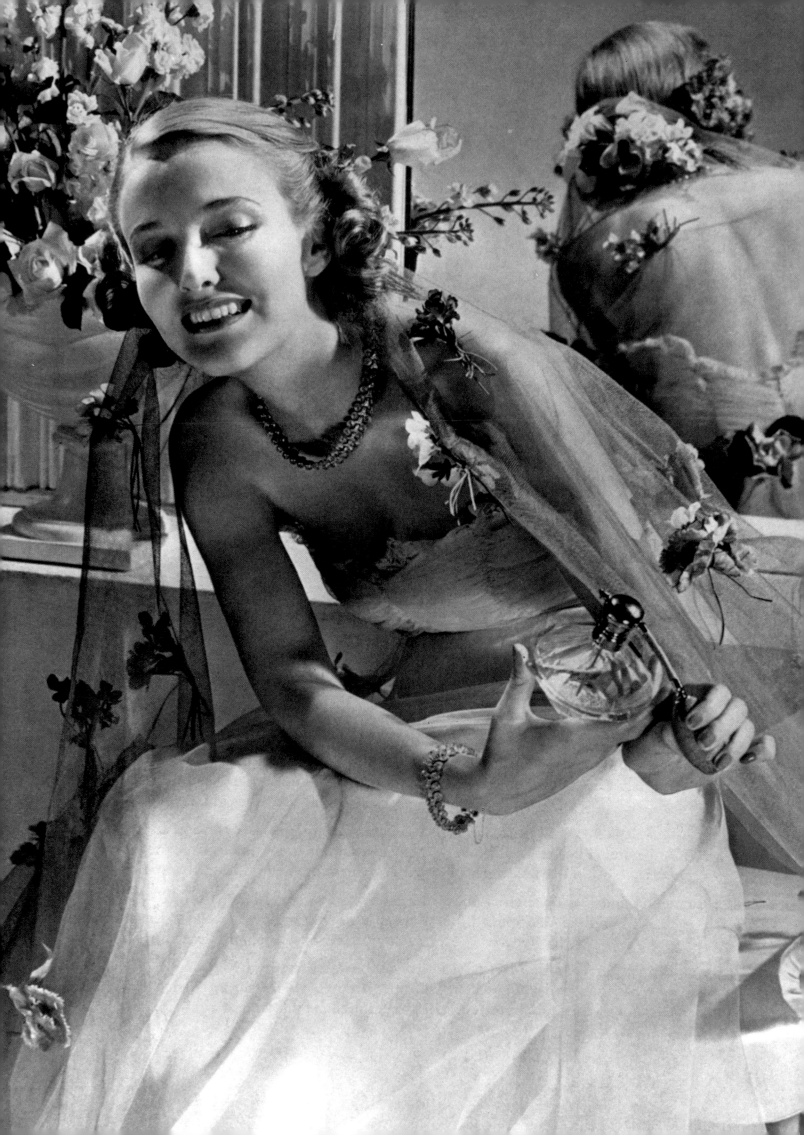

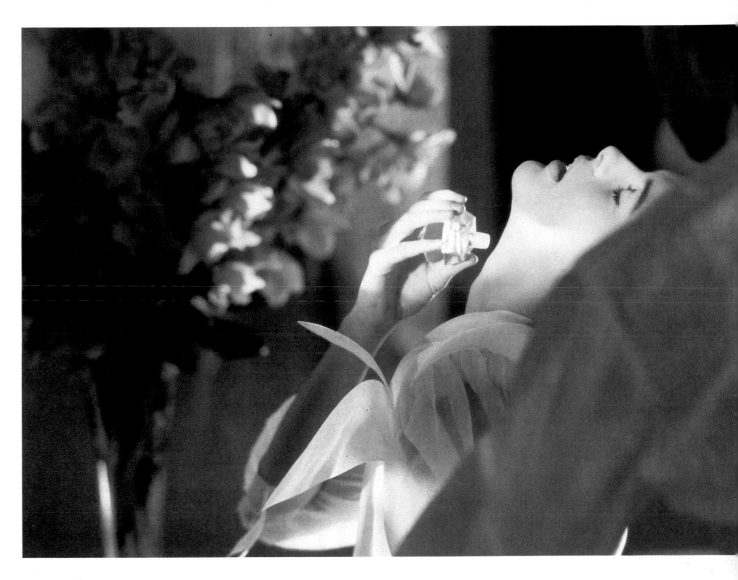

Above
Arthur Elgort
1983

Left
Edward Steichen
1938

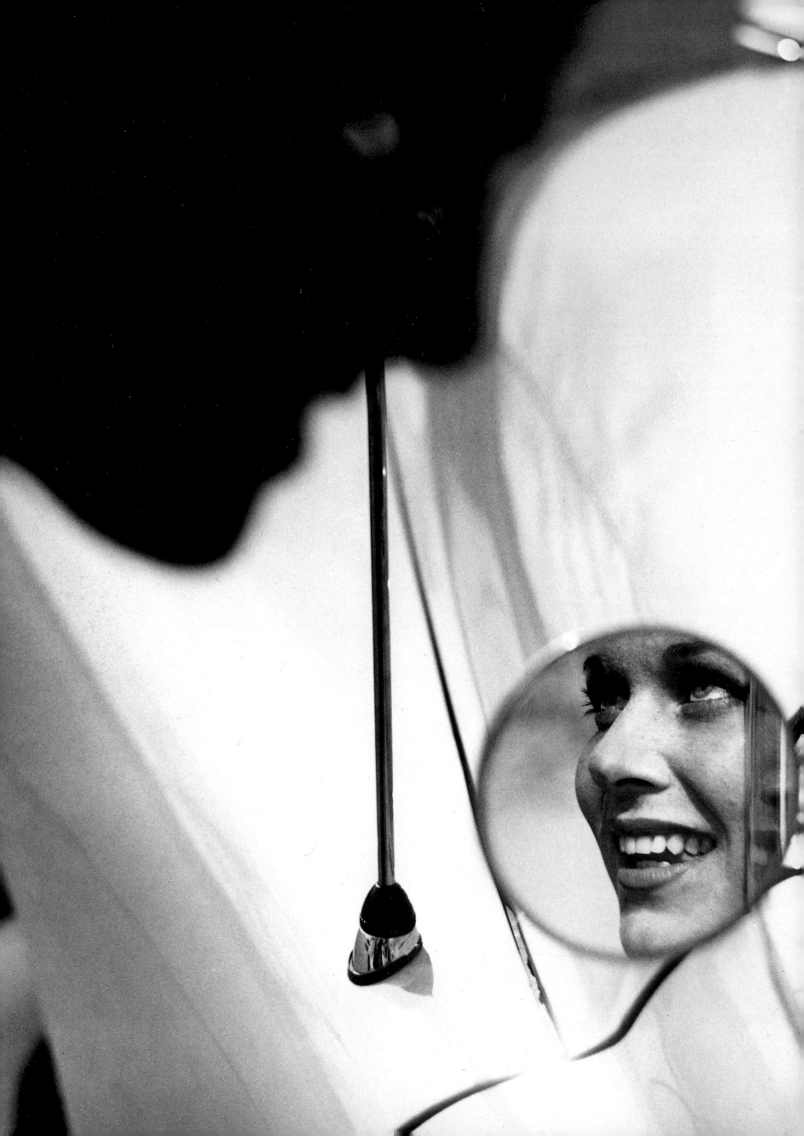

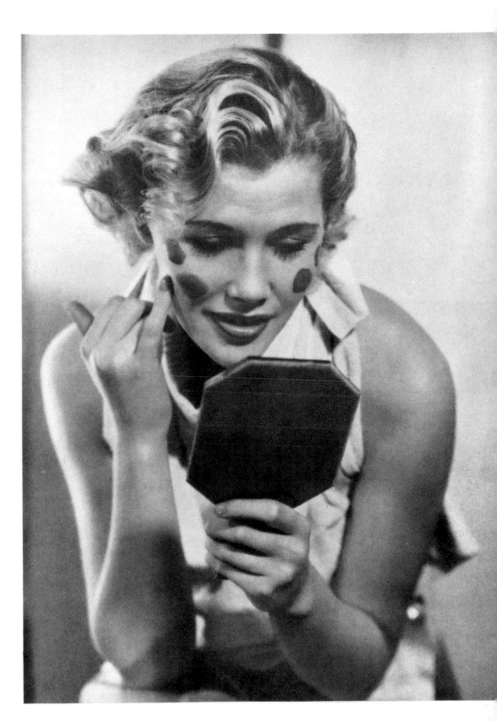

Above
Arik Nepo
1936

Left
Frances McLaughlin-Gill
1950

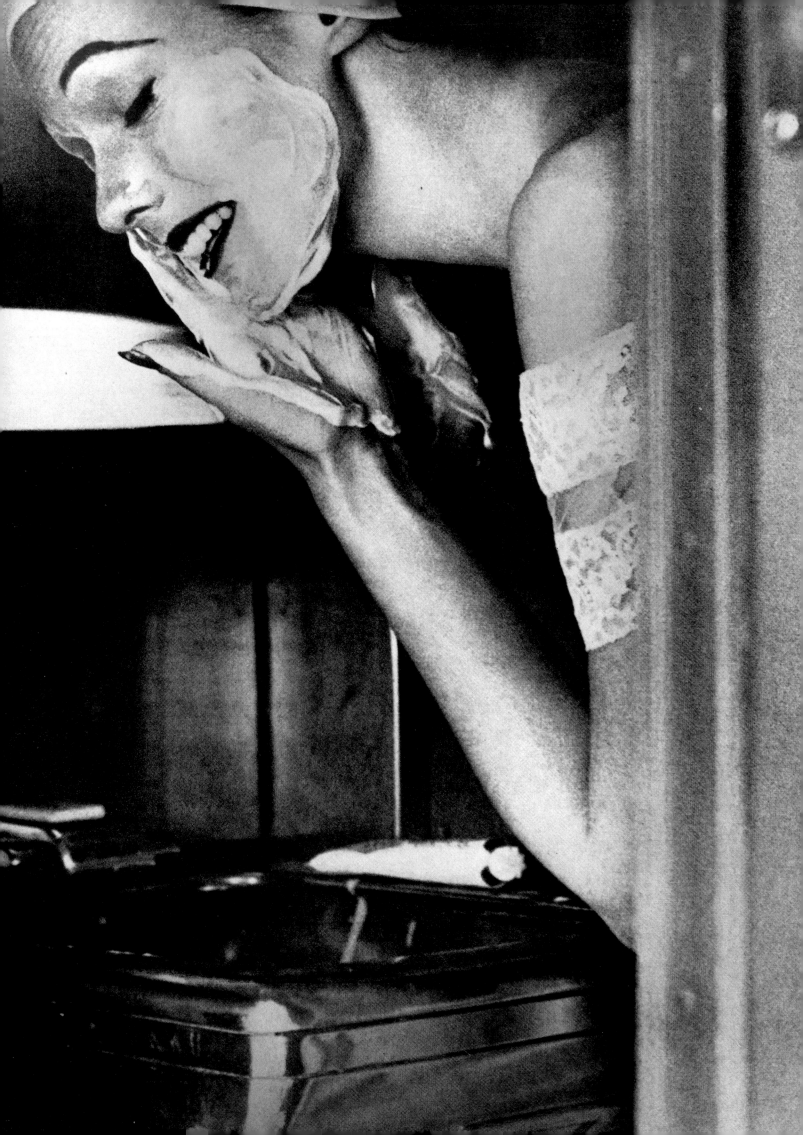

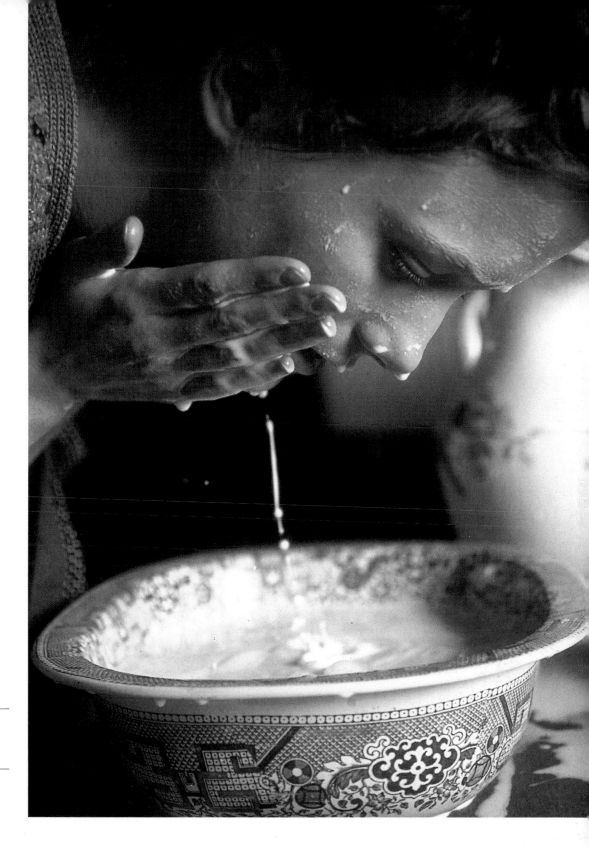

Left
Paul Himmel
1953

Right
Tony Kent
1973

Overleaf
Helmut Newton
1968

61

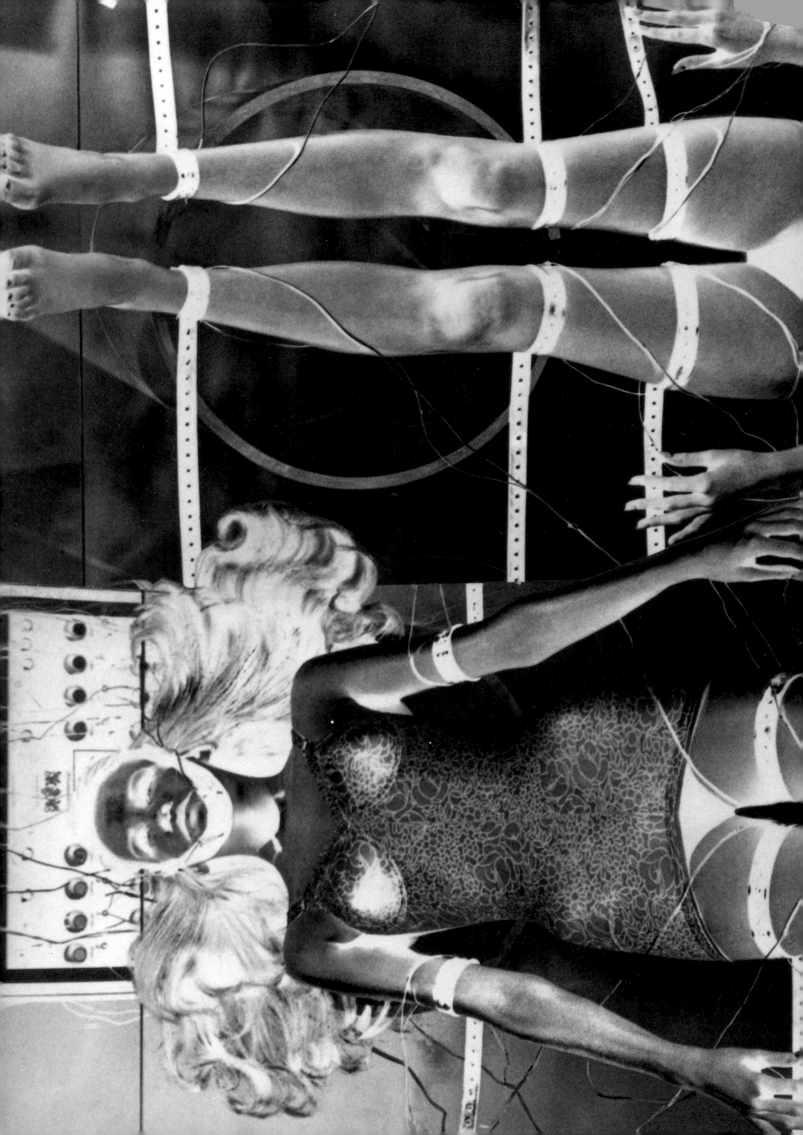

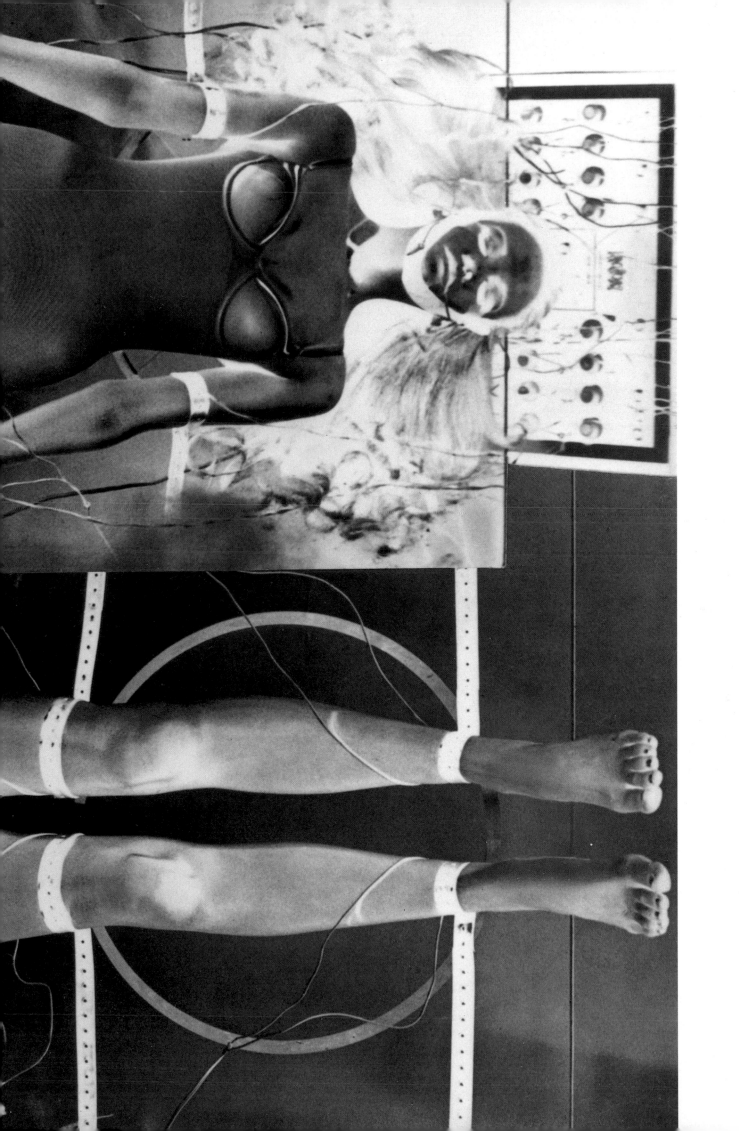

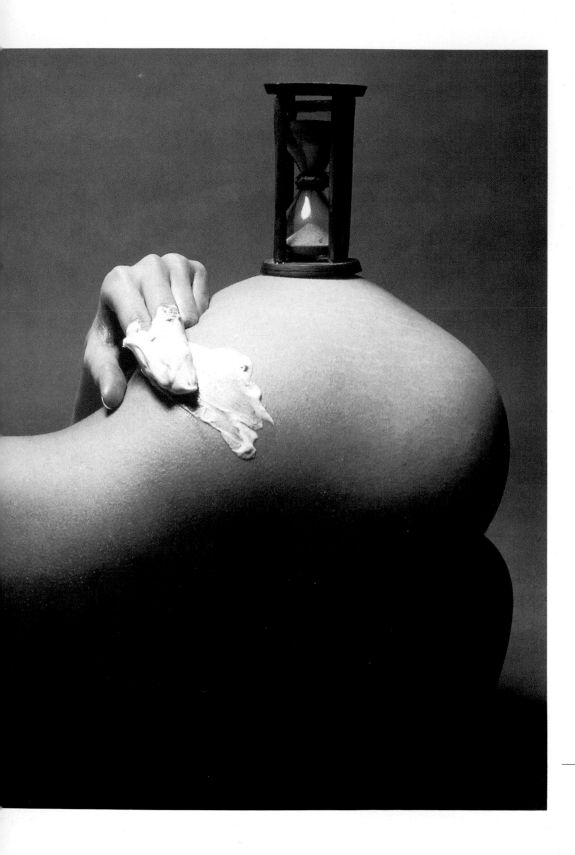

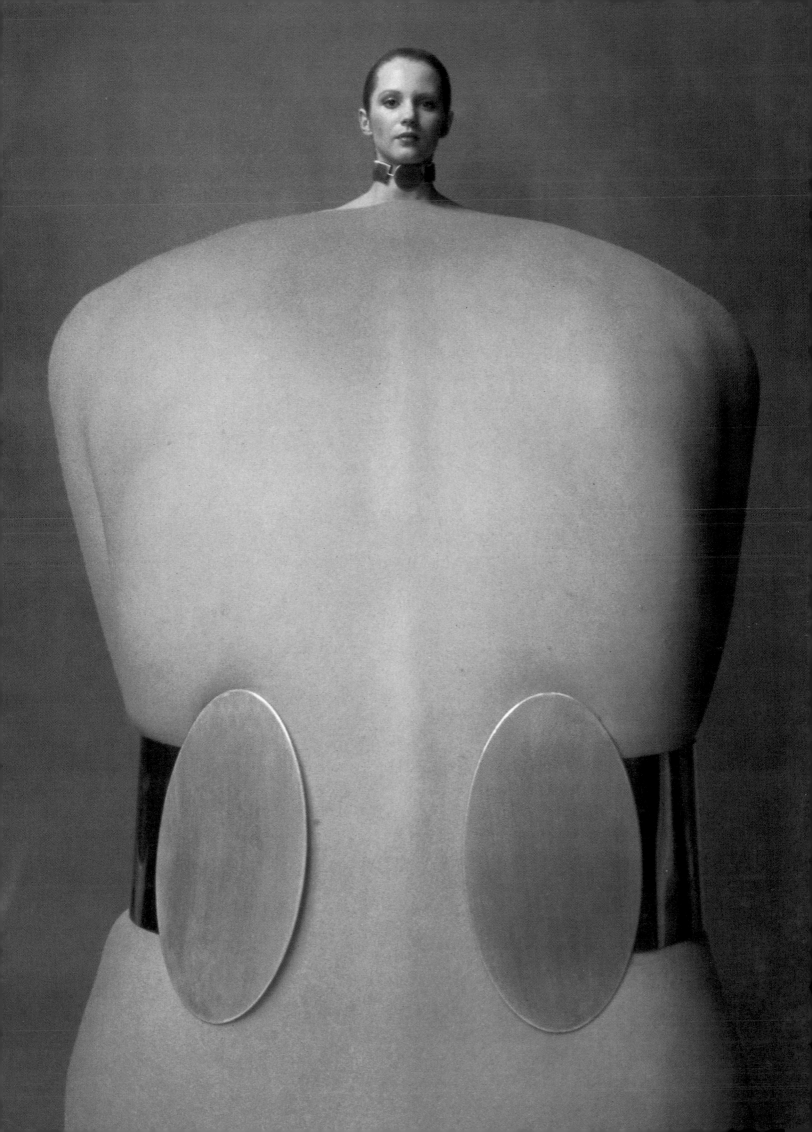

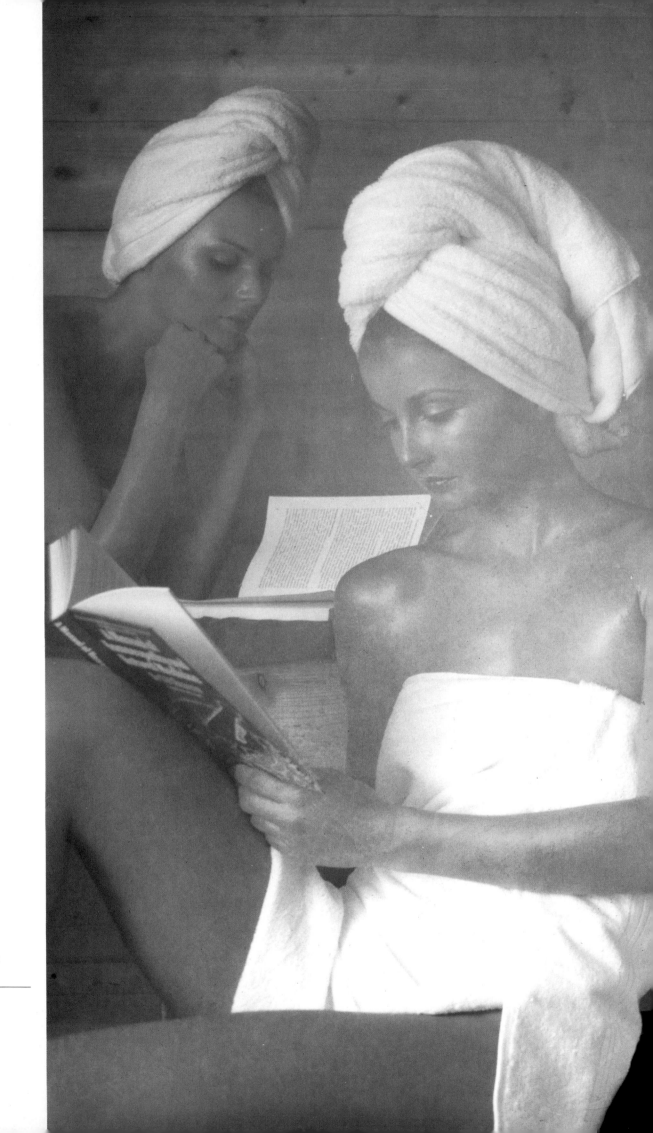

Right
Barry Lategan
1976

Overleaf
Hans Feurer
1981

66

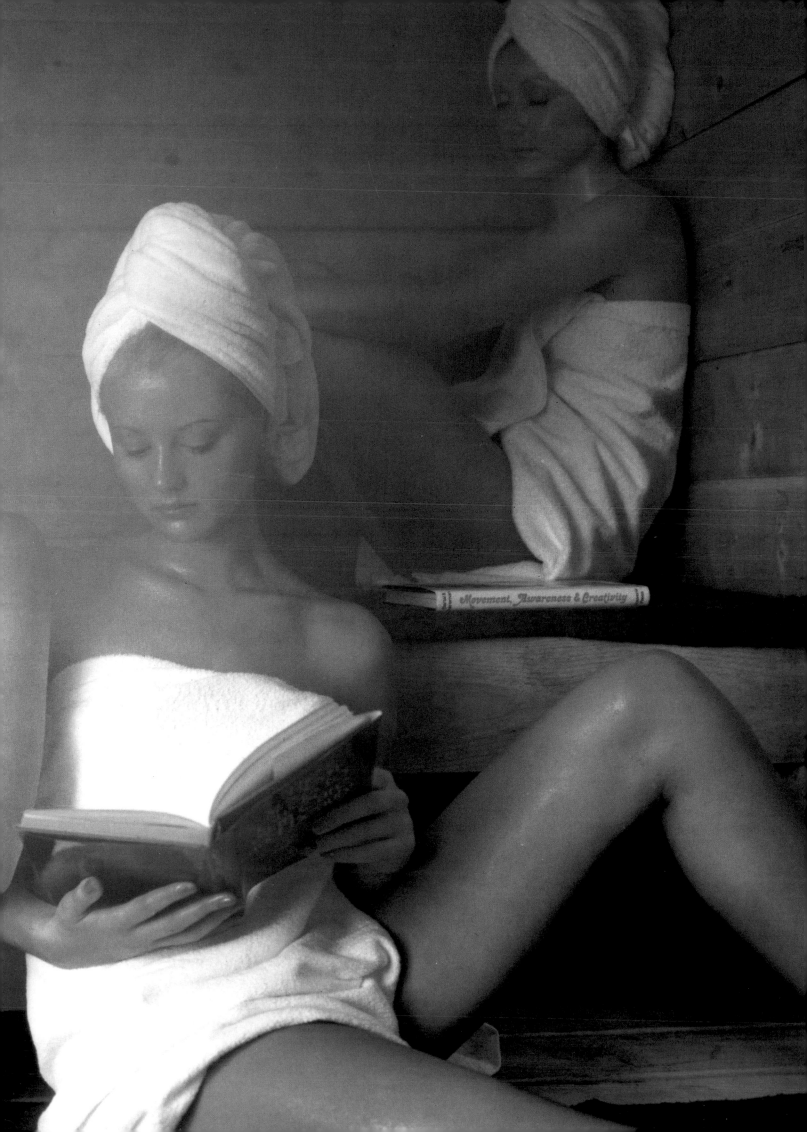

Movement, Awareness & Creativity

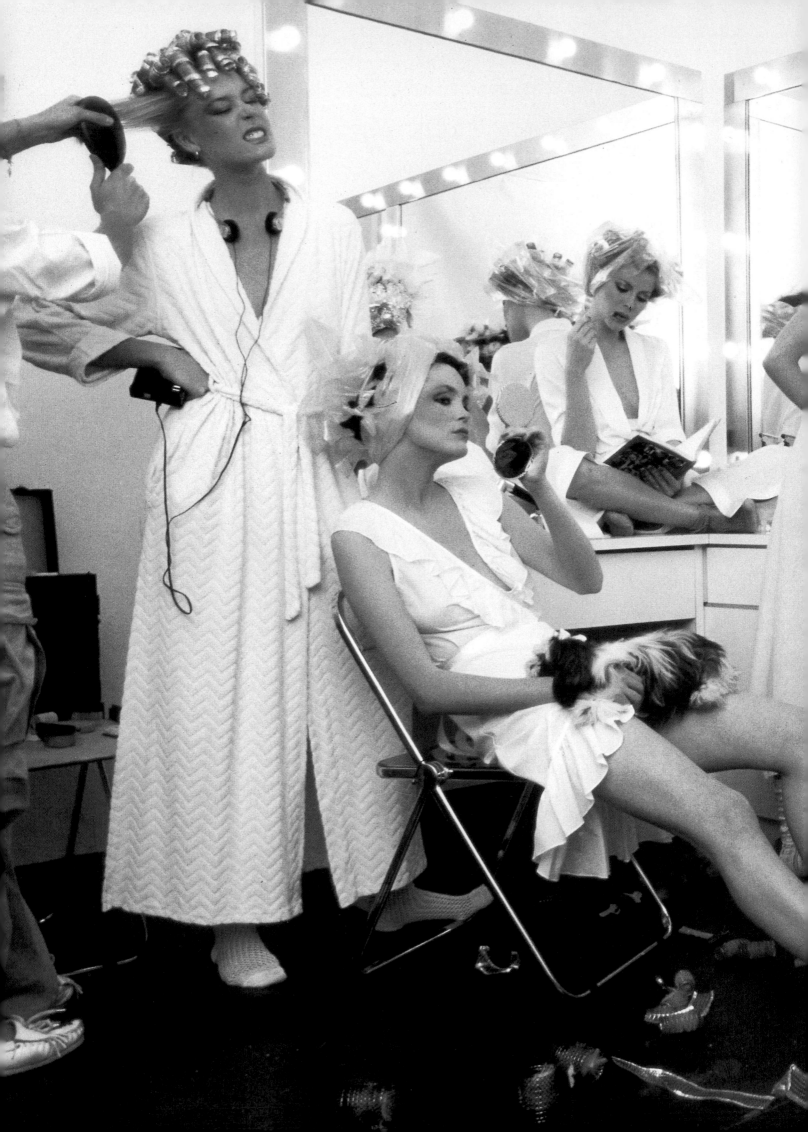

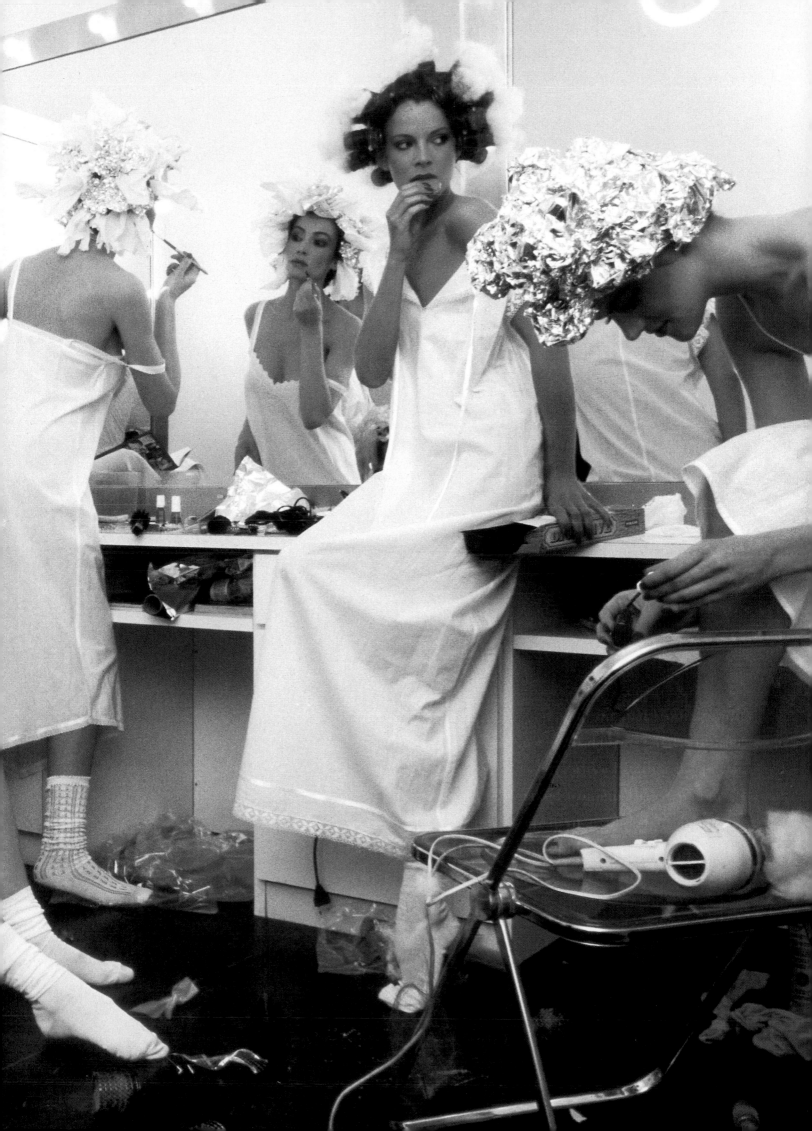

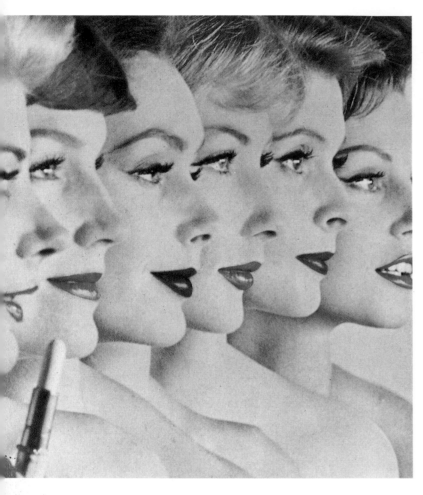

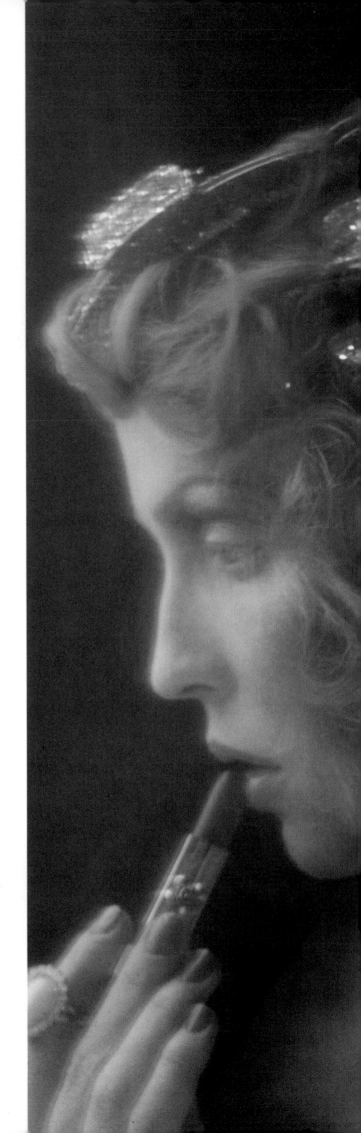

Above
John Rawlings
1959

Right
Barry Lategan
1975

Overleaf
Guy Bourdin
1973

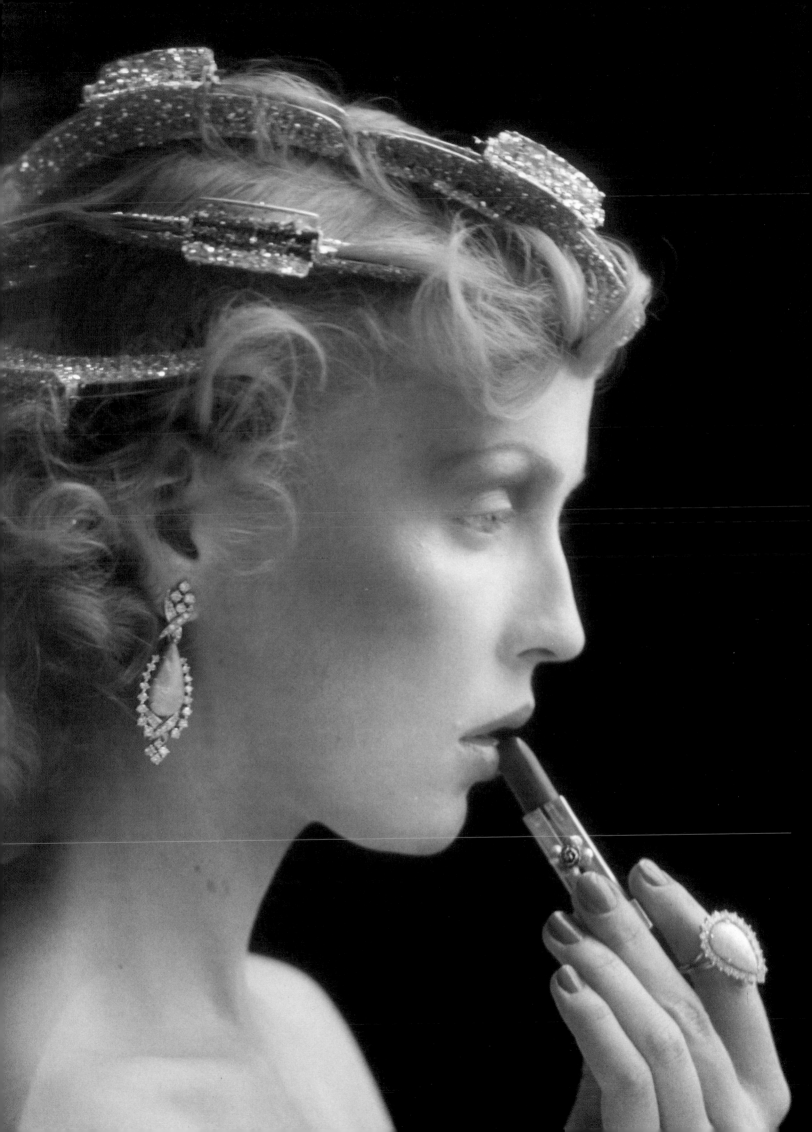

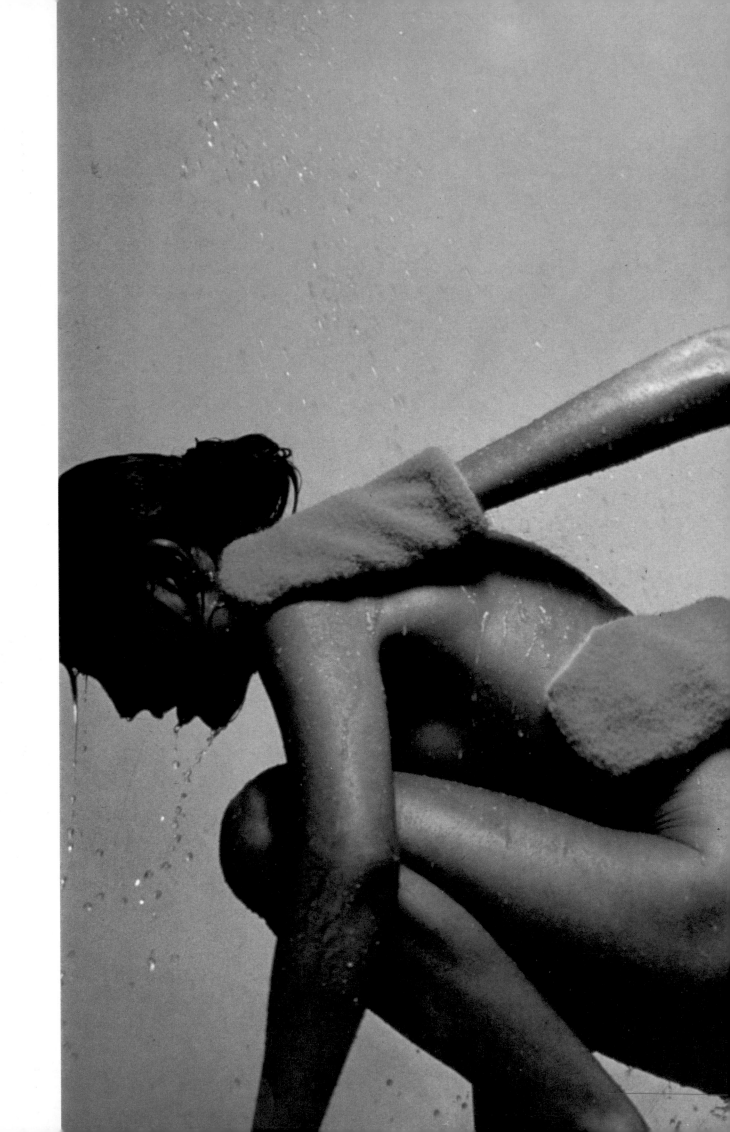

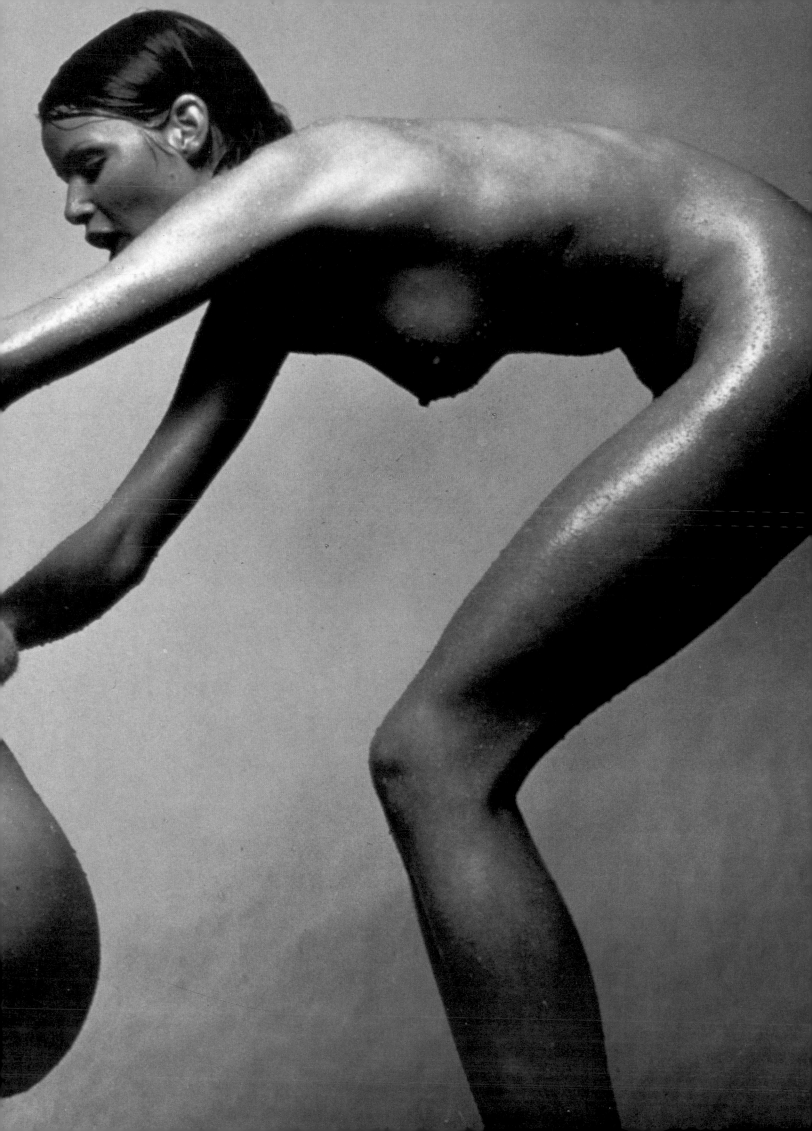

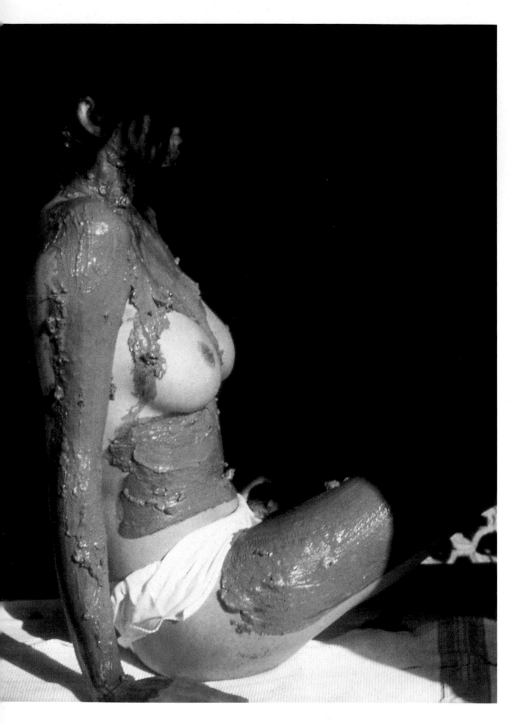

Above
Barry McKinley
1982

Right
Irving Penn
1985

Overleaf
Guy Bourdin
1978

74

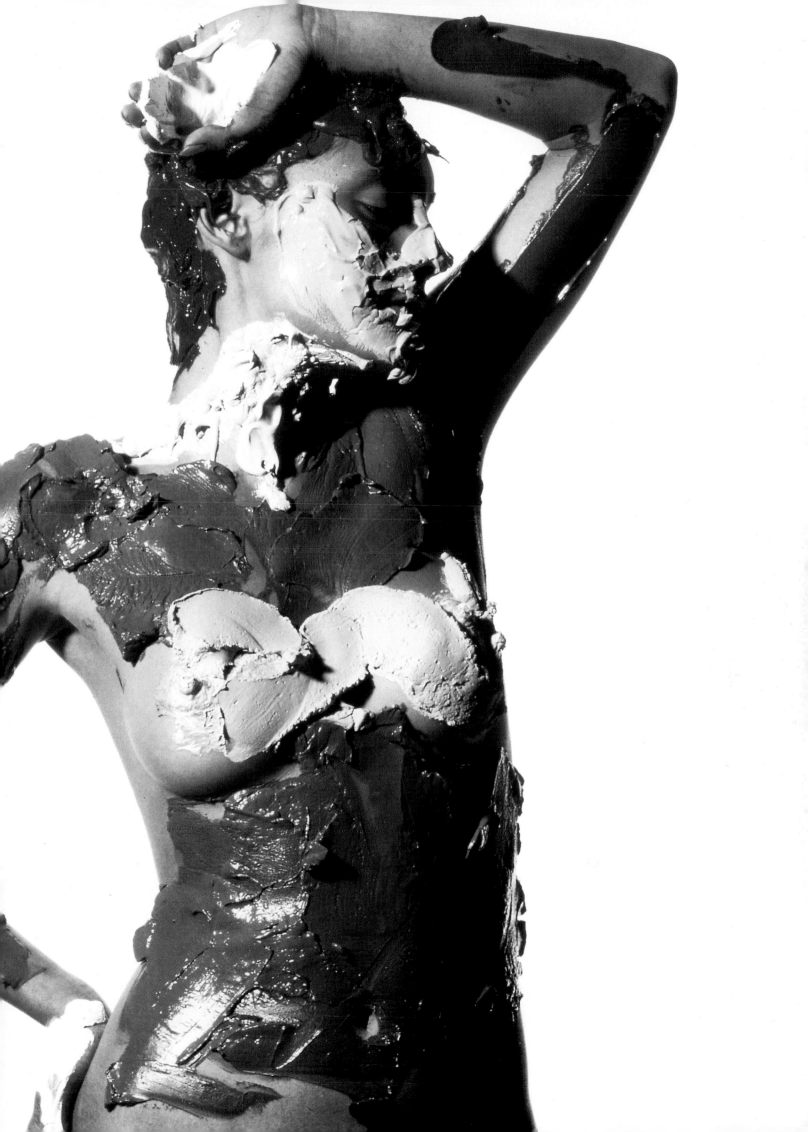

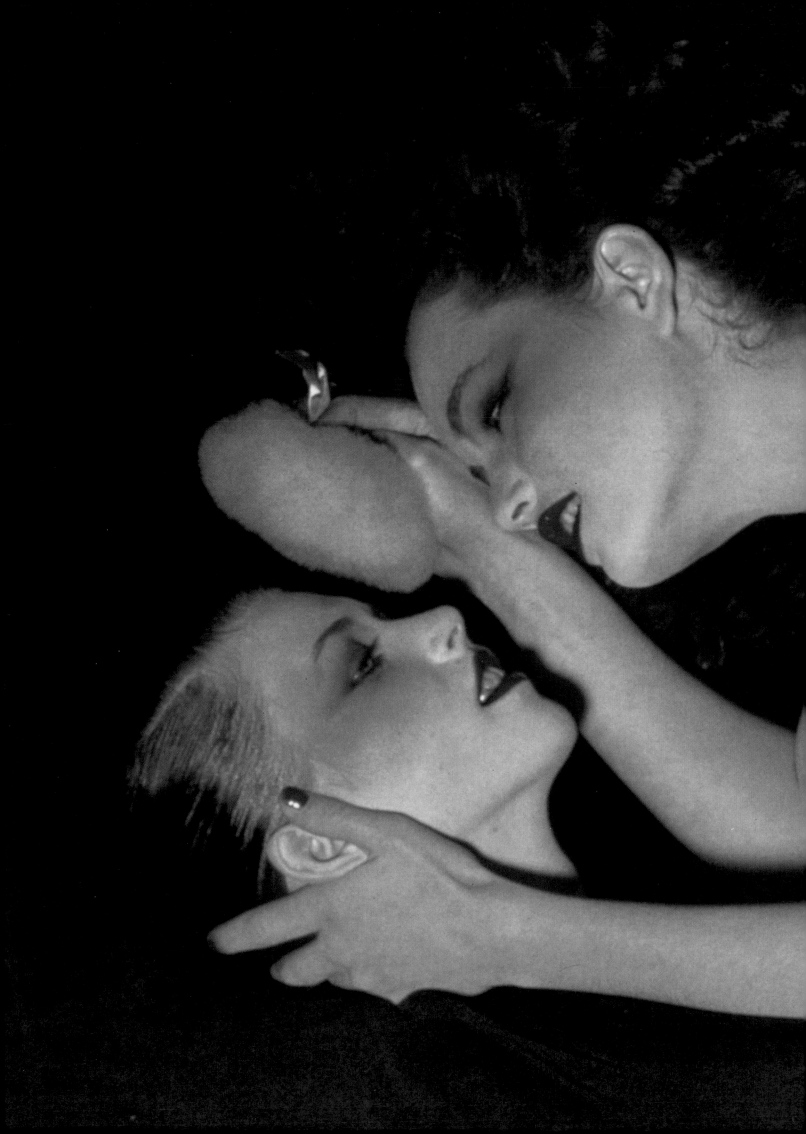

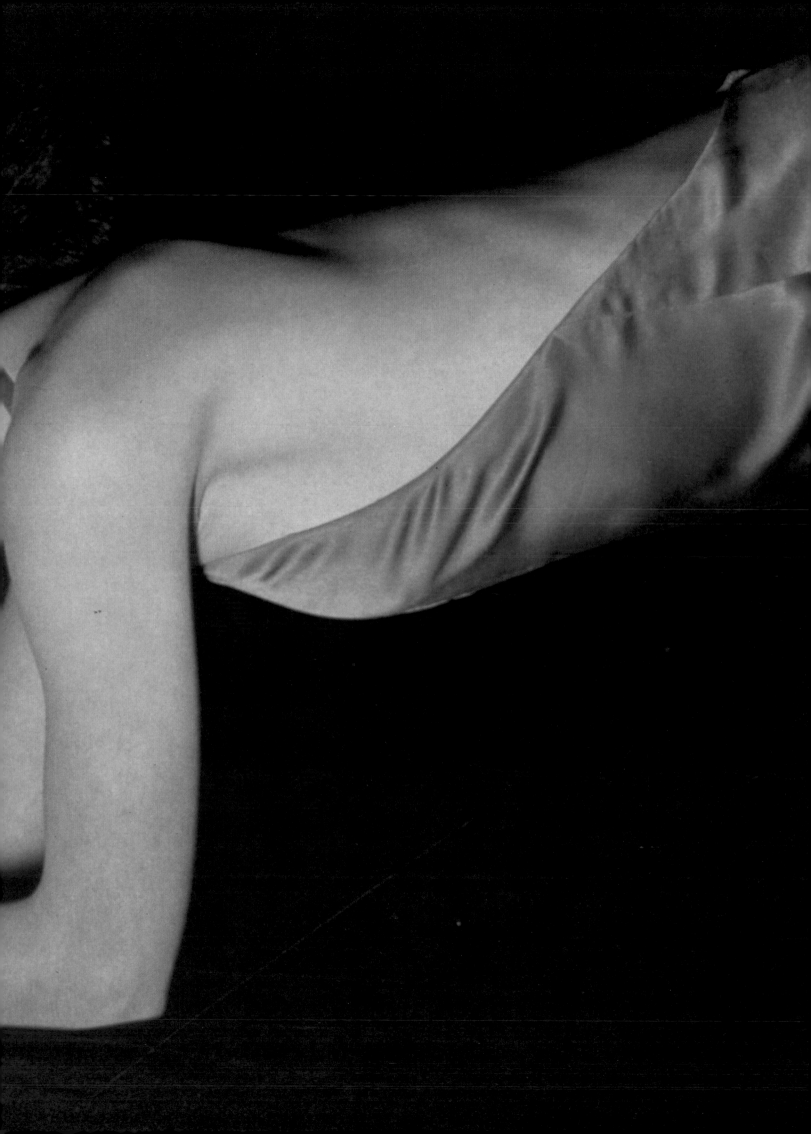

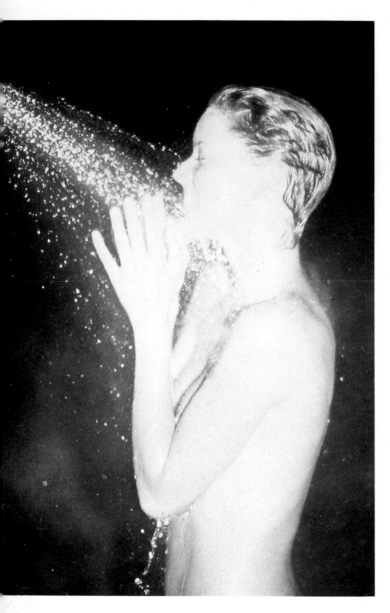

Above
Arthur Elgort
1980

Right
Guy Bourdin
1969

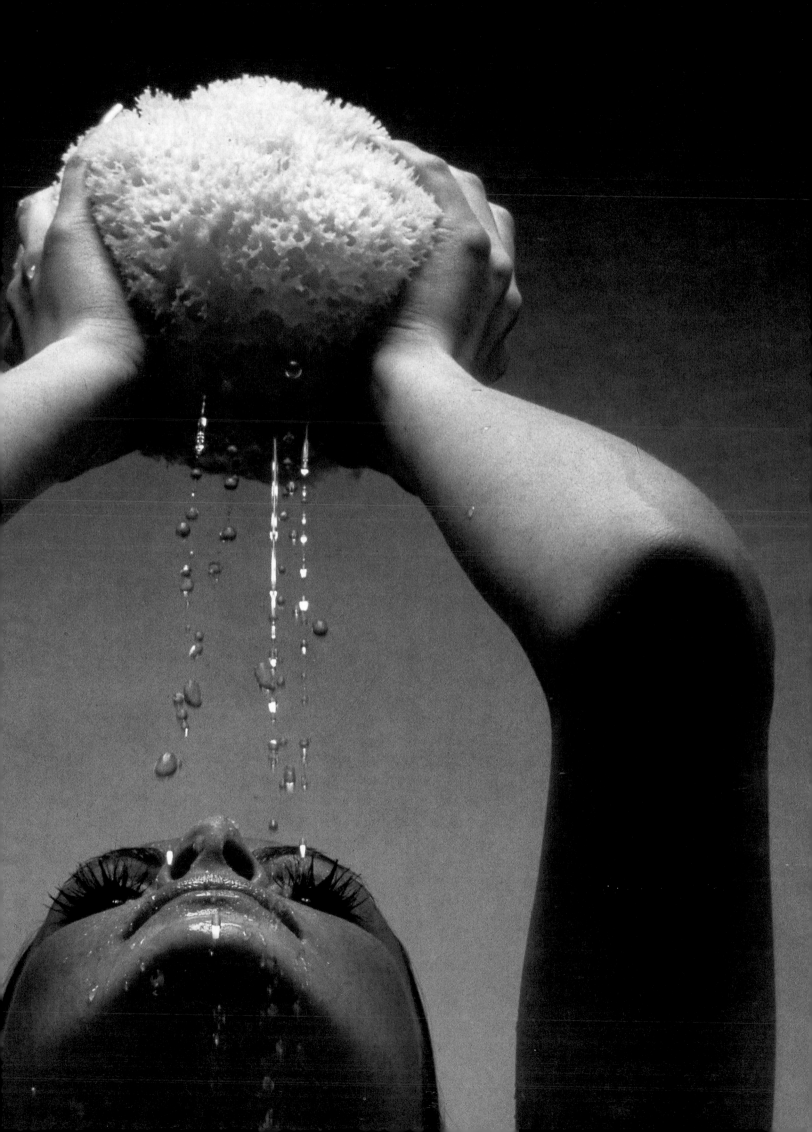

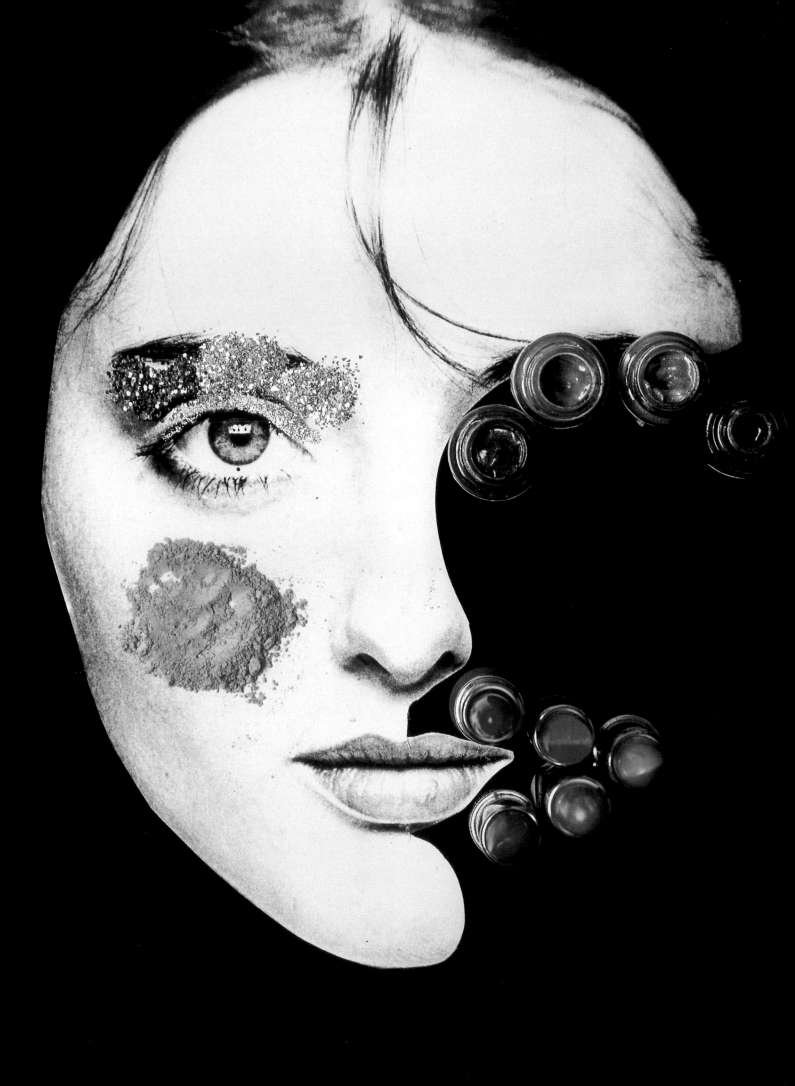

Left
Just Jaeckin
1969

Right
Irving Penn
1965

Overleaf
Denis Piel
1980

81

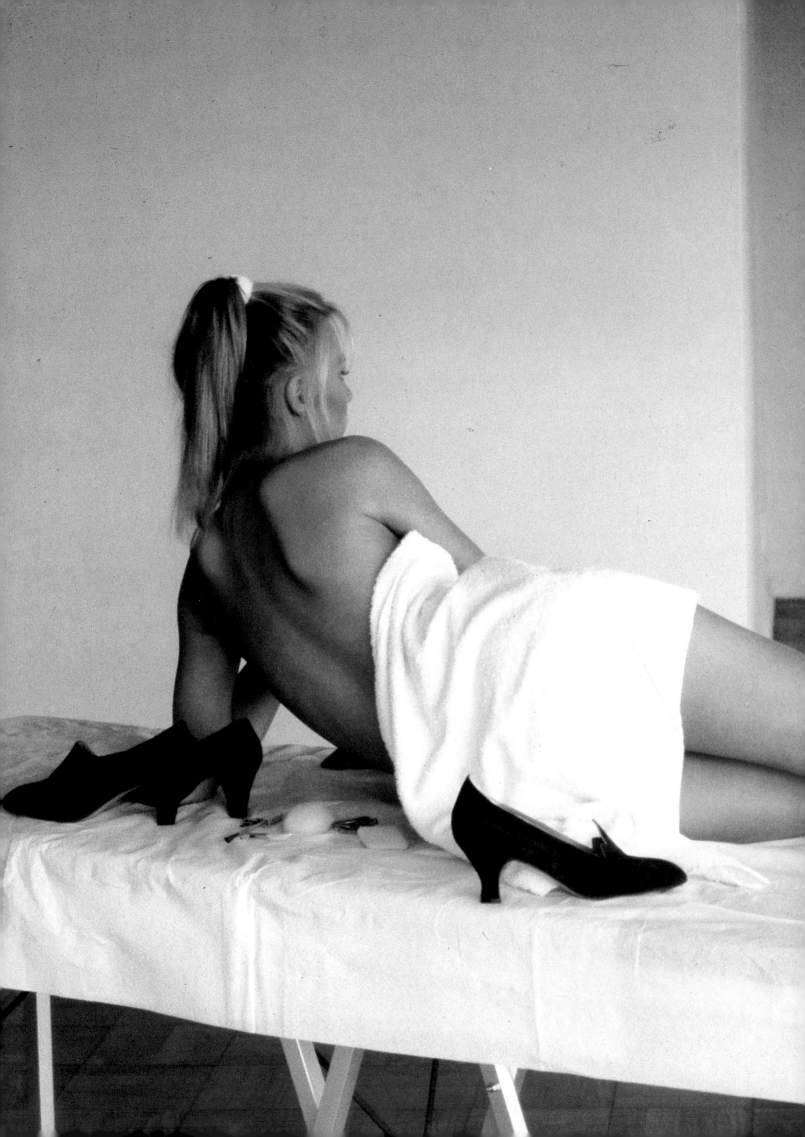

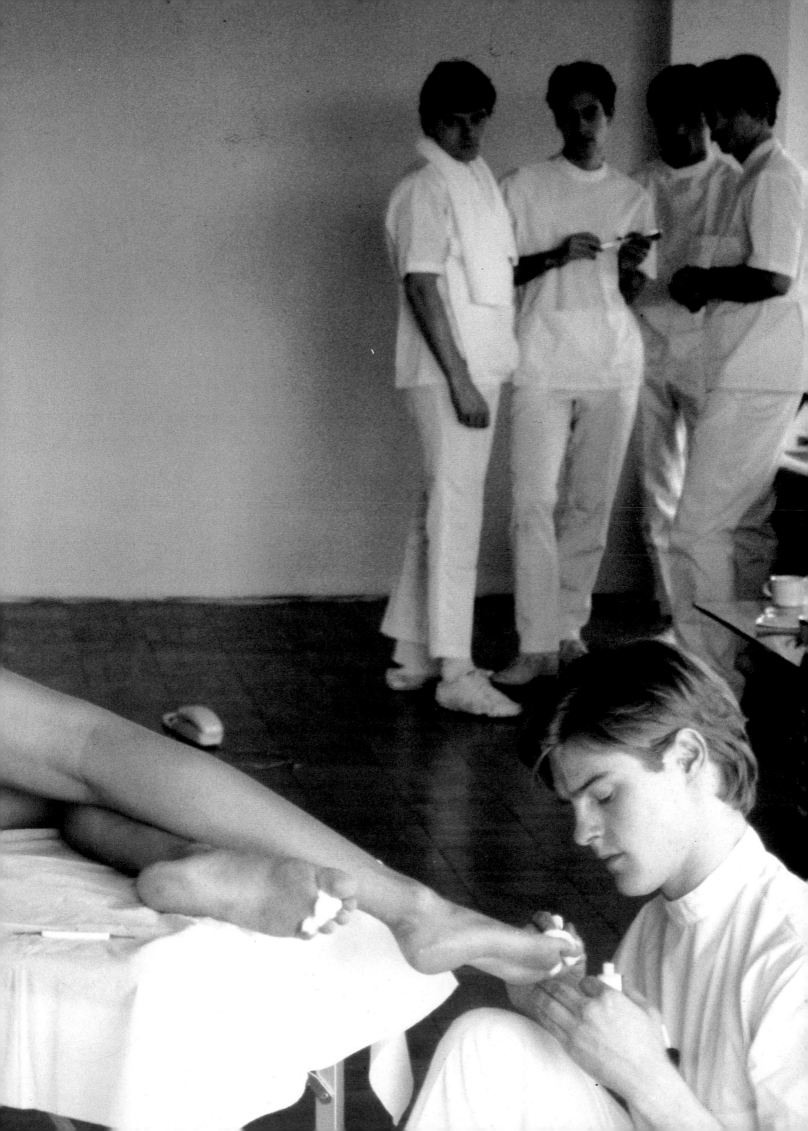

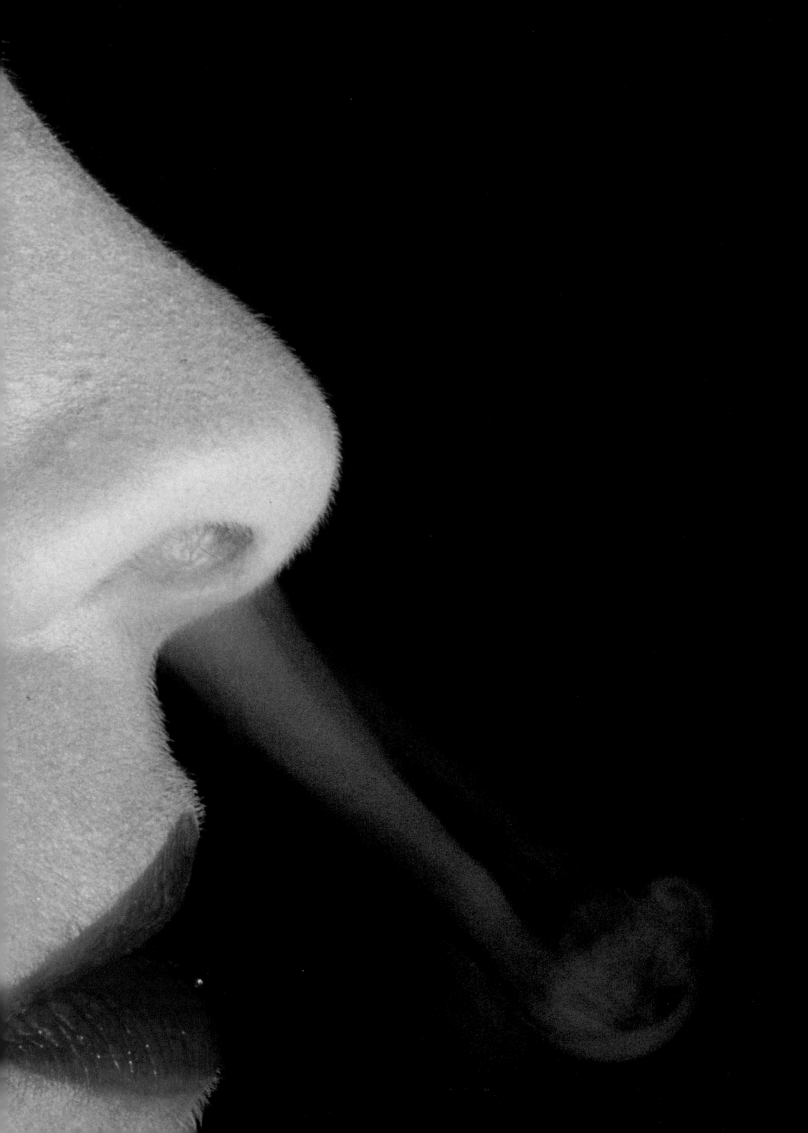

Close-up

'The photographers developed by them have, in the pages of the Condé Nast Publications, solved new aesthetic problems, instigated major changes, and augmented the horizons of photography . . .' Frank Crowninshield, 1941

Over the years some of *Vogue*'s most arresting and eye-catching images have been provided by close-up beauty pictures. Photographers' imaginations have worked overtime to find original ways of tackling this kind of shot, from the poise and elegance of Steichen and Horst with their details of legs and hands, to the graphic power and technical bravura of Lester Bookbinder's still-lifes. Hiro brings a touch of disquieting surrealism to a close-up of a toe and one of *Vogue*'s newest recruits, Neil Kirk, succeeds in finding a new way of depicting feet.

Traditionally, artists have made studies of details such as legs and hands as steps towards a finished painting. The camera lens, with its facility for selective framing, found new ways of seeing, and throughout the twentieth century the close-up shot has been understood as one of the medium's strongest inherent attributes. Writing about *Beauty in Our Time* in 1961, Alexander Liberman placed the use of the close-up picture in an interesting context: 'Do we realise that we have become infinitely more observant? Through photography, films, television, magazines, newspapers, our gifts of observation have been developed beyond those of any inhabitants of this planet until now. We ponder carefully the close-up of eyes, mouths; we observe, like some obsessed scientific observer of beauty symptoms, the slightest twitch that changes the usual pattern and immediately gives us a personal clue on which to base a unique beauty valuation. This intensification of beauty awareness has become a challenge to women today.'

Left
Guy Bourdin
1977

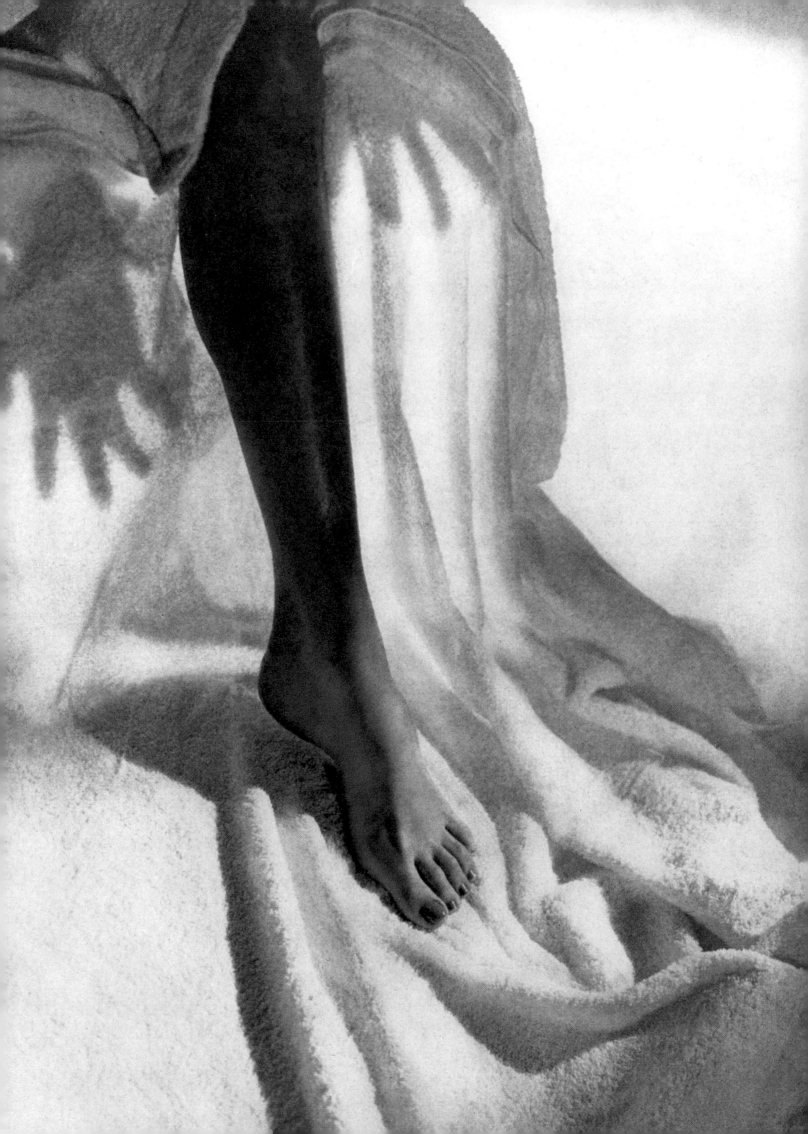

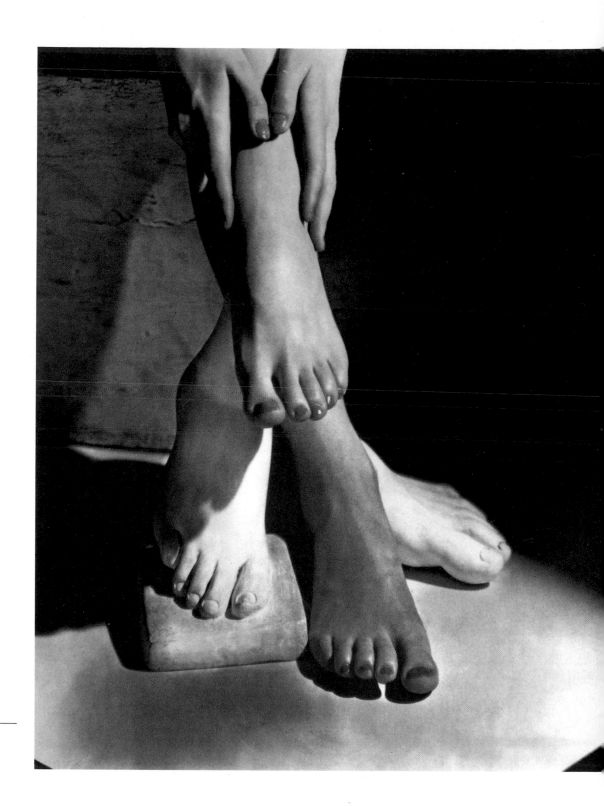

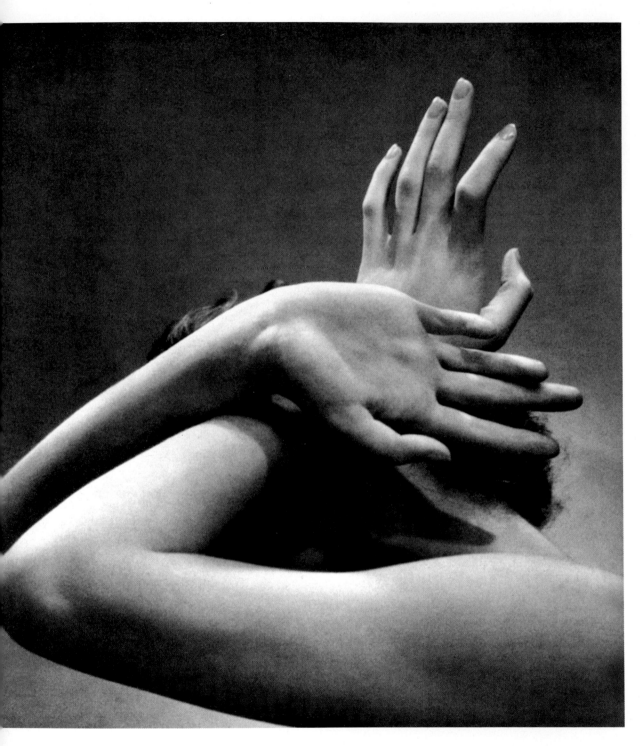

Edward Steichen
1934

Right
Frances McLaughlin-Gill
1950

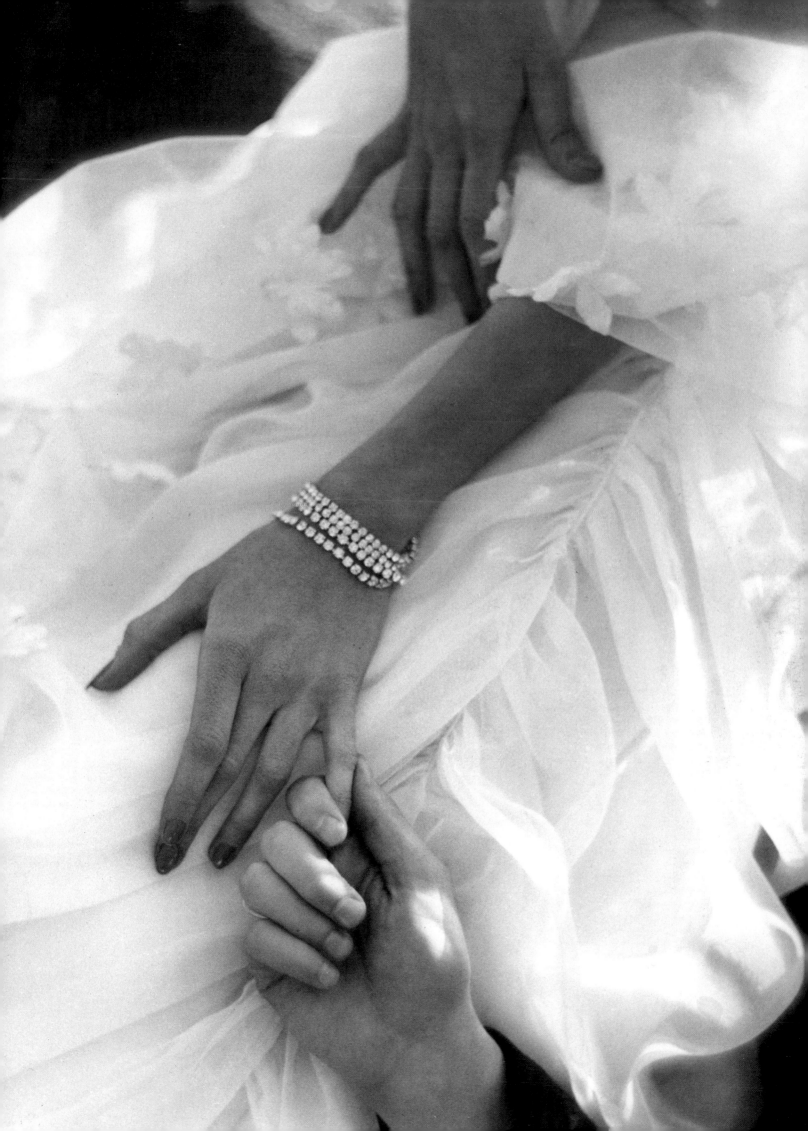

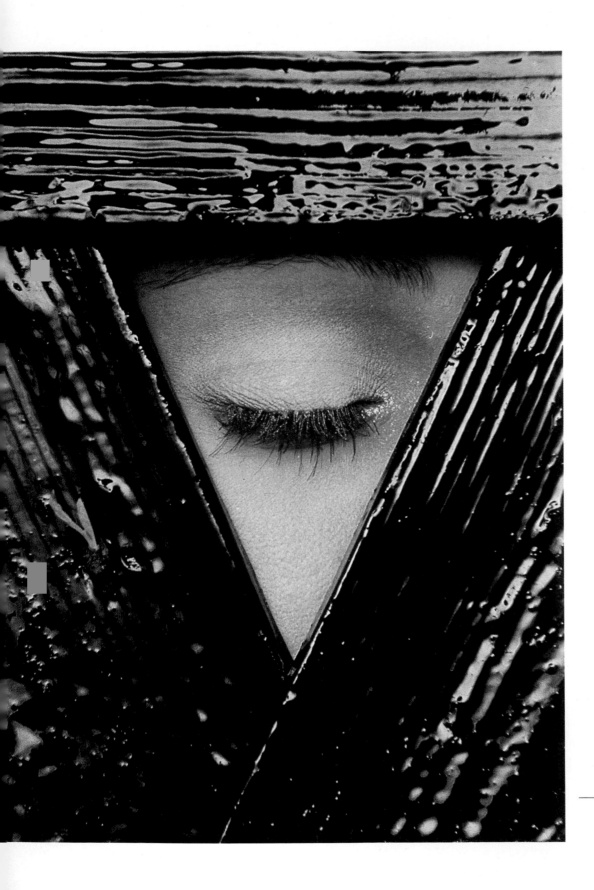

Left
Guy Bourdin
1969

Right
Irving Penn
1982

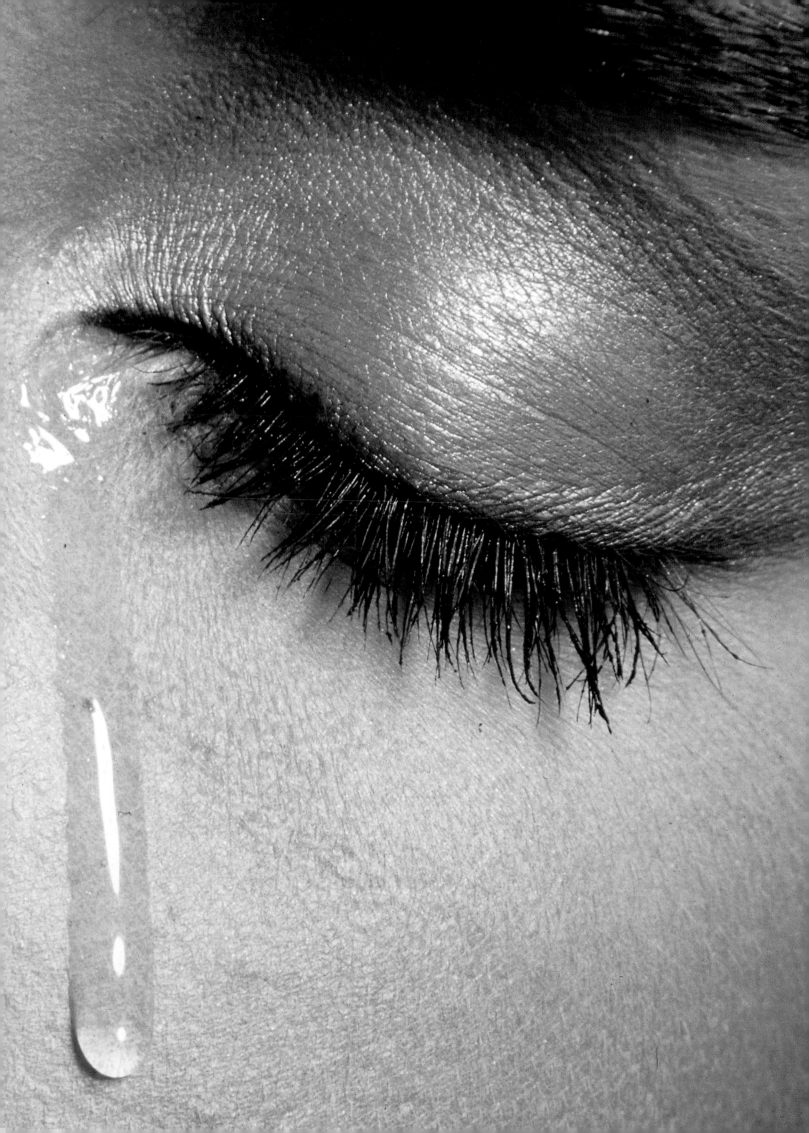

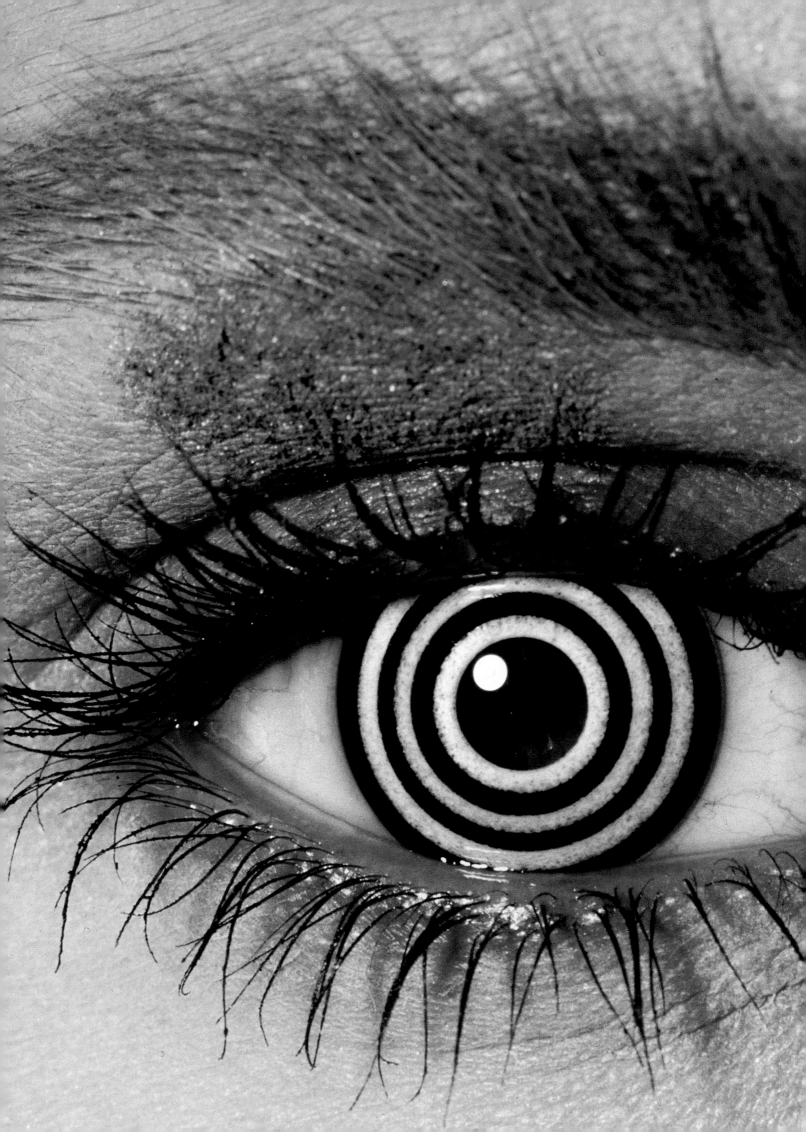

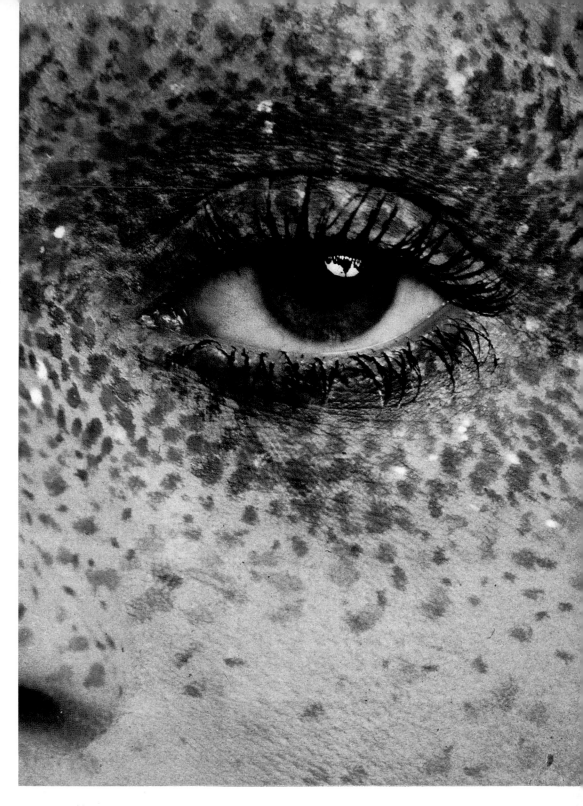

Above
Alex Chatelain
1970

Left
Irving Penn
1983

Overleaf
David Bailey
1985

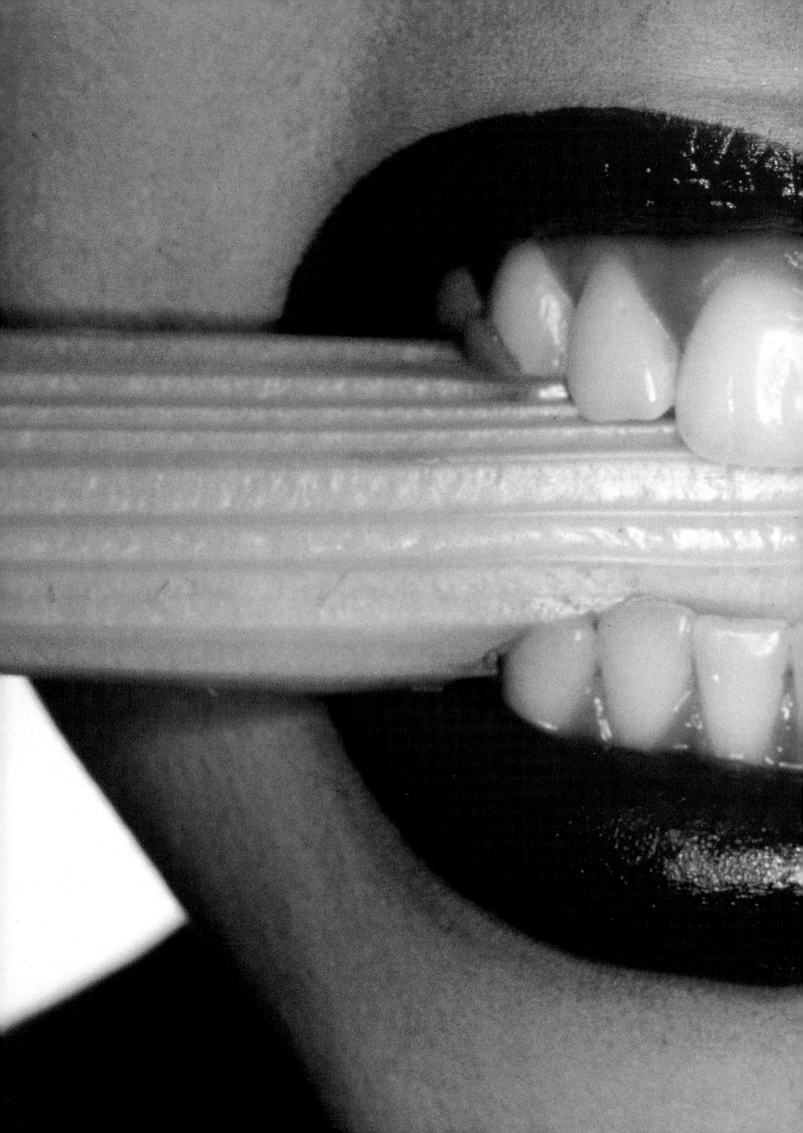

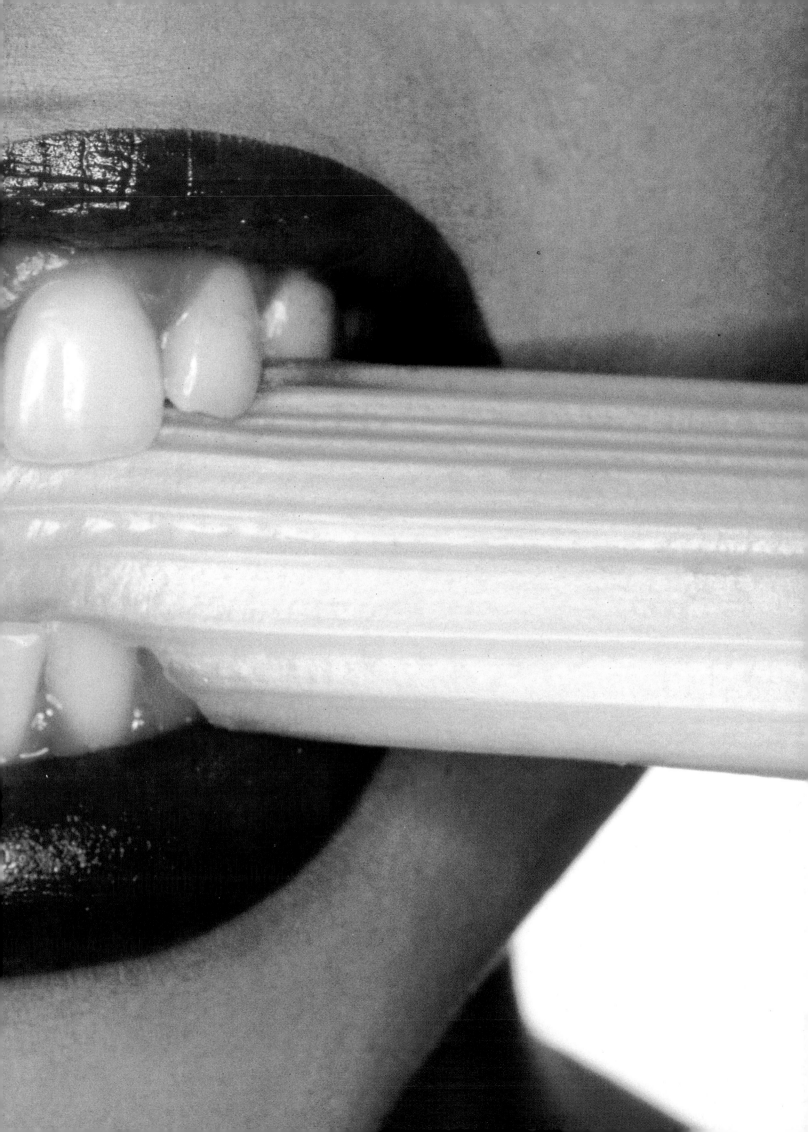

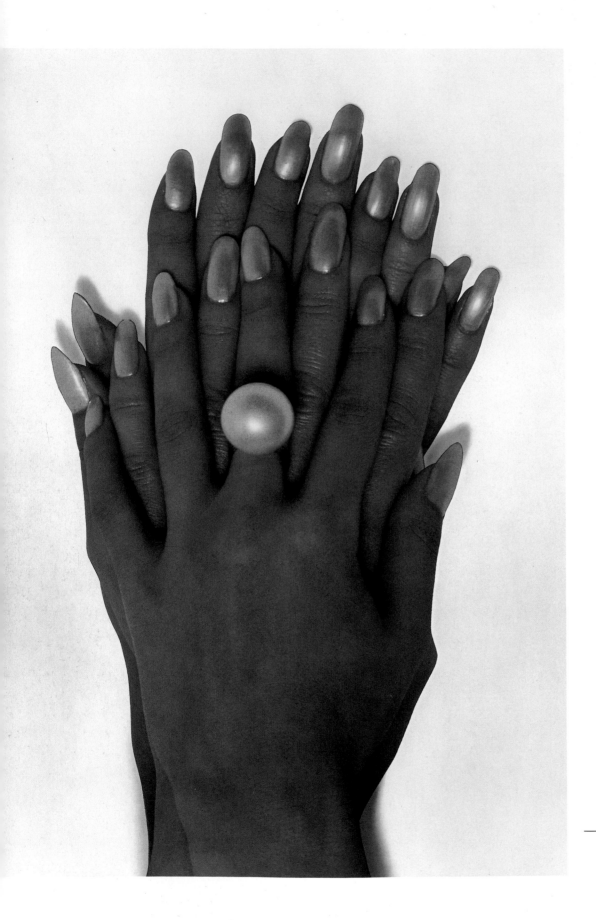

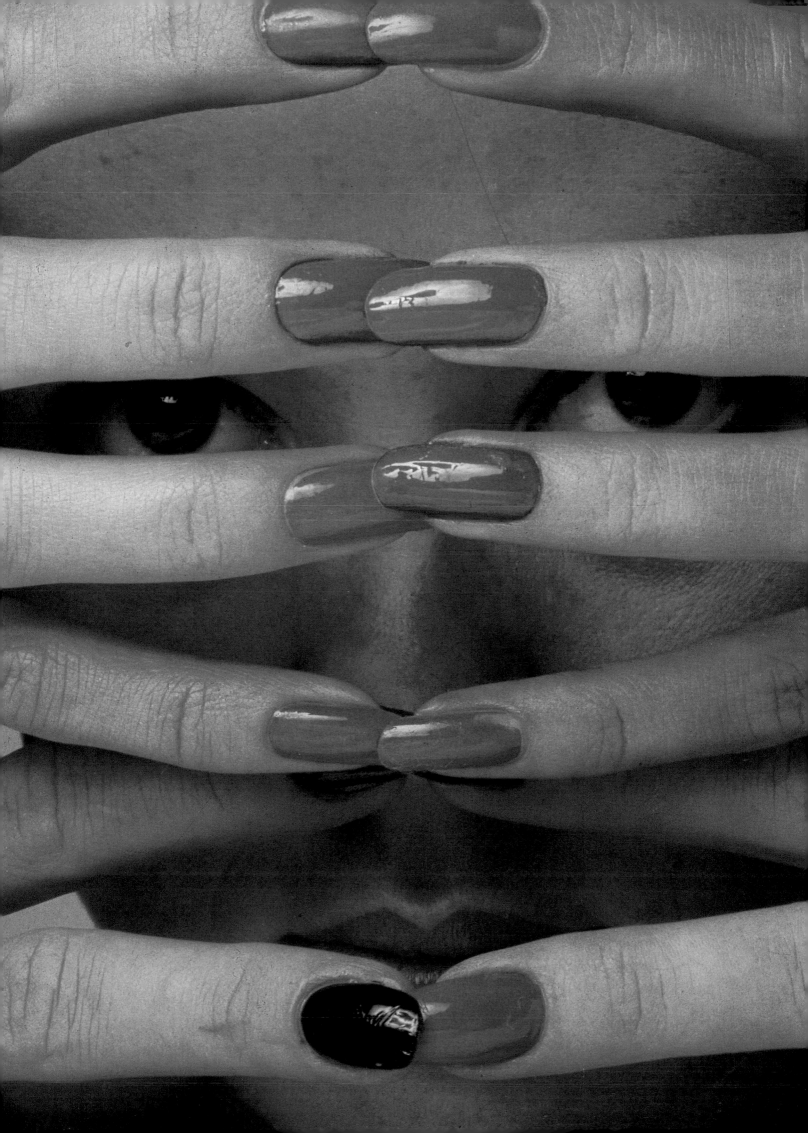

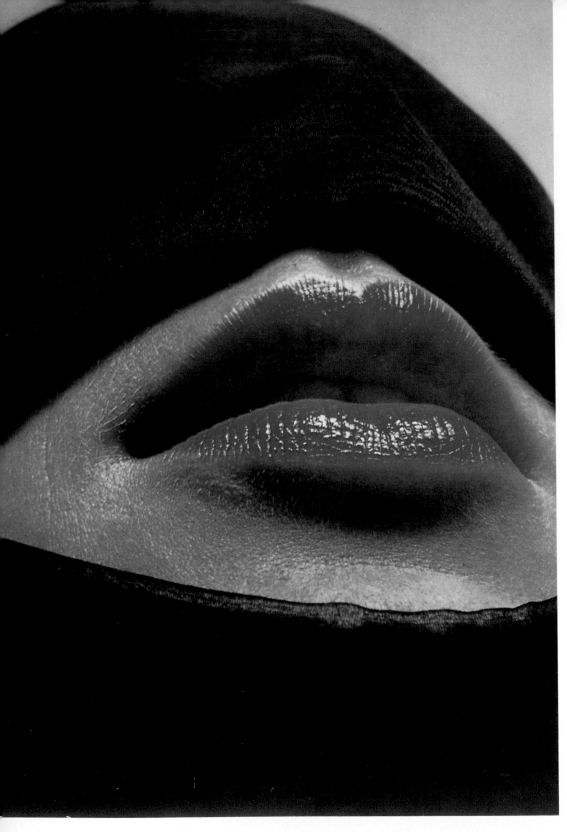

Above
Guy Bourdin
1968

Right
Irving Penn
1966

98

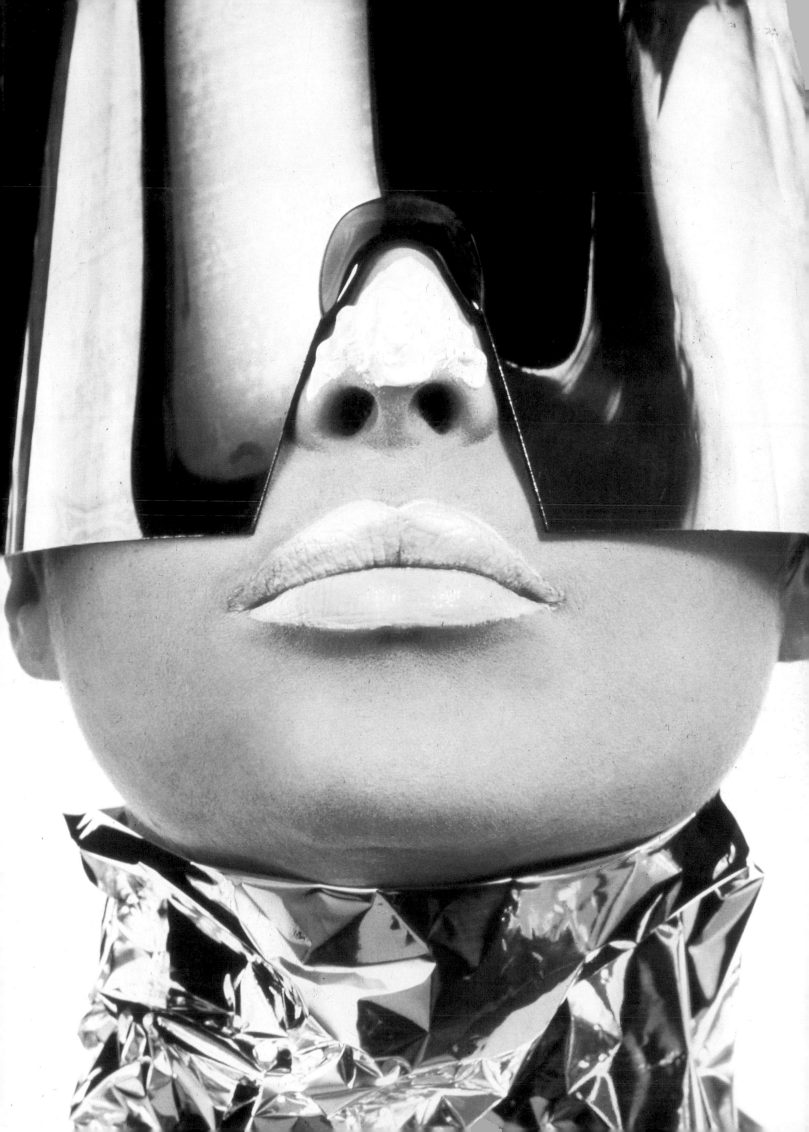

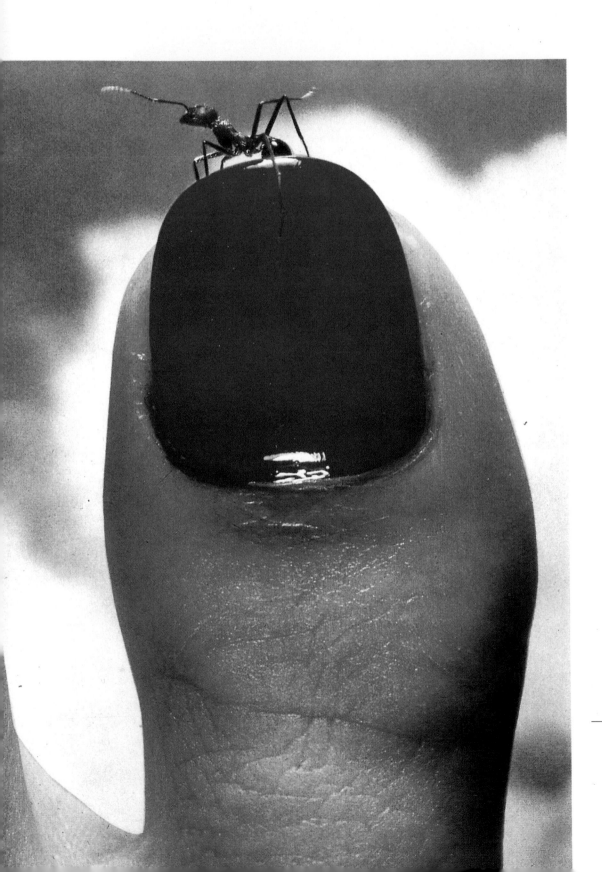

Left
Hiro
1982

Right
David Bailey
1975

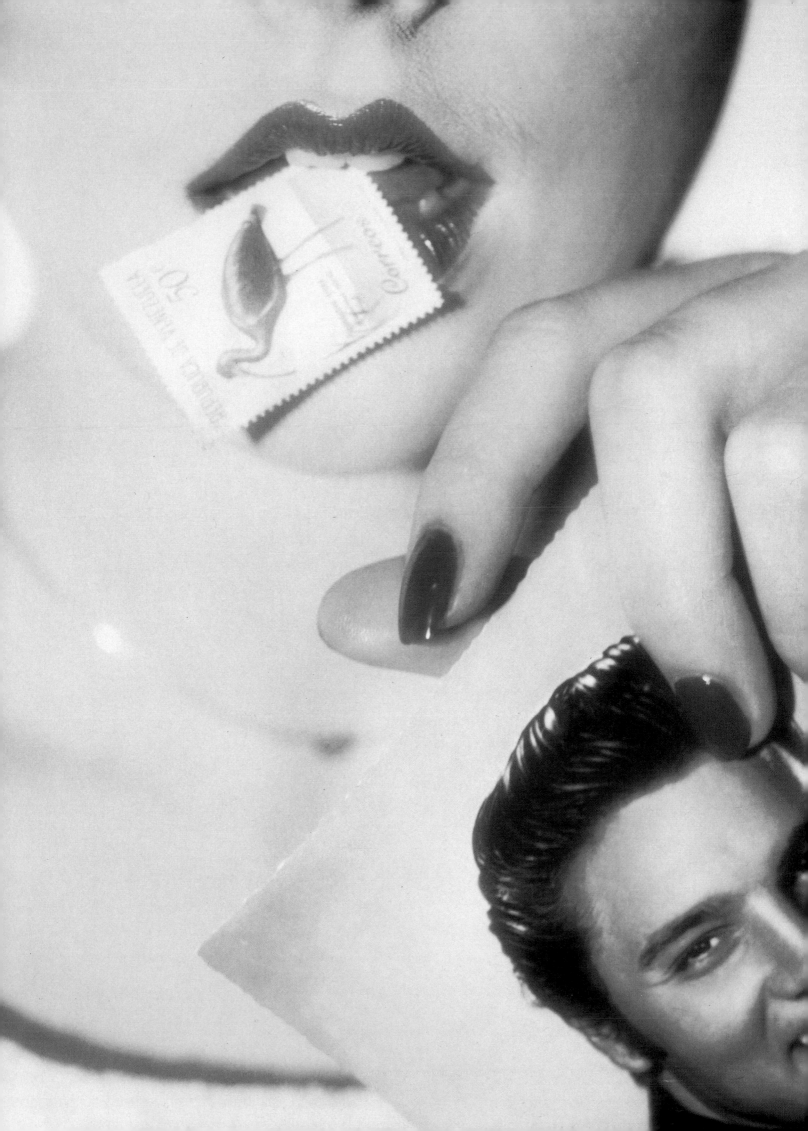

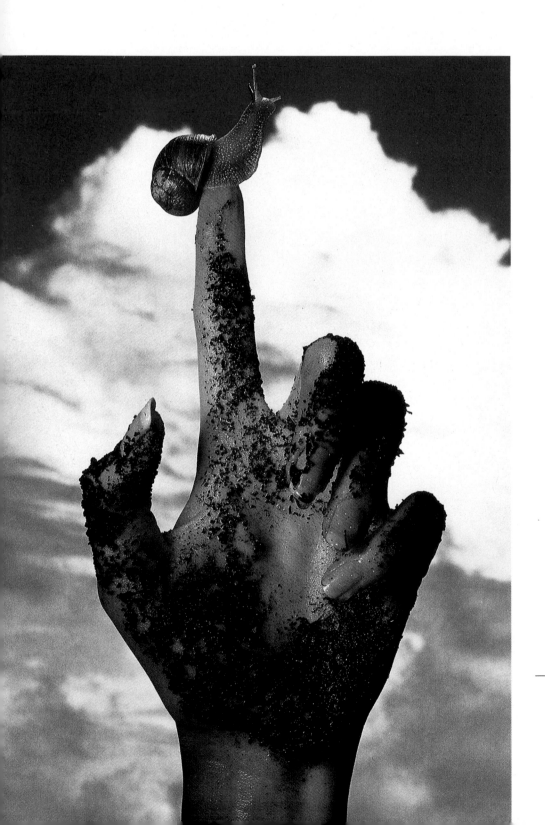

Left
Hiro
1986

Right
Guy Bourdin
1969

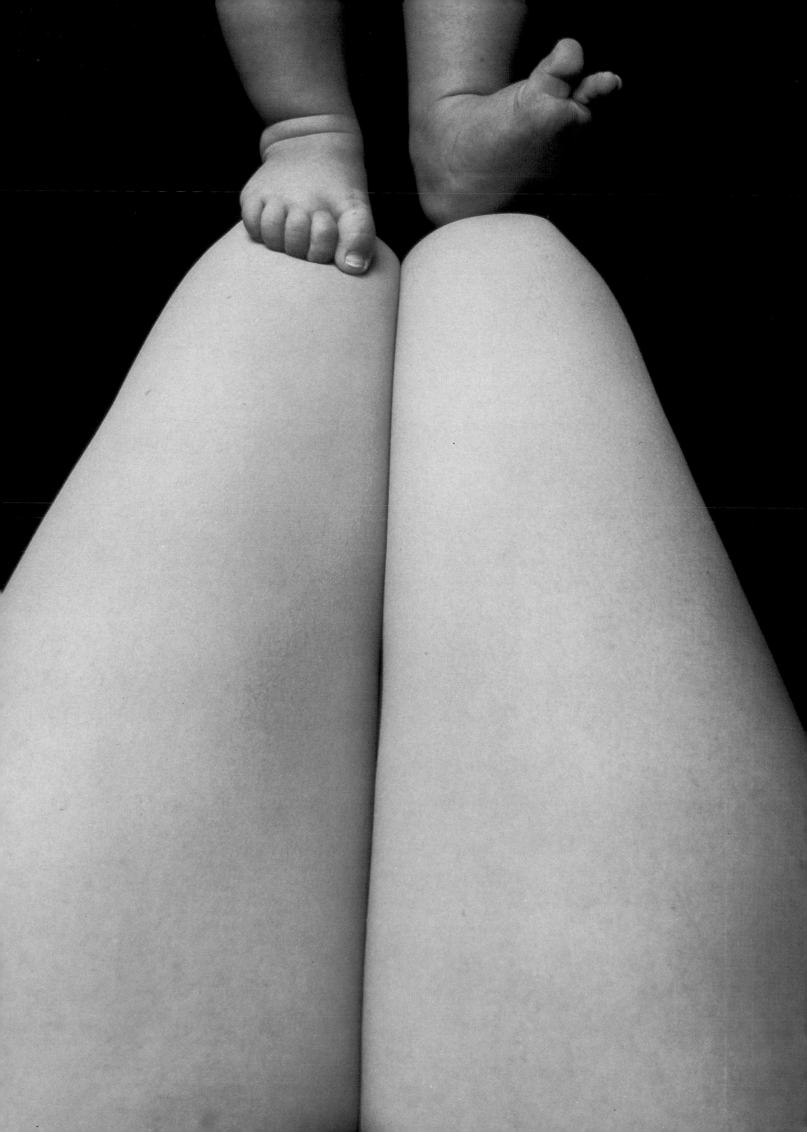

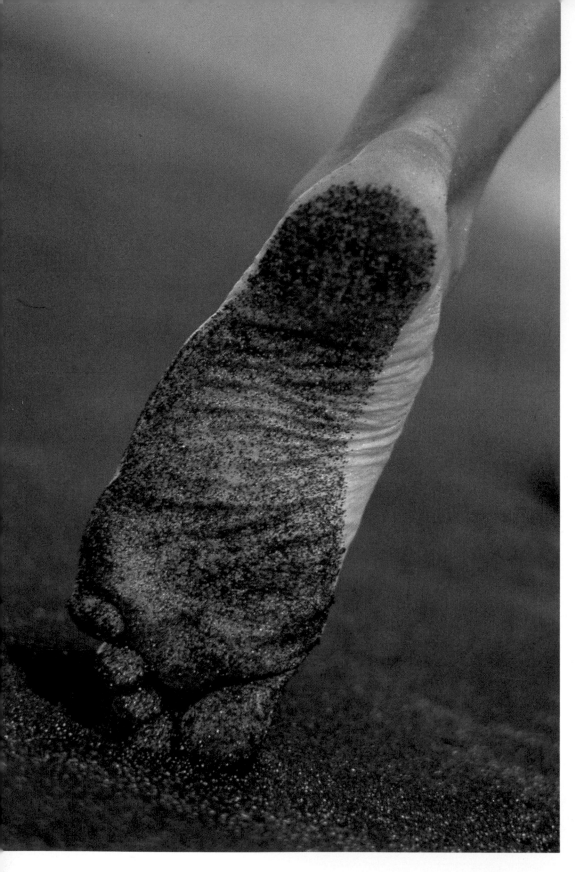

Above
Neil Kirk
1986

Right
Albert Watson
1985

104

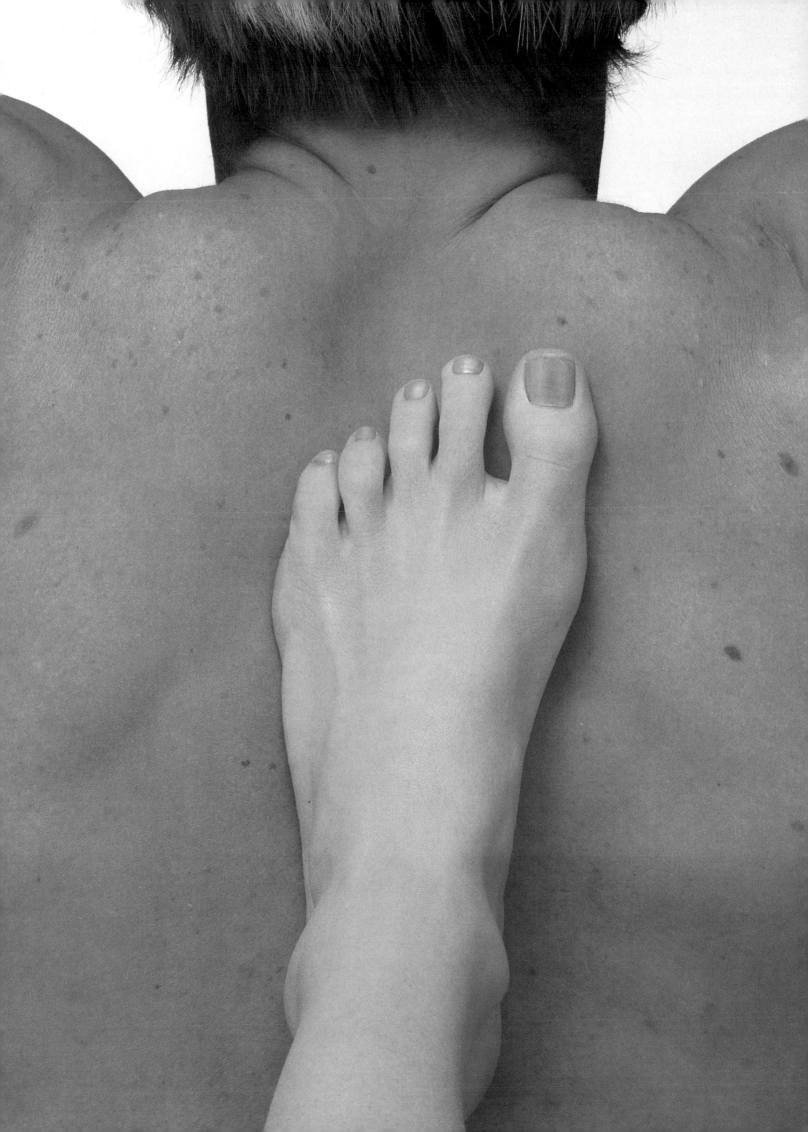

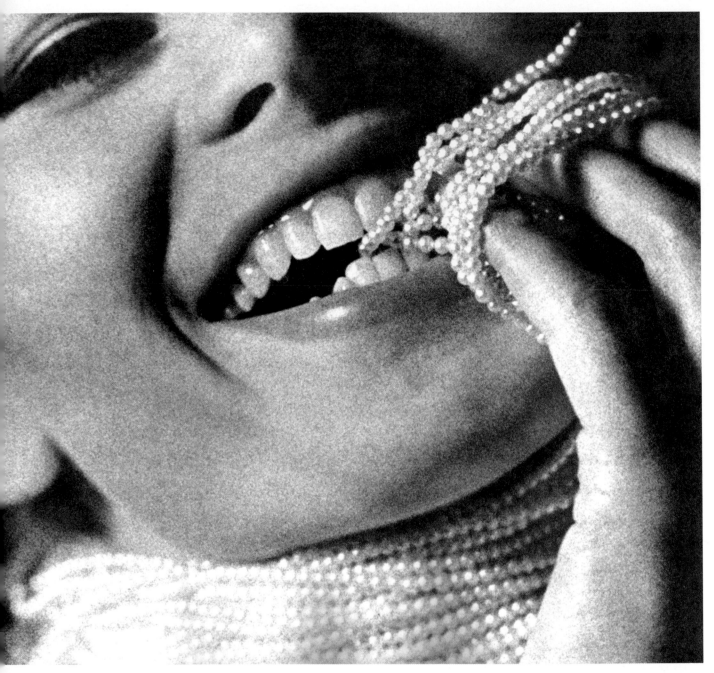

Above
Bert Stern
1963

Right
Bert Stern
1961

Overleaf left
Lester Bookbinder
1973

Overleaf right
Clive Arrowsmith
1970

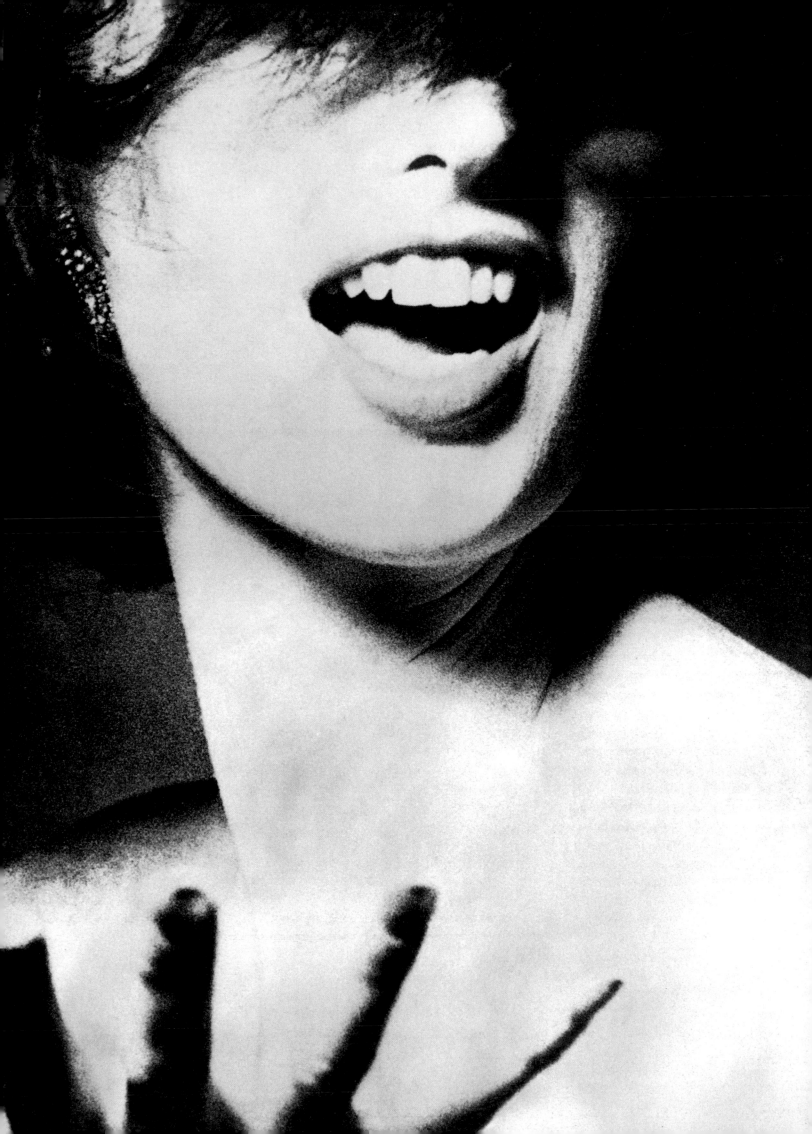

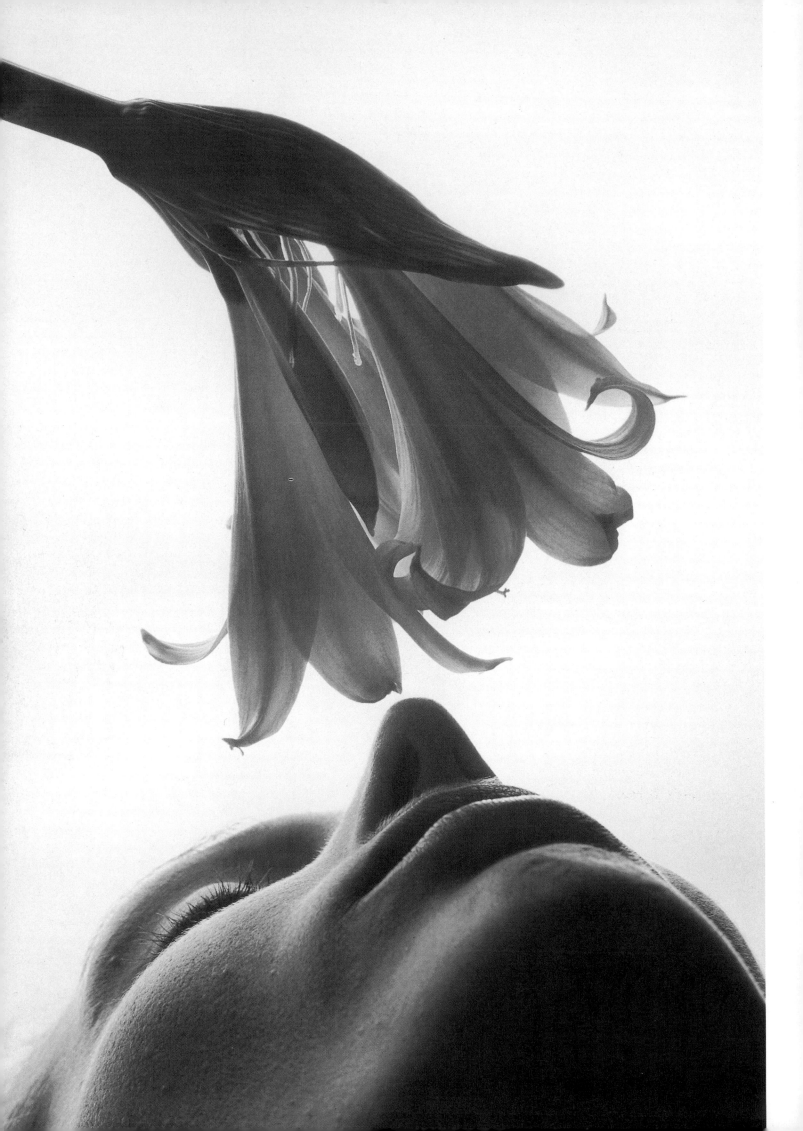

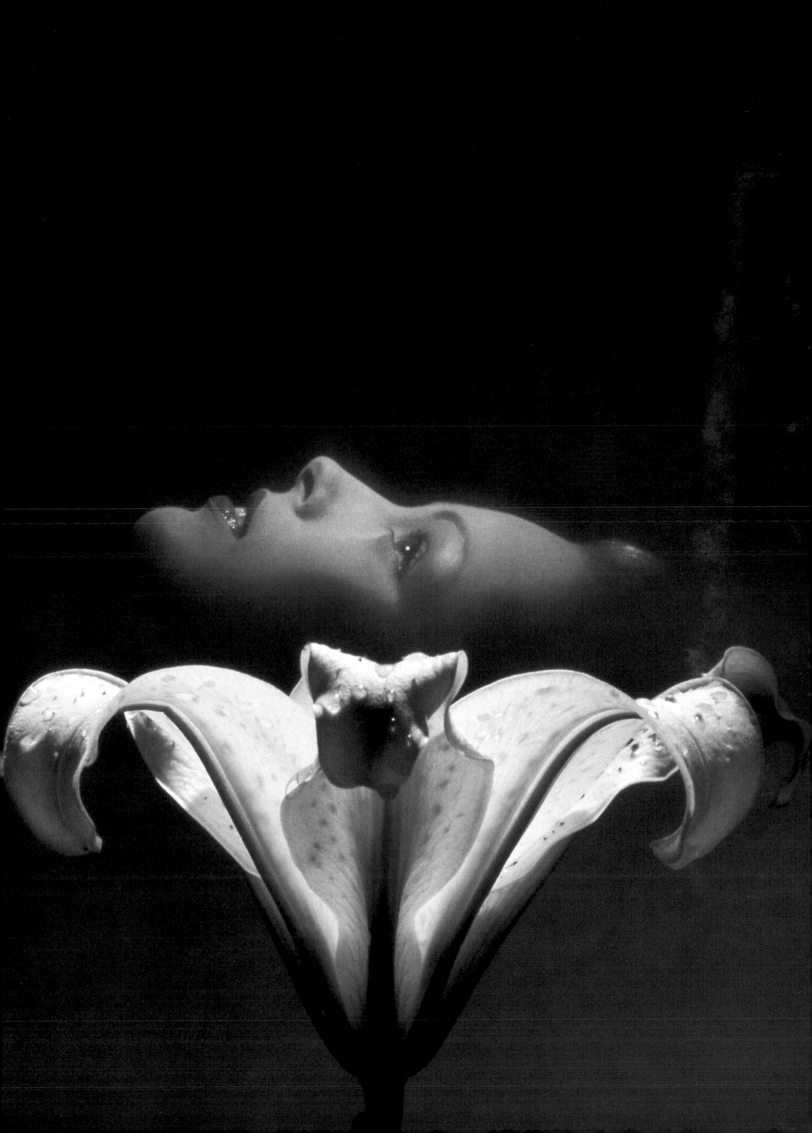

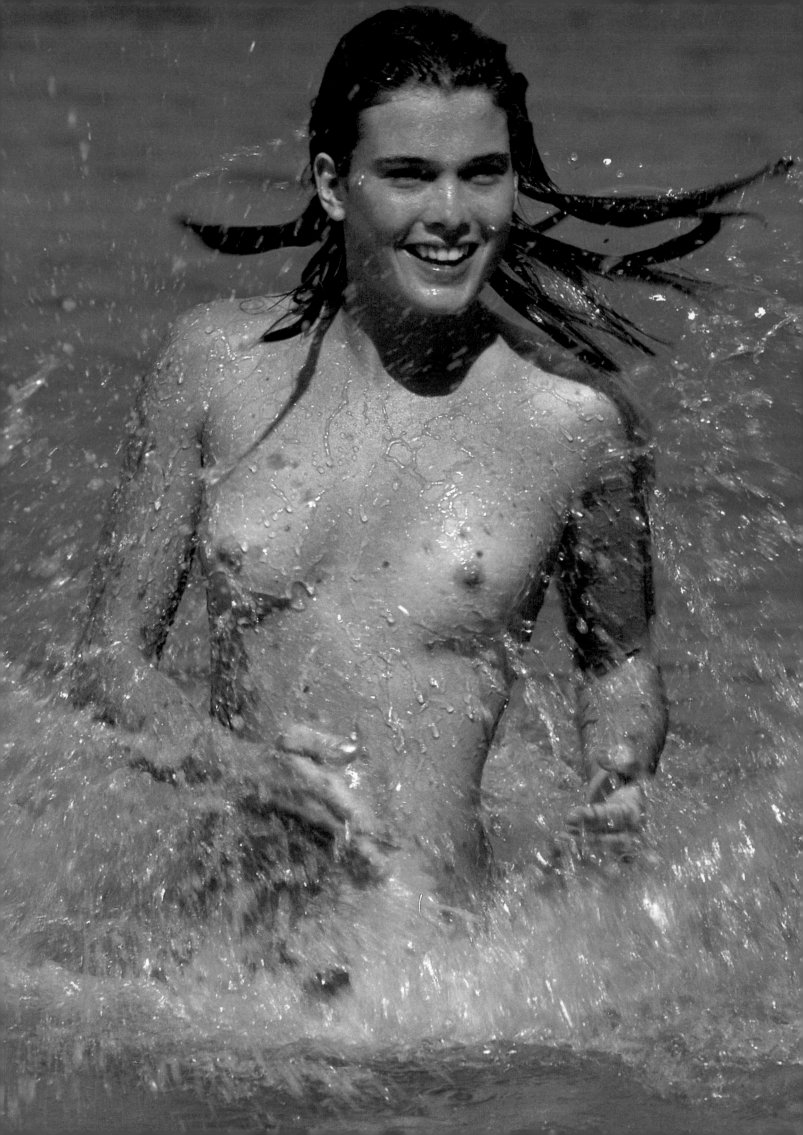

Action

'A much better judge of beauty than legendary old Paris with his golden apple is today's camera.' Vogue, 1944

The action realism which Toni Frissell pioneered in *Vogue*'s beauty pages has come full circle and is an approach much favoured in the 1980s. Frances McLaughlin-Gill carried on the tradition with great skill through the forties and fifties – how strikingly modern many of her photographs appear today. Arthur Elgort's earliest ambitions in the direction of ballet have also come full circle, as a balletic leap is enacted for *Vogue* in his New York studio. Bruce Weber is perhaps the photographer most identified with the *plein-air* approach today, and he brings a wonderfully natural mood to his beauty photographs.

The photographs by Marco Glaviano and Jean Pagliuso both show the woman dominated by their backgrounds, and both were used as dramatic double-page spreads in *Vogue*. Glaviano's picture recalls the models-chased-by-aeroplane series Helmut Newton made for British *Vogue* in the sixties. Newton himself is represented here by two shots with space-age overtones, an early example from French *Vogue* and an amusing recent picture used in the German edition. In 1944 Dr Agha, formerly *Vogue*'s art director, complained that studio fashion photography was '. . . a cross between stagecraft, interior decoration, ballet and society portrait painting done by camera', advocating instead the lively 'fashion snapshot'. Notwithstanding Agha's opinions what has happened in fashion and beauty photography is that room has been found for a wide range of approaches, studio and outdoors, formal and informal. Fashion and beauty photographers continue to find innovatory ways of depicting beauty, following no hard and fast rules but adapting their approach to ever-changing demands.

Left
Bruce Weber
1980

111

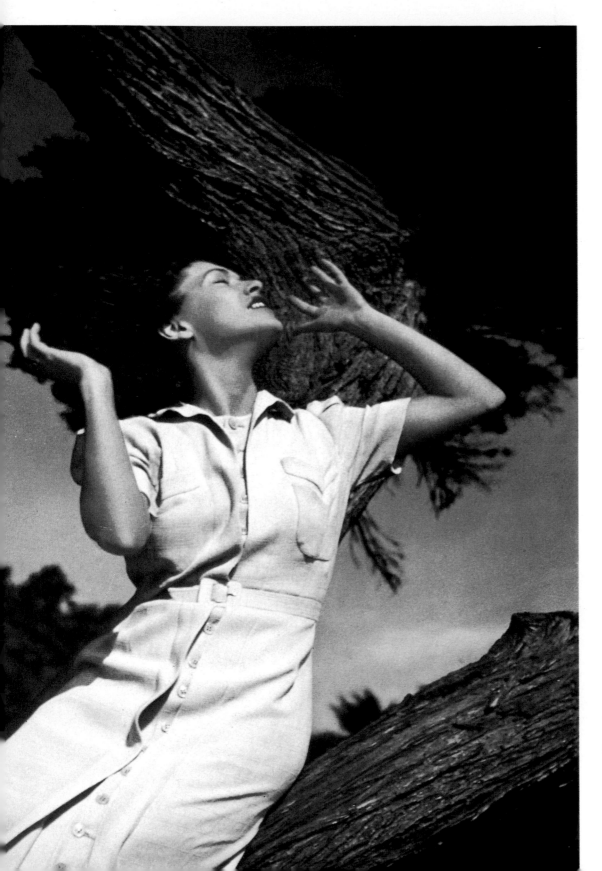

Left
Toni Frissell
1938

Right
Frances McLaughlin-Gill
1948

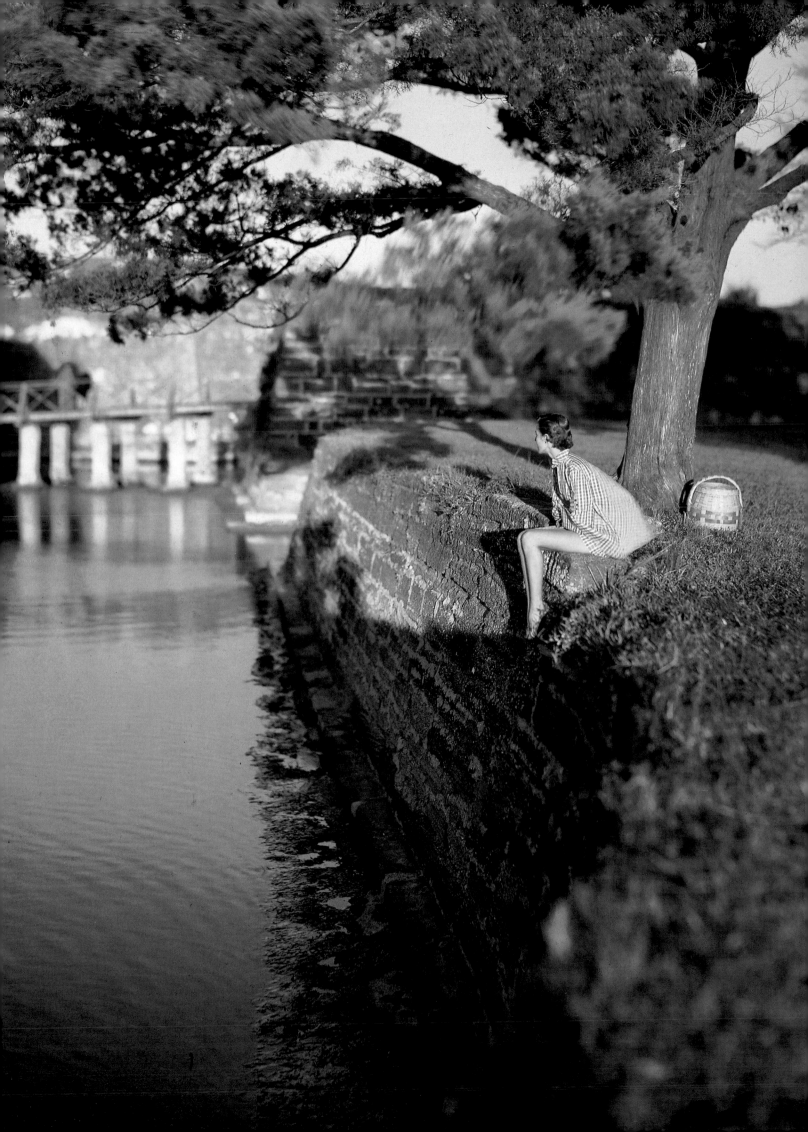

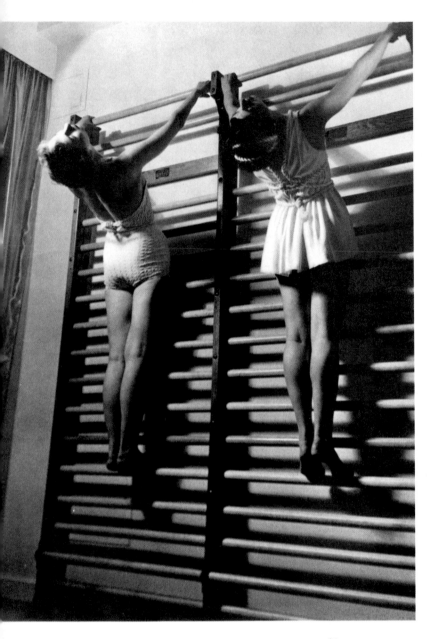

Above
Anton Bruehl
1937

Right
Frances McLaughlin-Gill
1950

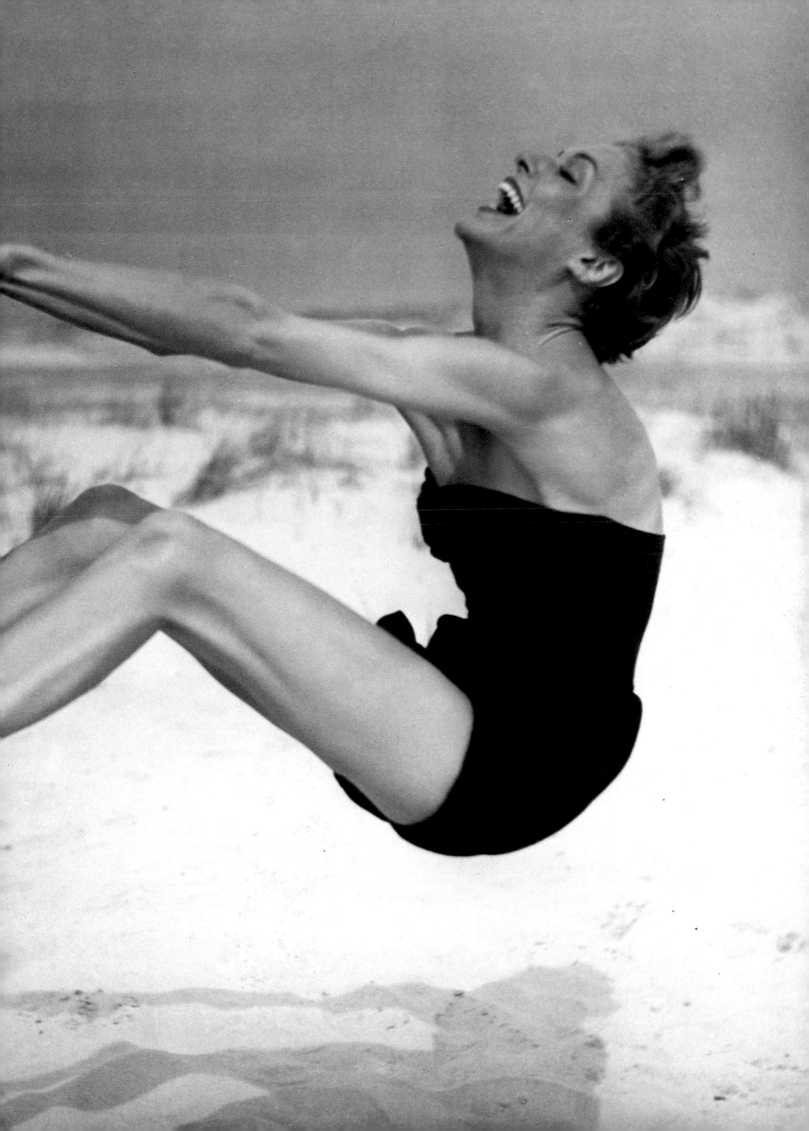

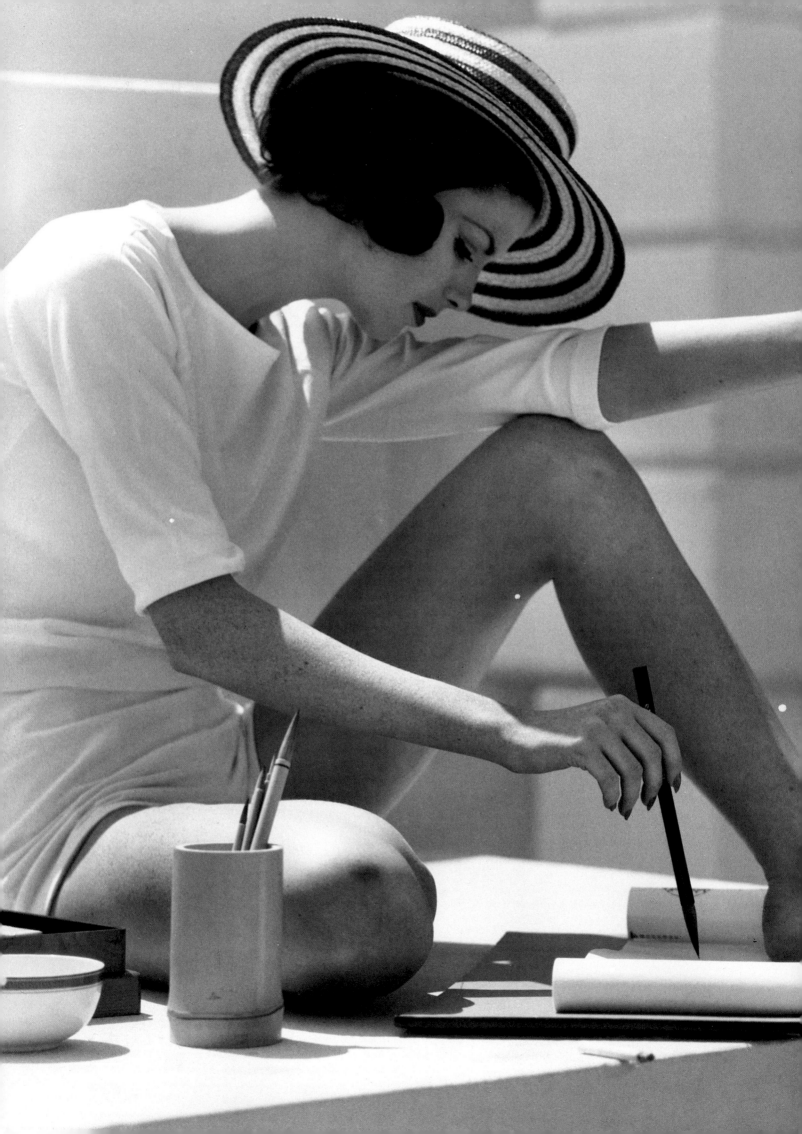

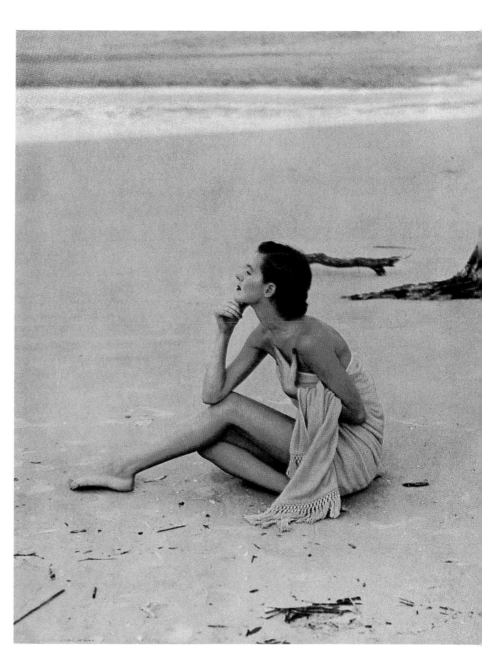

Above
Frances McLaughlin-Gill
1950

Left
Frances McLaughlin-Gill
1960

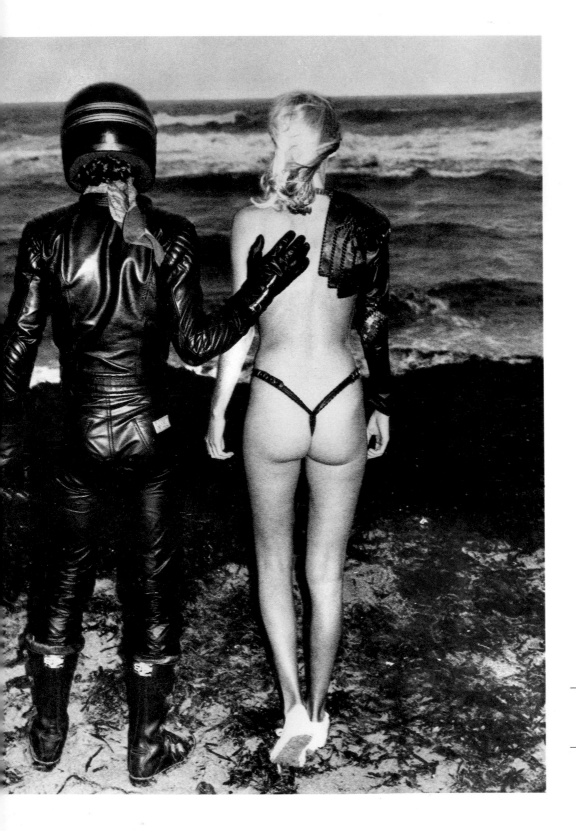

Left
Helmut Newton
1982

Right
Patrick Demarchelier
1983

Overleaf
Marco Glaviano
1981

118

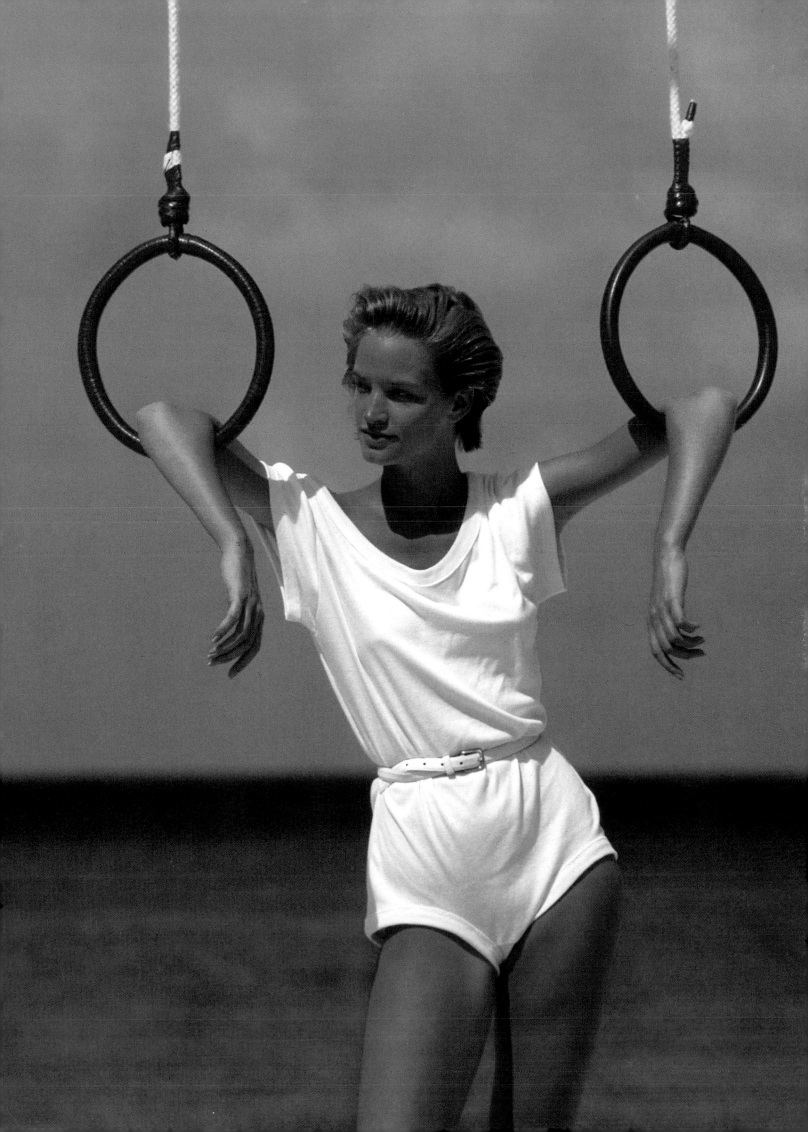

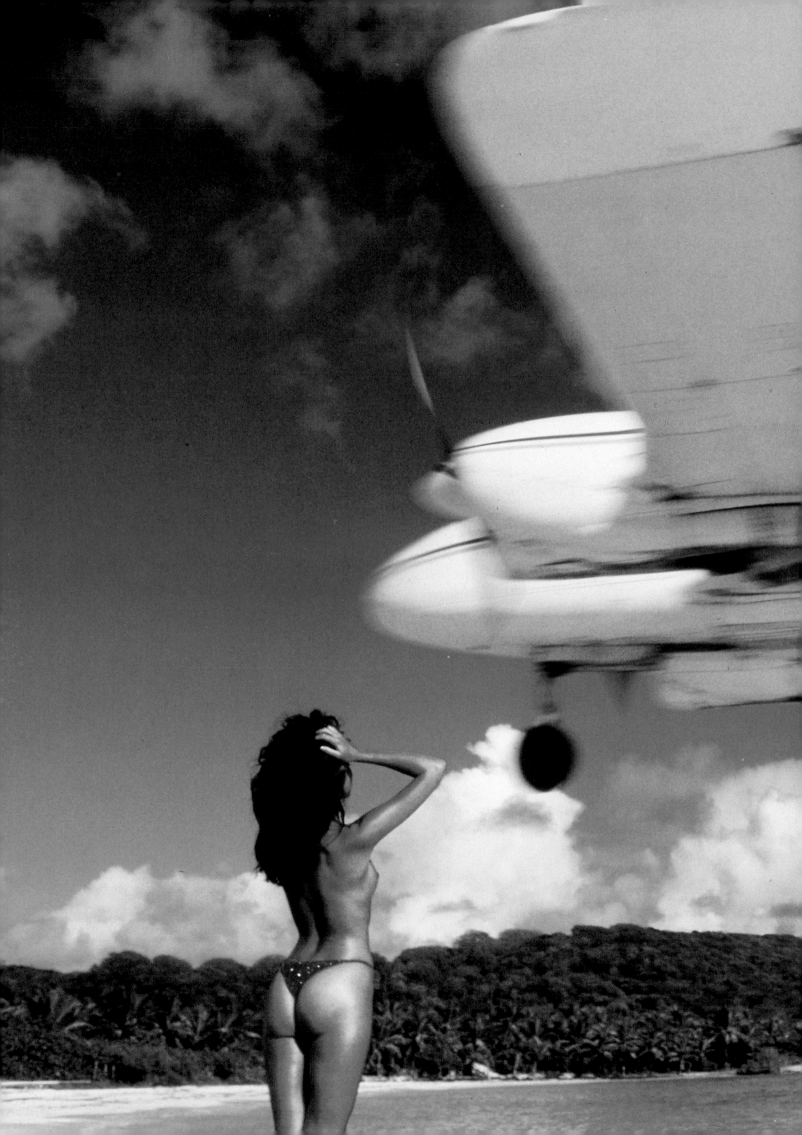

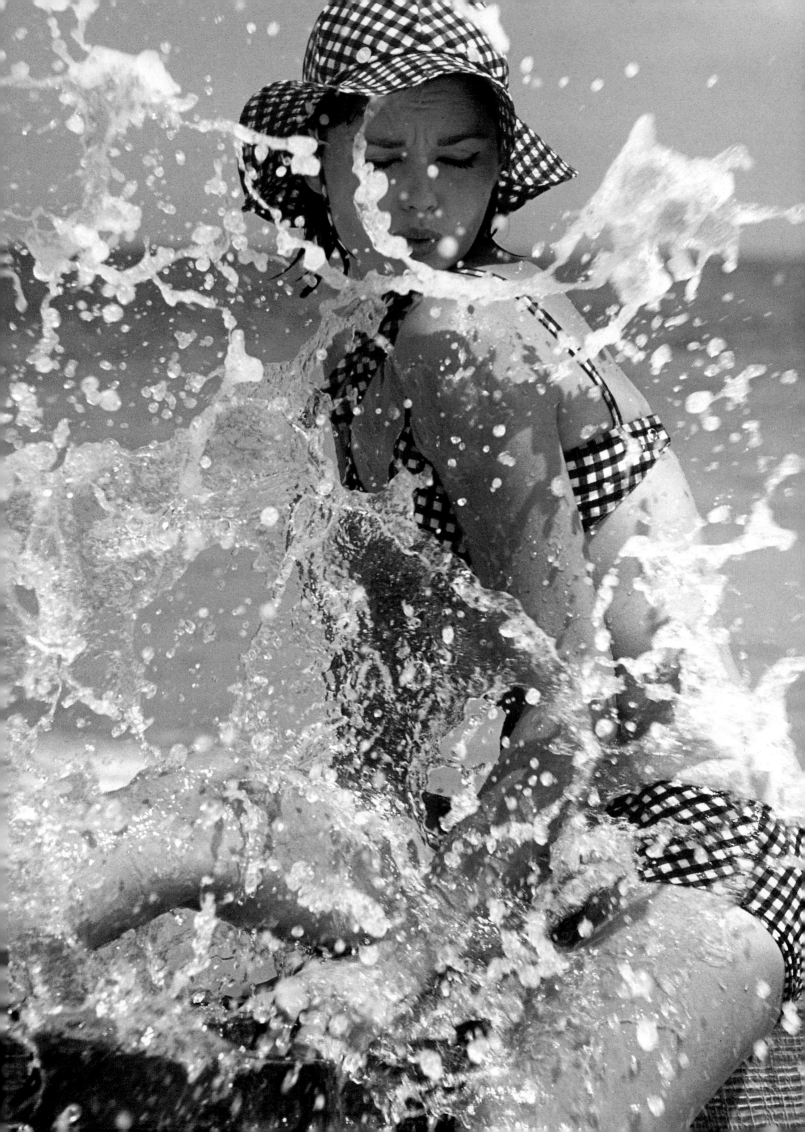

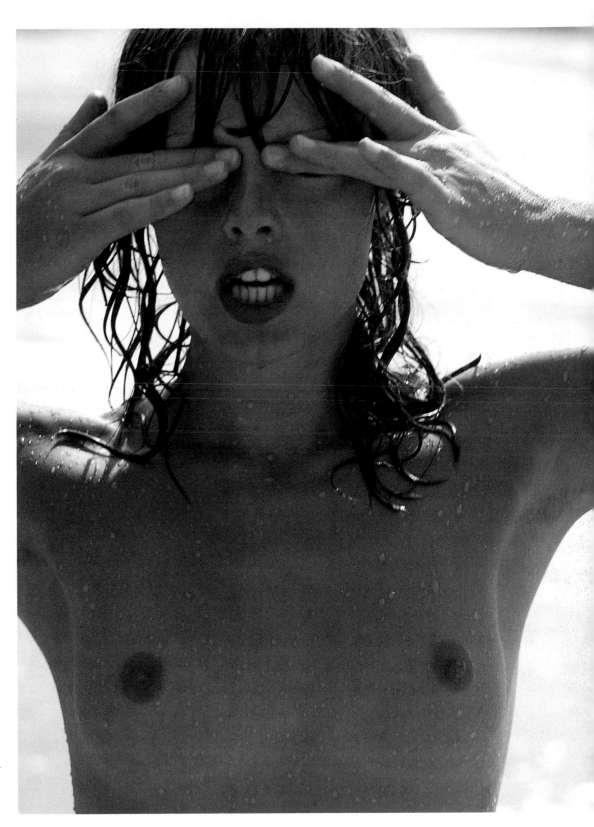

123

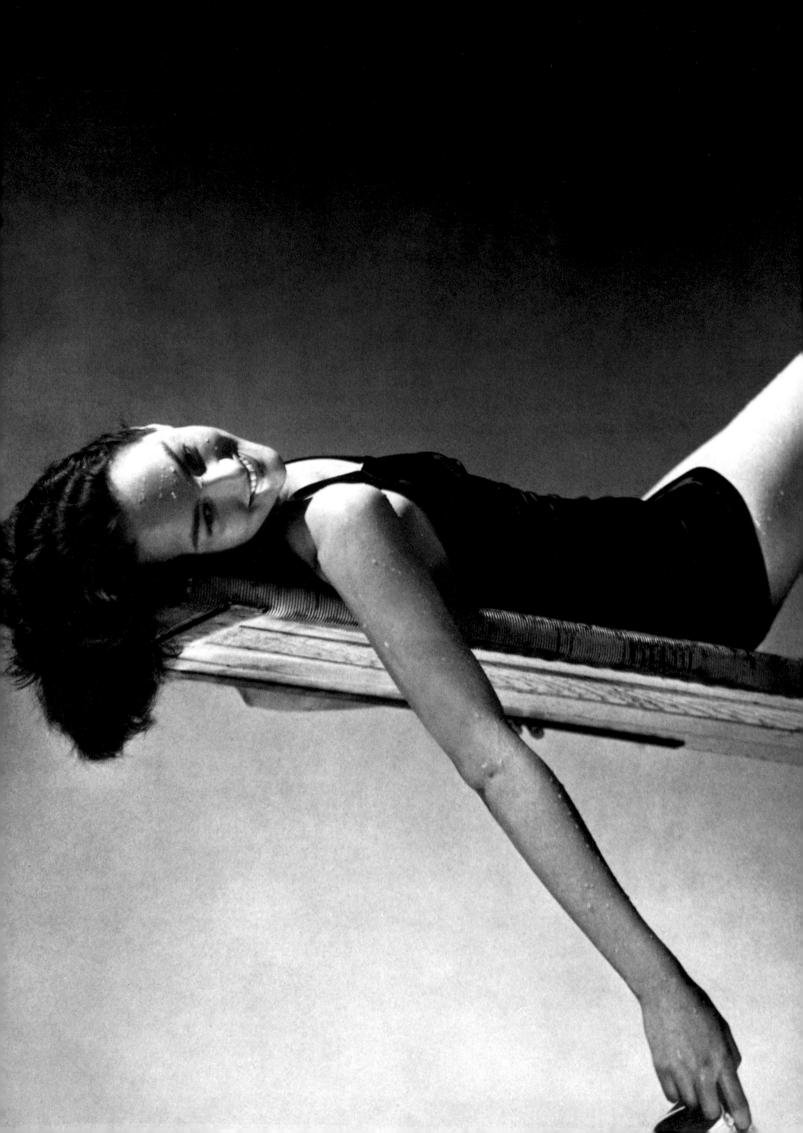

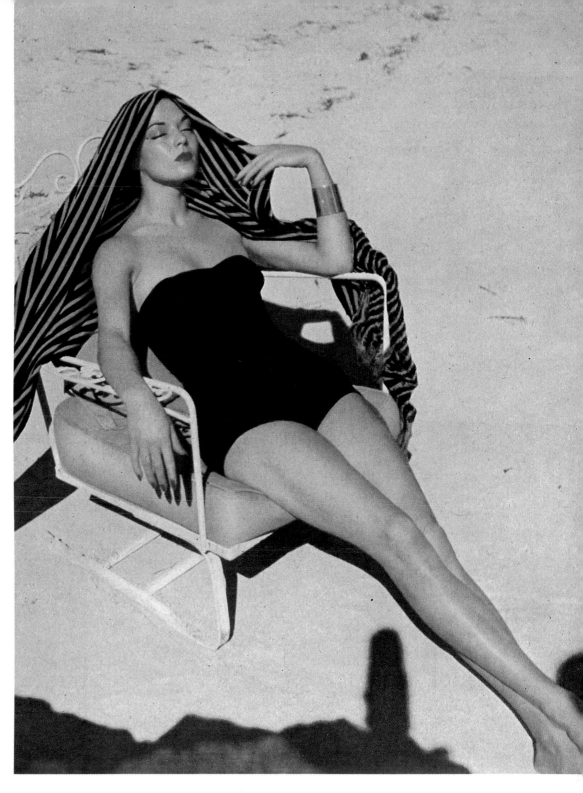

Above
Clifford Coffin
1951

Left
Edward Steichen
1937

Overleaf
Jean Pagliuso
1977

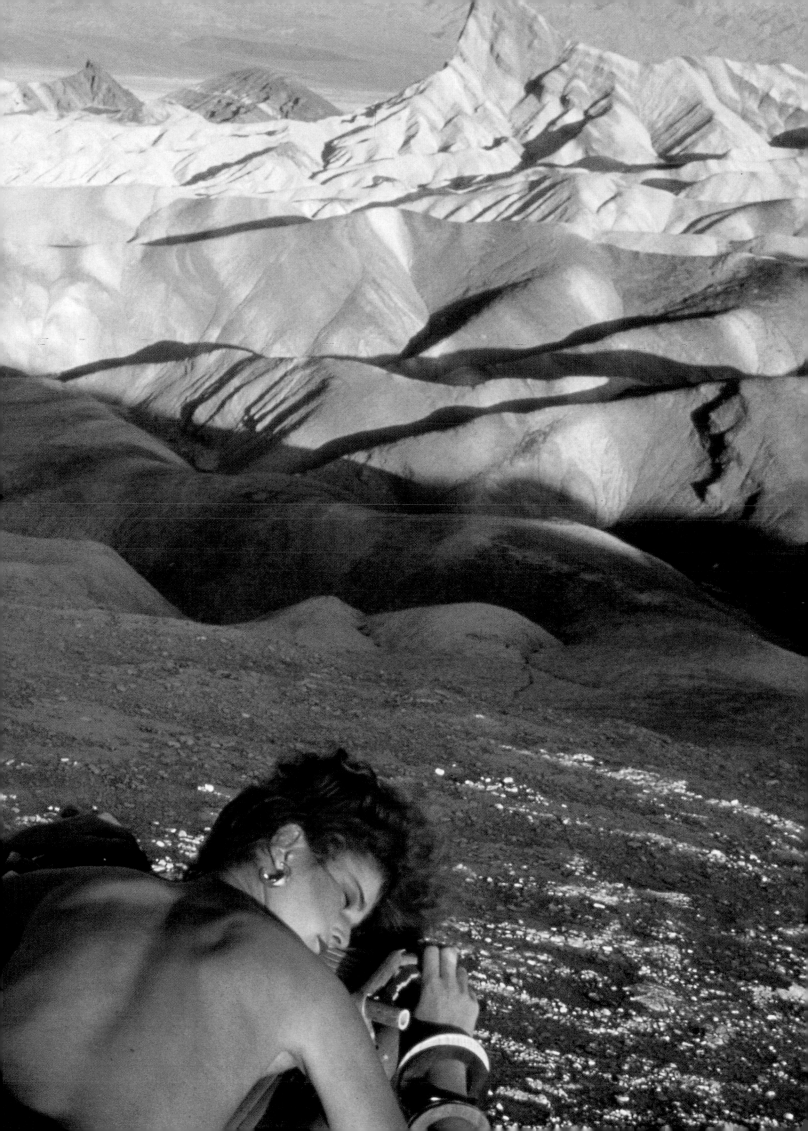

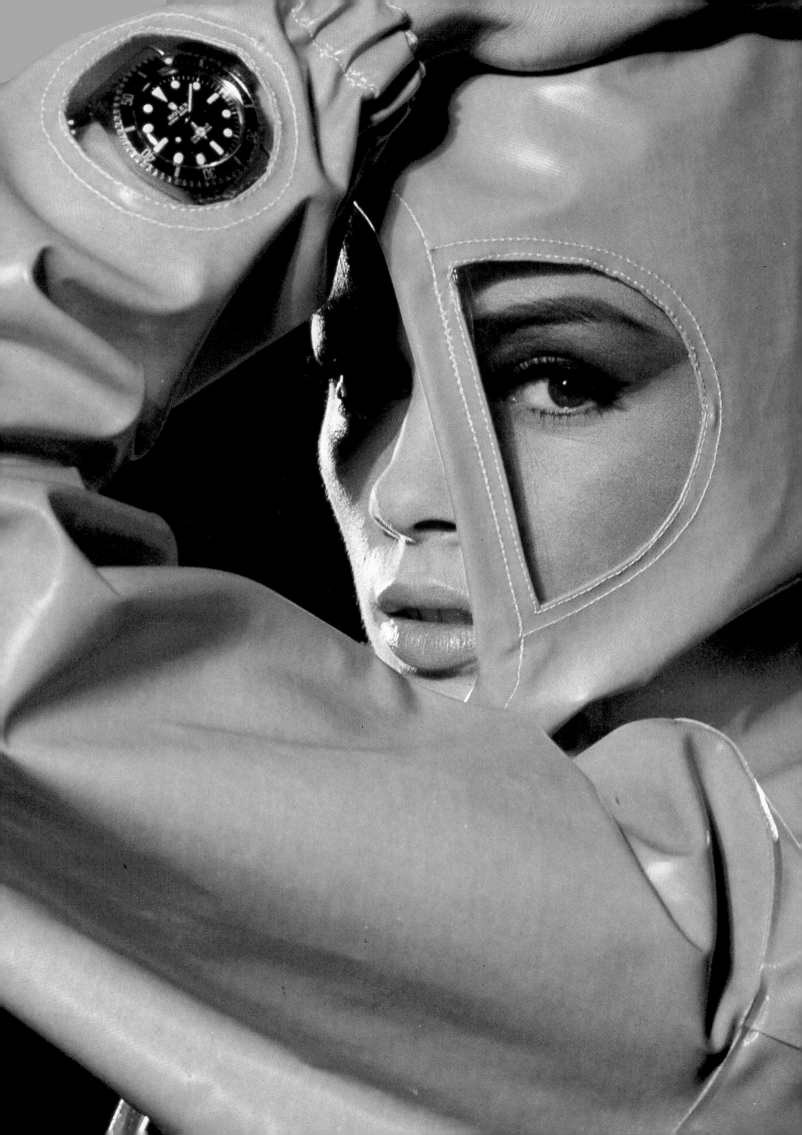

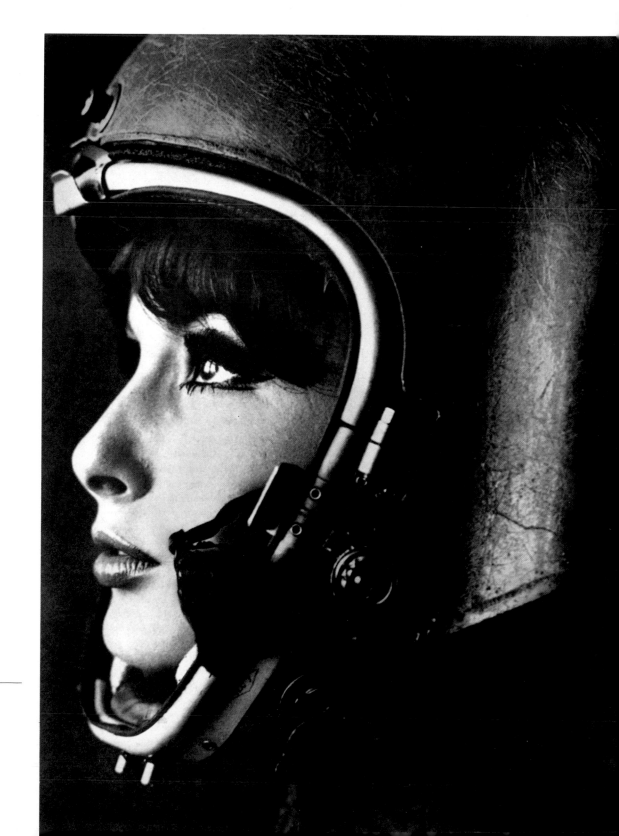

Left
Helmut Newton
1965

Right
Art Kane
1962

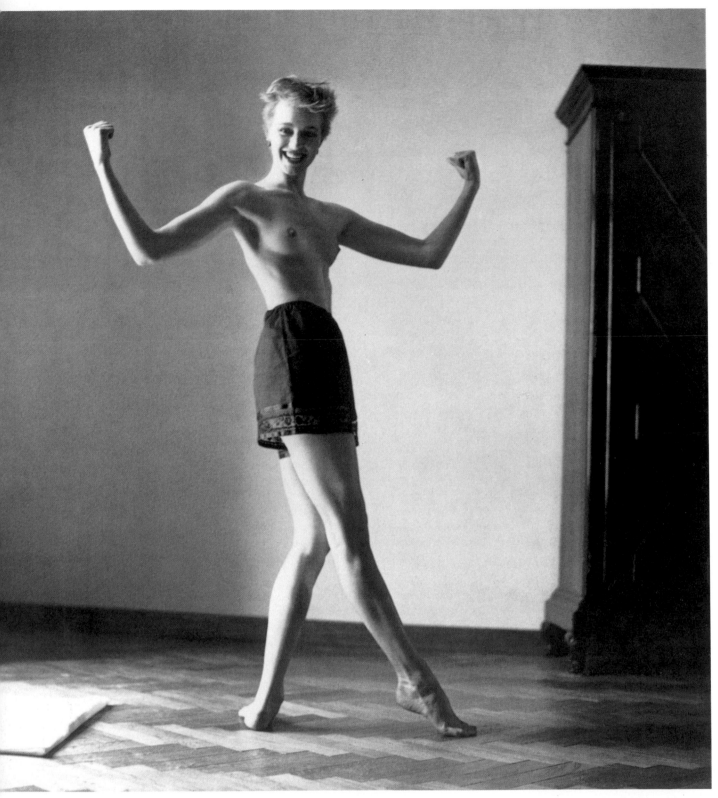

Above
Arthur Elgort
1981

Right
Neil Kirk
1986

Overleaf
Arthur Elgort
1981

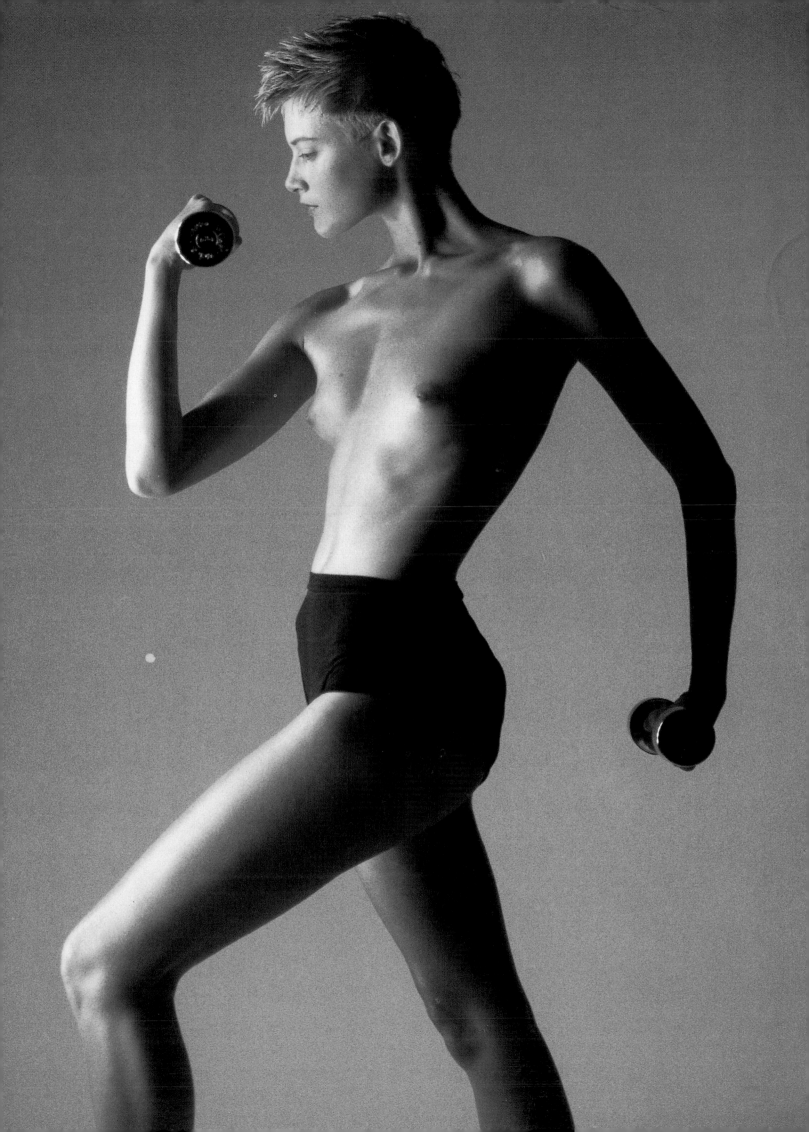

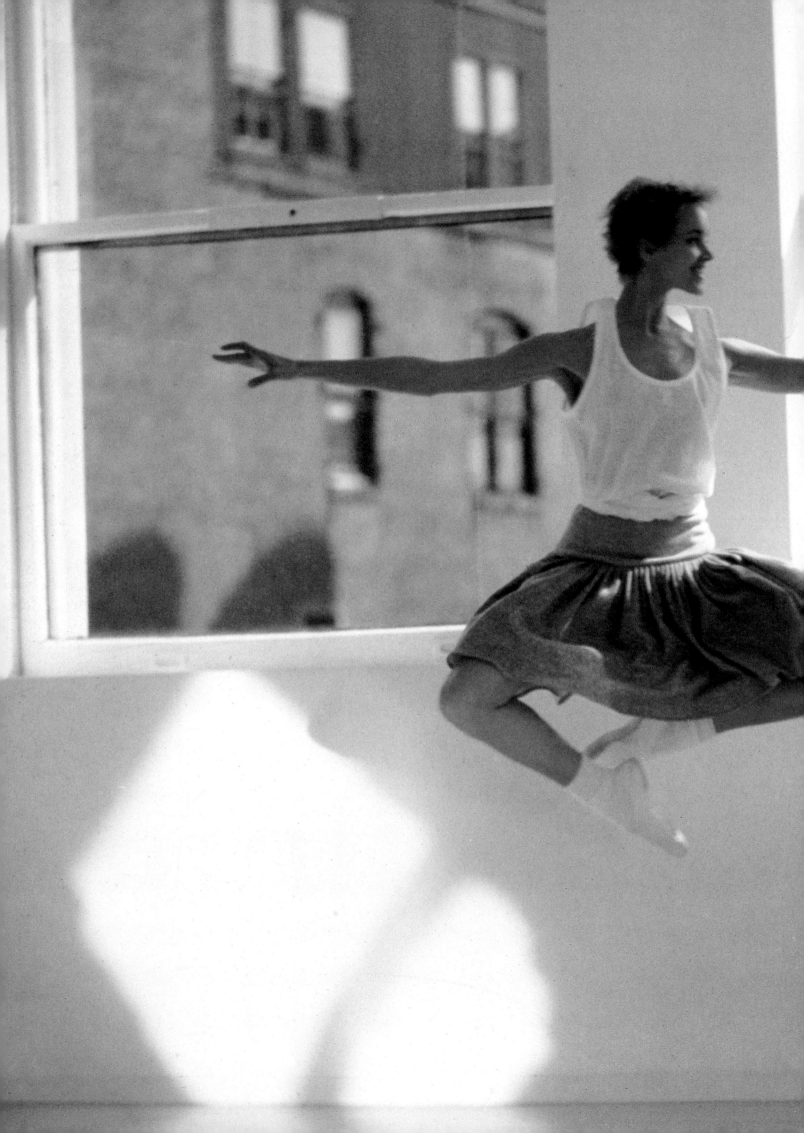

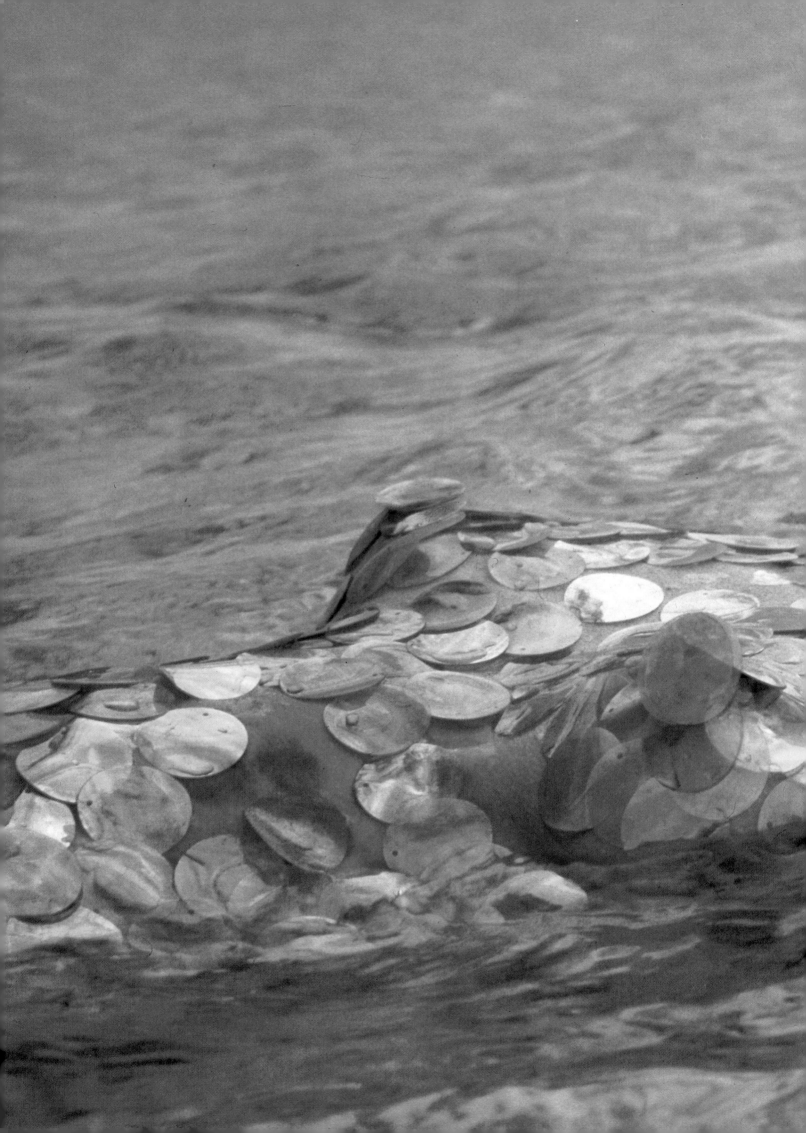

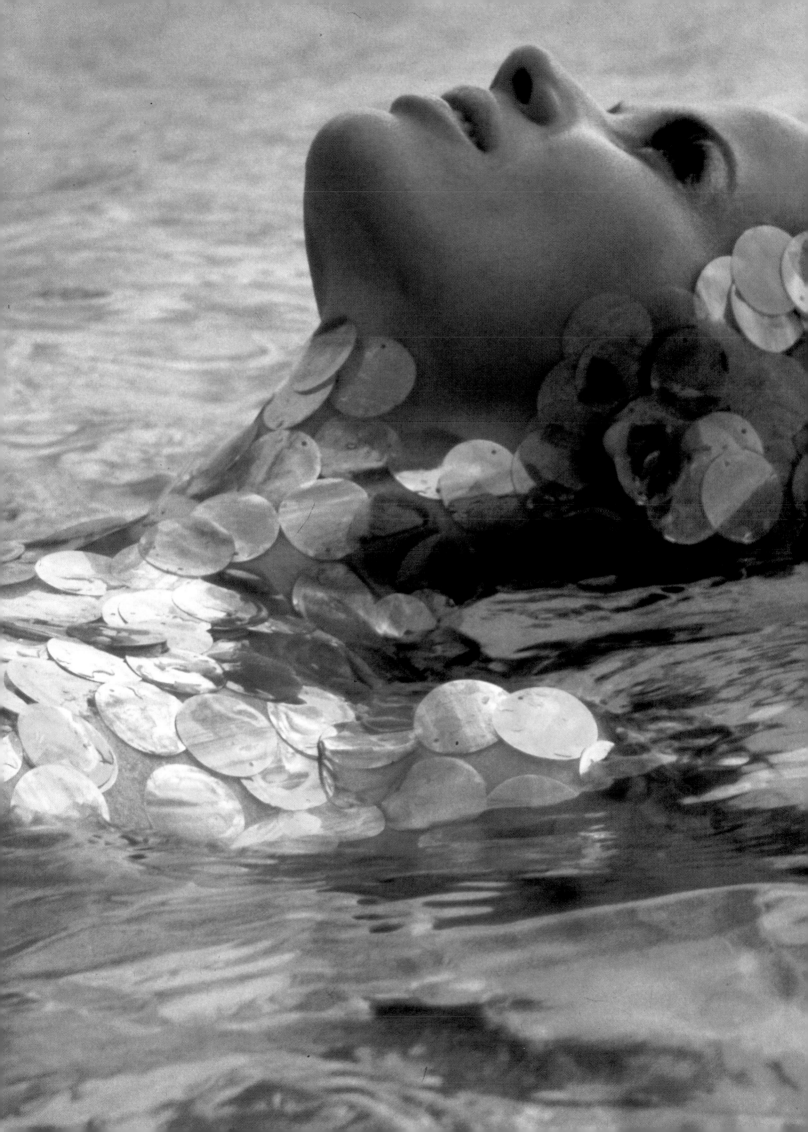

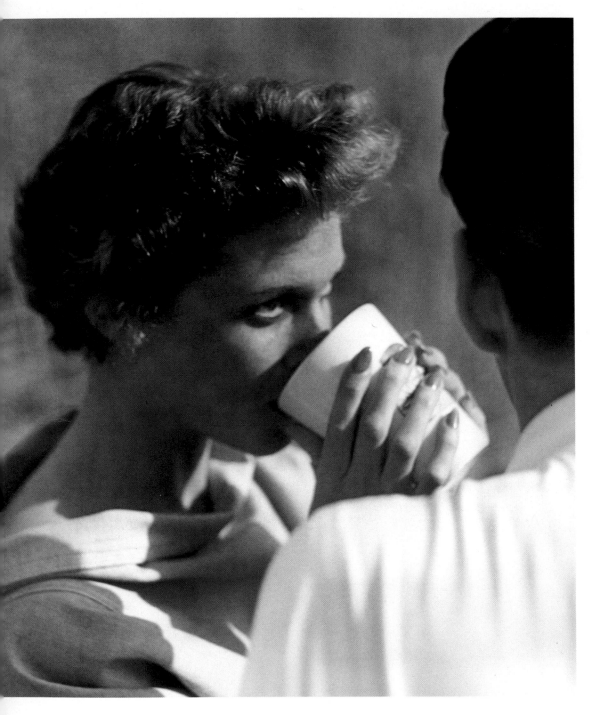

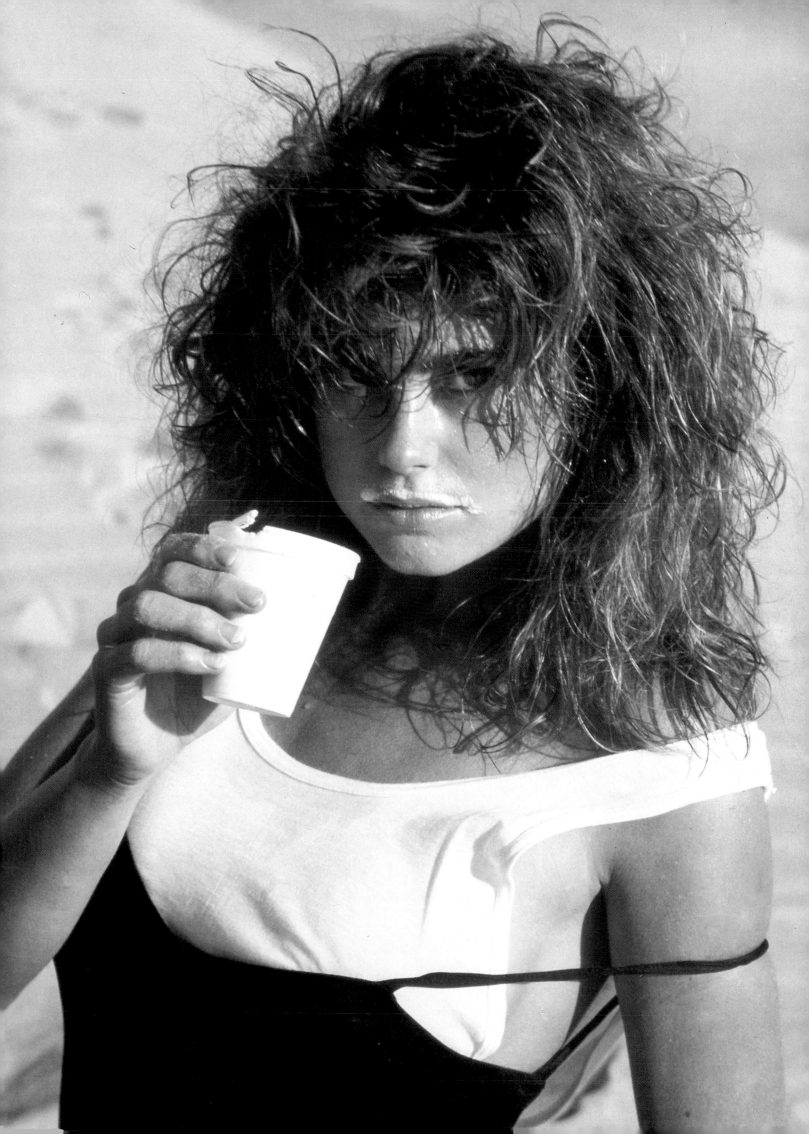

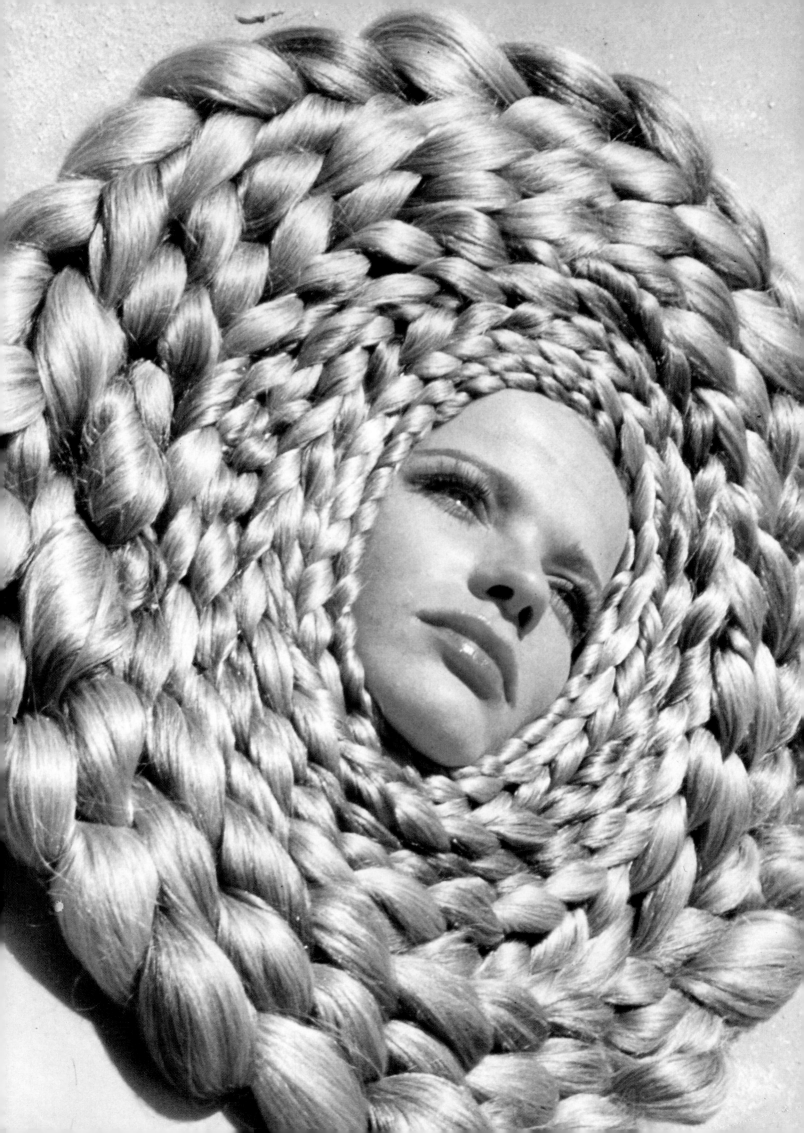

Headlines

'Beauty is nature plus art: an indivisible unity dependent upon the Hair beneath the hat; the Make-up to complement; the Figure beneath the dress; the Hand within the glove; the Foot within the shoe . . .' Beauty Book, 1948

Photographing a hairstyle is undoubtedly the beauty photographer's most difficult task. The technical problems involved in illustrating the hair itself have tended to stifle creative ambition. Perhaps for this reason, some of the most successful shots of this kind have approached the subject somewhat obliquely. Barry Lategan's sparkler topping adds a suitably whimsical touch of humour. Norman Parkinson, who said: 'I set out to get on film the look my sitter gives as a temptress to the privacy of her own looking glass', probably did not have in mind a lily-pond as the setting for this exercise, yet this cross between Ophelia and Excalibur makes a highly effective and unusual photograph.

John Sadovy's hair treatment photograph is an outstanding example of this kind of picture, and Rubartelli's photographs show how ideal Verushka's striking features were as the basis for the more extravagant sixties hair creations. Along more conventional lines Lategan's picture of Ingrid Boulting, despite its crepuscular tones, highlights sufficient of the long neo Pre-Raphaelite curls to make its point.

Robert Randall's photograph of the girl with a poodle is of particular interest in its use of *contre-jour* lighting. This technique is now largely outmoded, though it was frequently employed by Penn and Avedon around 1950 to great effect. Here Randall has cleverly exploited its graphic and descriptive qualities, making the beauty point in a clear, economical way.

Left
Franco Rubartelli
1967

139

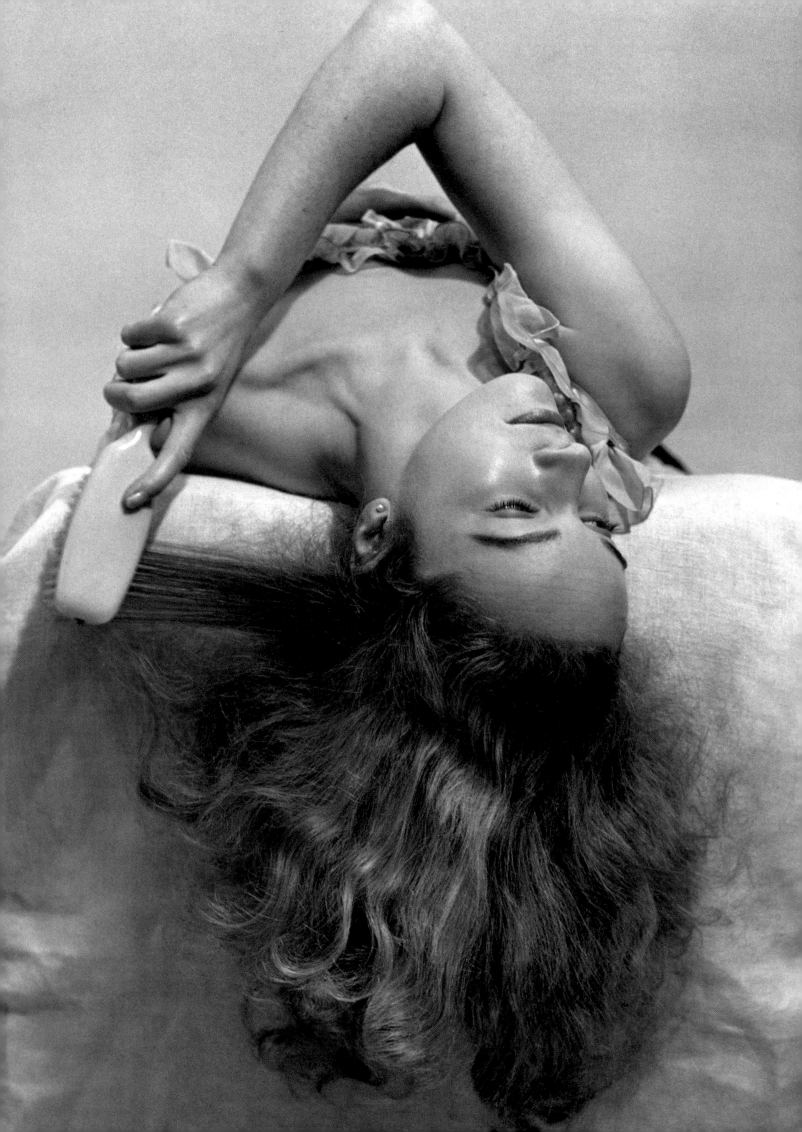

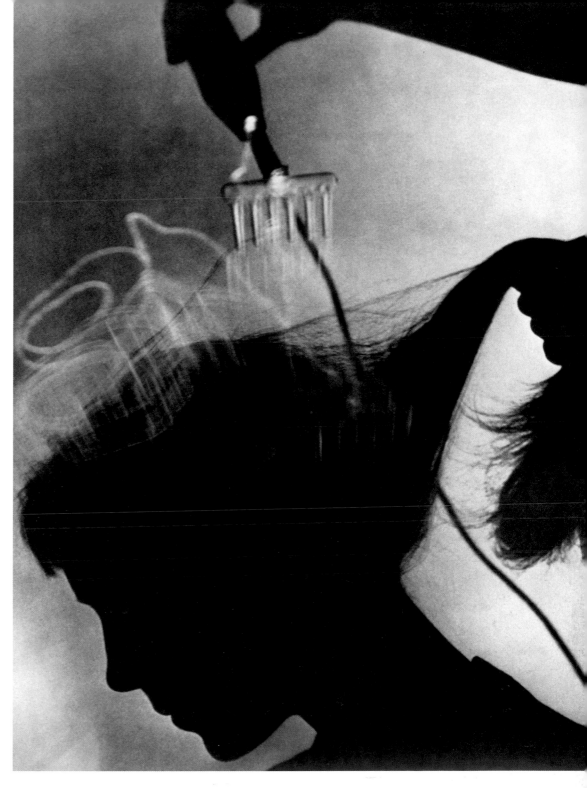

Above
John Sadovy
1954

Left
John Deakin
1952

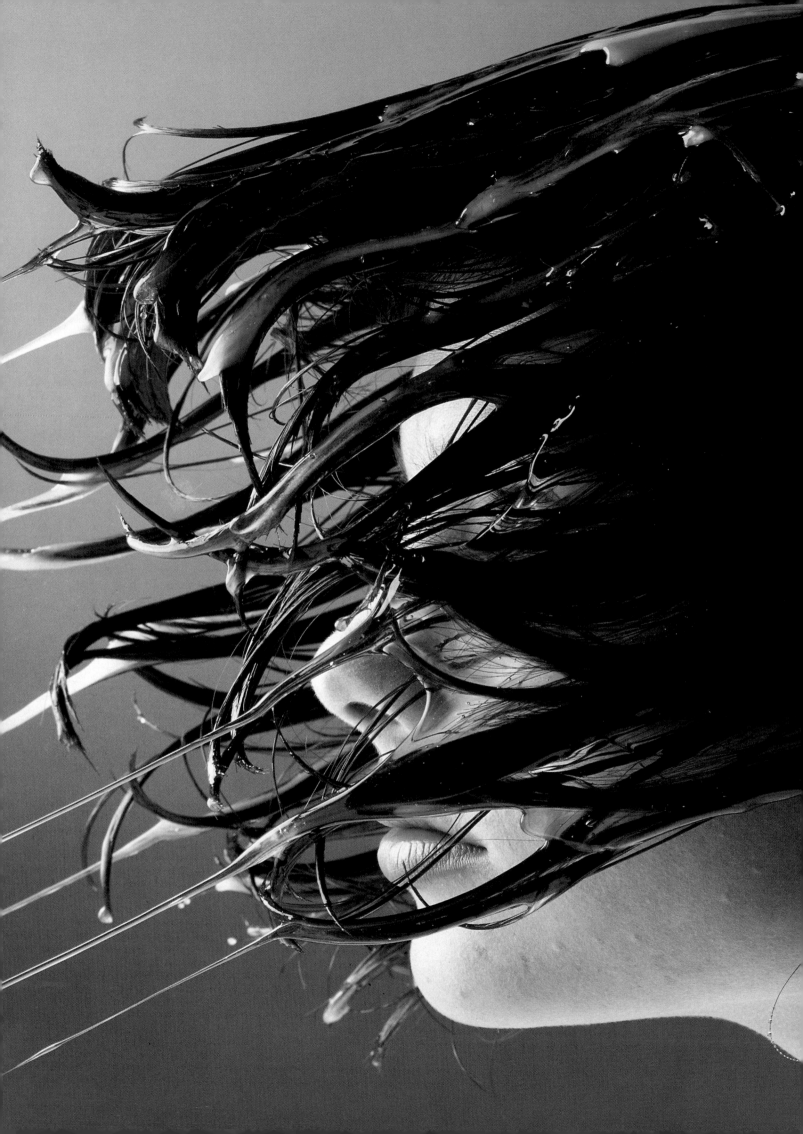

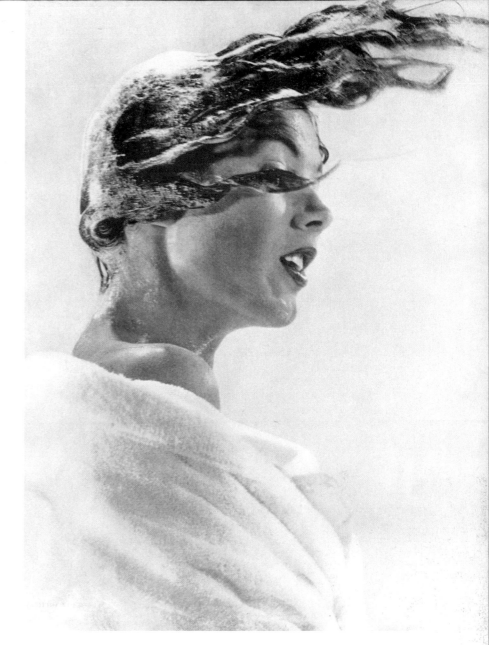

Above
Gjon Mili
1943

Left
Piero Gemelli
1984

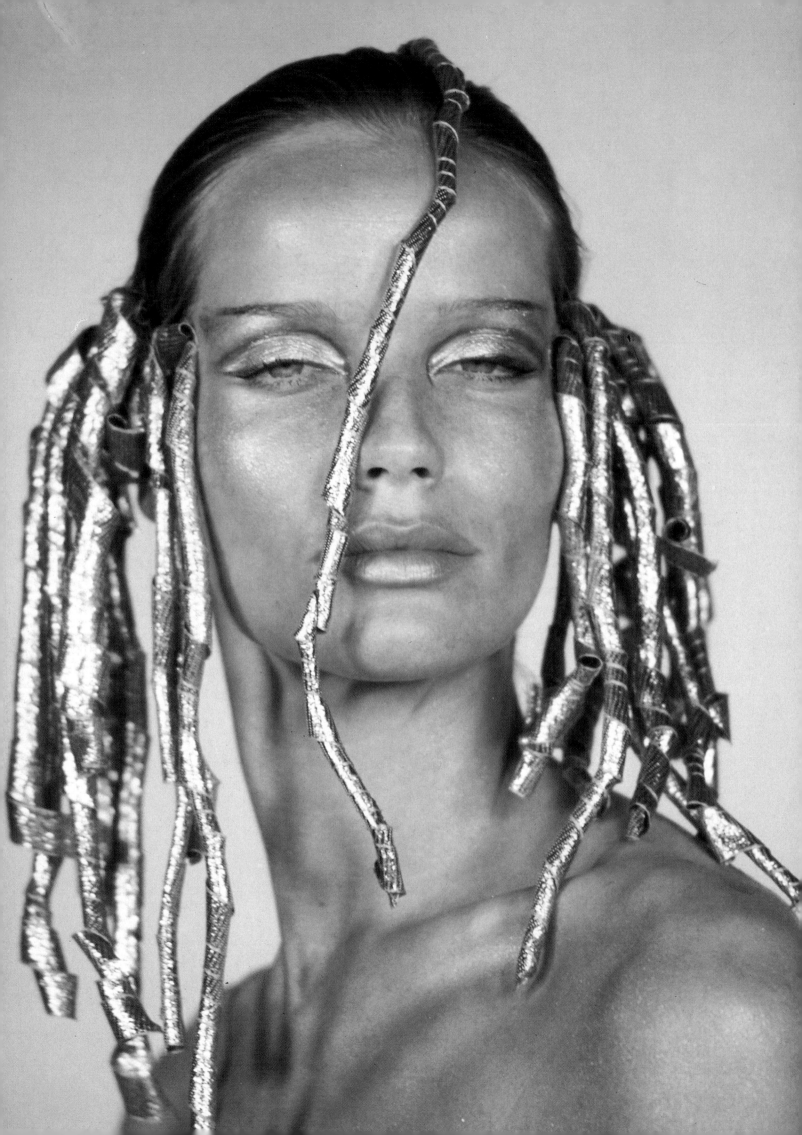

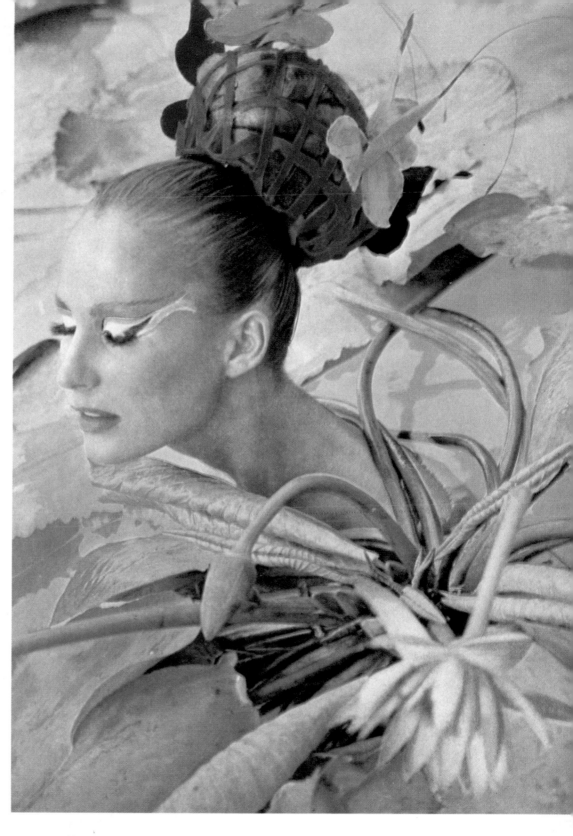

Above
Norman Parkinson
1965

Left
Franco Rubartelli
1968

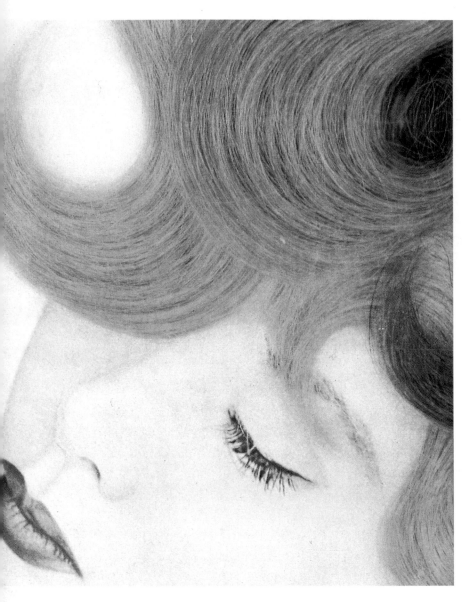

Above
Clifford Coffin
1953

Right
Barry Lategan
1975

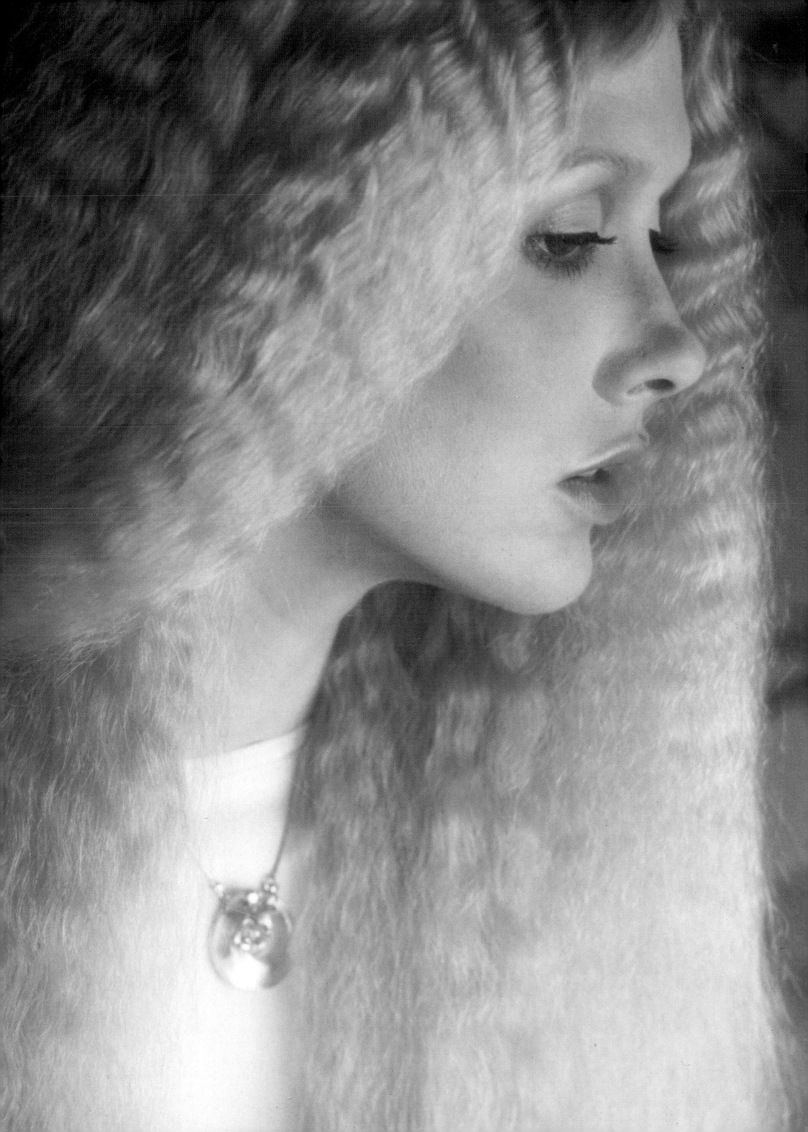

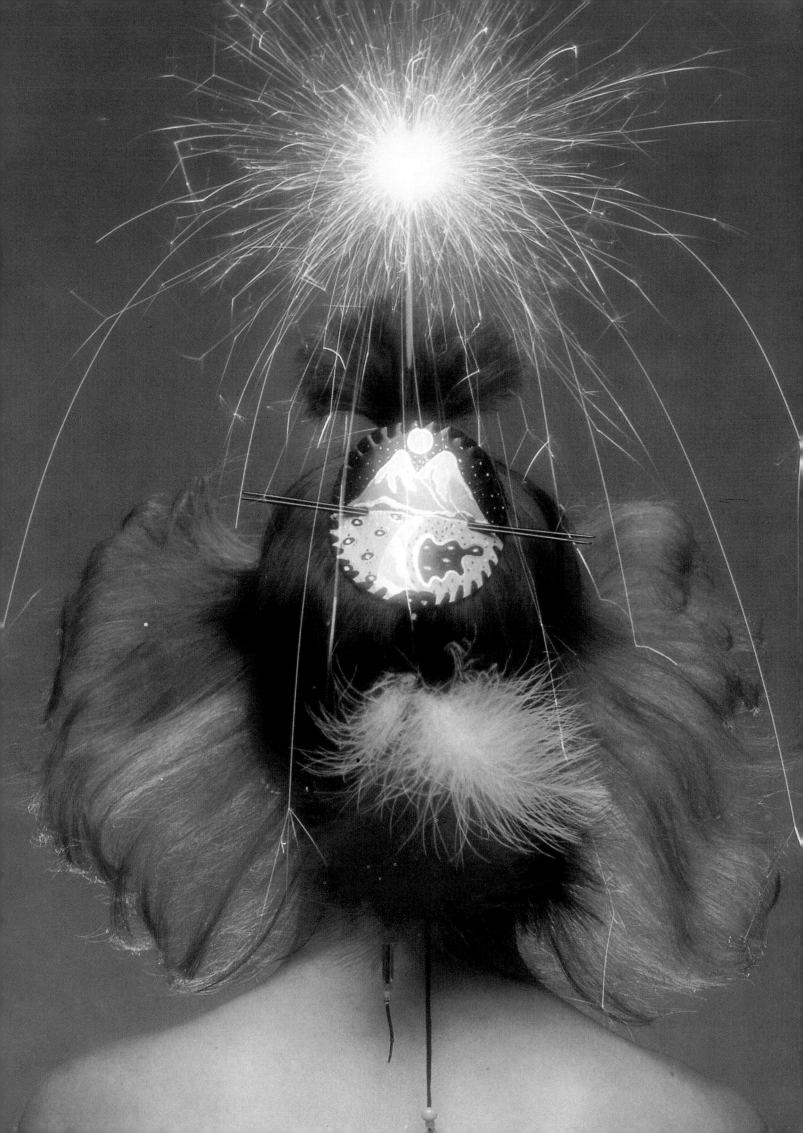

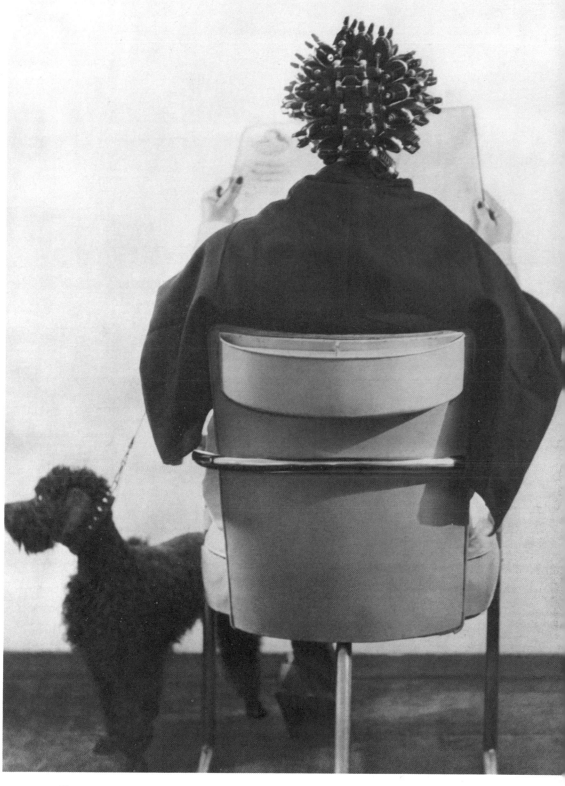

Above
Robert Randall
1951

Left
Barry Lategan
1971

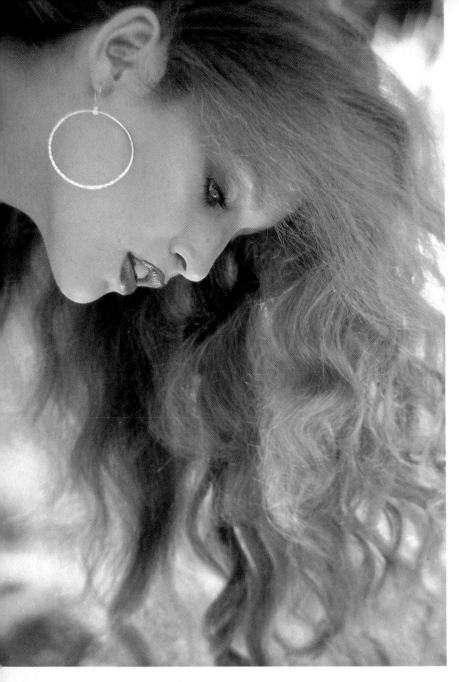

Above
Norman Parkinson
1975

Right
Franco Rubartelli
1968

150

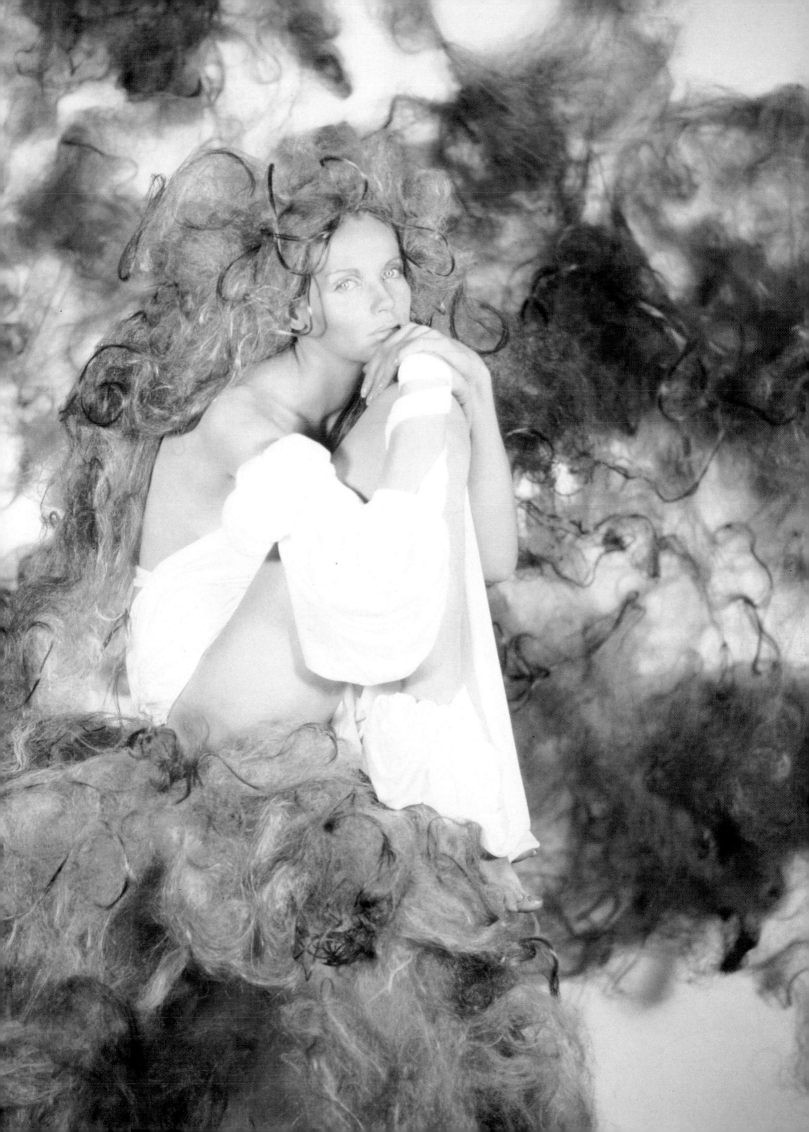

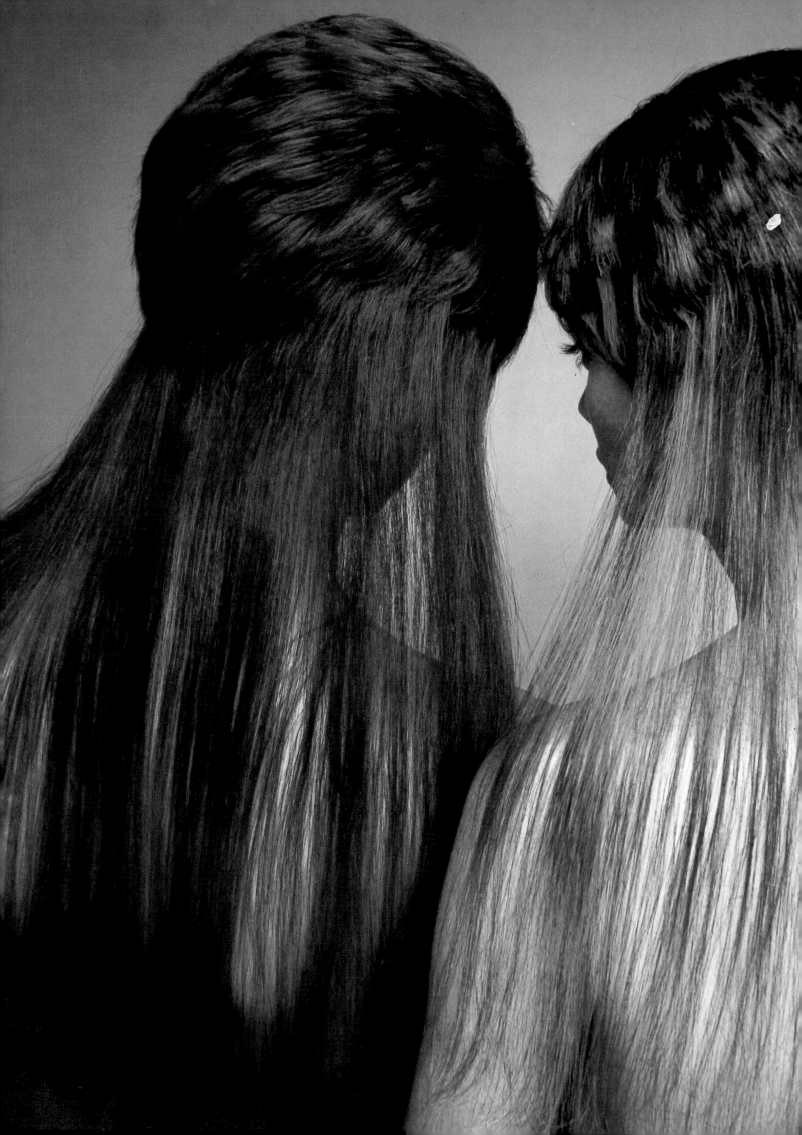

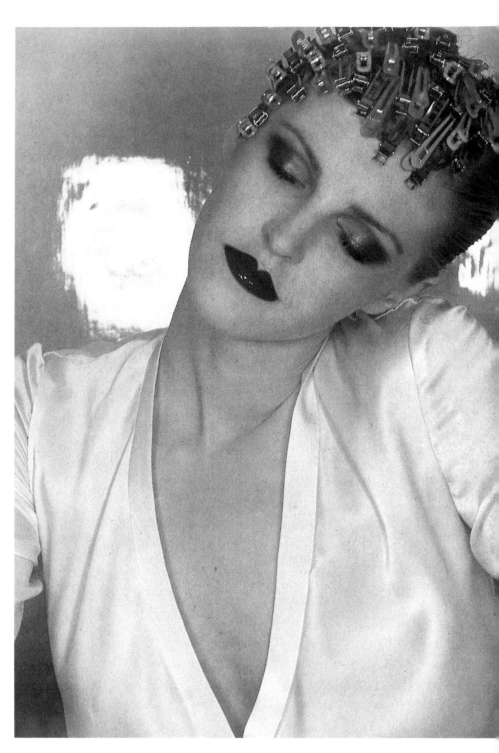

Above
Guy Bourdin
1973

Left
Barry Lategan
1970

153

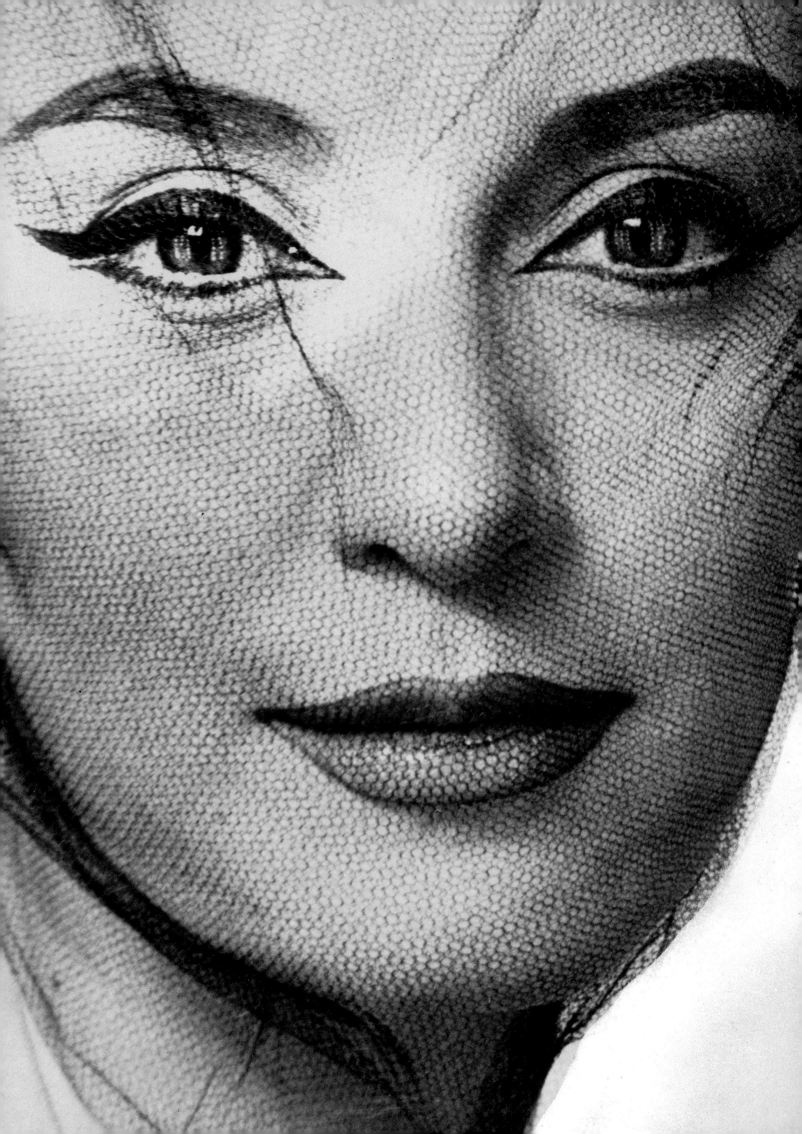

Making faces

'Whatever the look of the moment, the season,
a woman's memories of make-up are an intimate,
timeless fantasy...' Vogue, 1985

'What is the new Beauty', asked Lesley Blanch in *Vogue* in 1938, 'Does it strike a fresh note, or does it echo some past harmony?' Romantic echoes of the past have clearly been part of the beauty photographer's business, as the examples here by Sarah Moon, Deborah Turbeville and Joyce Tenneson testify. David Bailey's wistful portrait of Penelope Tree tellingly contrasts with Arthur Elgort's video monitor image, with its futuristic overtones. Two of Blumenfeld's early photographs from his Paris period show him in slightly more conventional mood than we expect; the air of mystery which a veil provides can be compared with later examples by William Klein and Barry Lategan. 'How seriously I take beauty', proclaimed Blumenfeld, 'All my portraits reflect my vision. The artist lives from variations on a single theme.'

James Laver, the fashion historian, referred to the camera as 'an engine for imposing types of beauty'. Certainly the beauty photographer has imposed – as well as reflected – the changing face of beauty; Horst's dramatic 1967 picture of the ethnic-based make-up recorded a look which, even in the days of flower-power, would have been rare on the streets, but Patrick Demarchelier's recent post-punk portrait is responding to a current – if minority appeal – look.

The most recent picture in this section is Frank Horvat's exquisite and refined colour photograph for Italian *Vogue*. A reportage photographer by natural inclination, Horvat has nevertheless been influential in the fashion field throughout his thirty years on *Vogue*. Perhaps best known for his pioneering use of long lenses on 35mm cameras, it is a genuine pleasure to see this established master use all of his experience to produce a shot which is simply beautiful.

Left
William Klein
1956

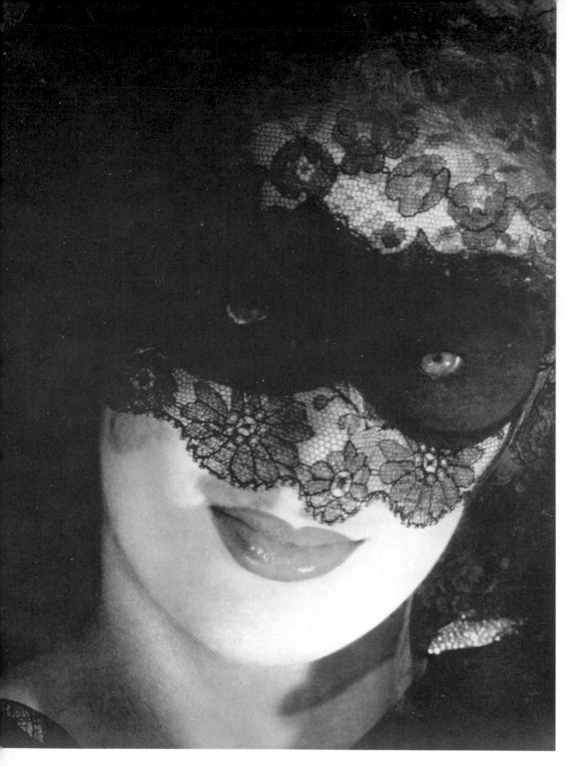

Above
Erwin Blumenfeld
1939

Right
Barry Lategan
1974

Overleaf
Peter Lindbergh
1984

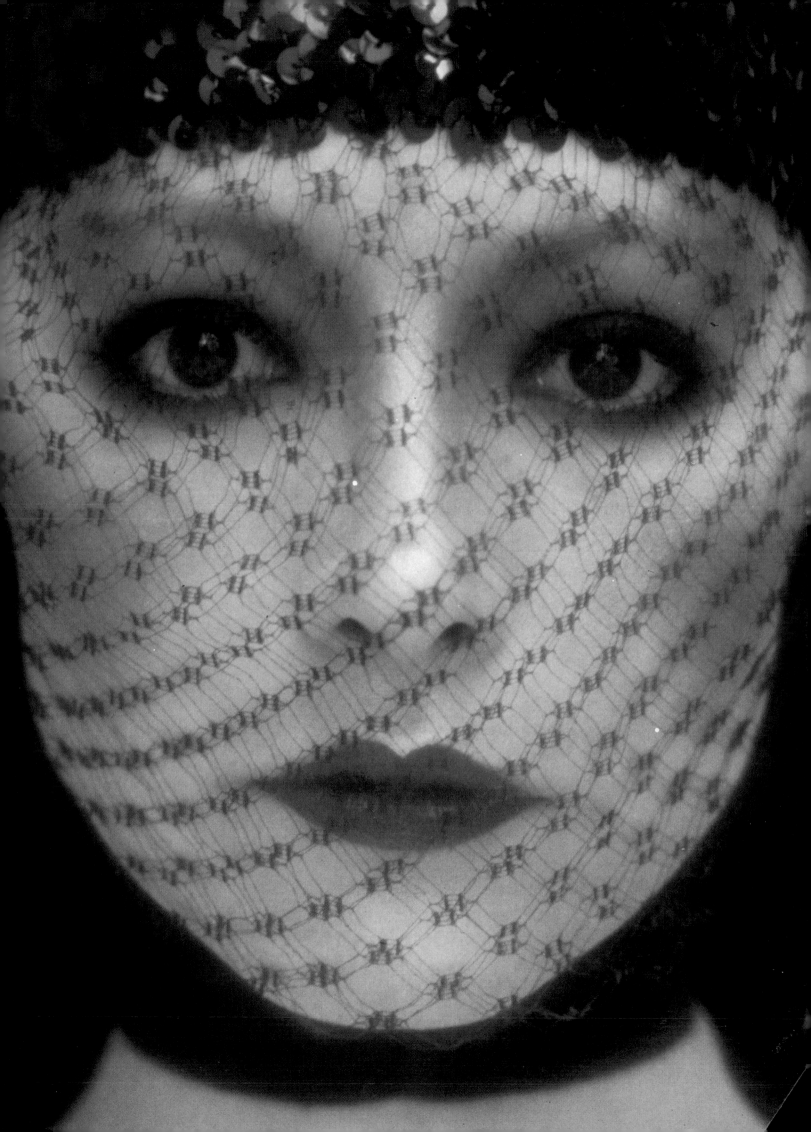

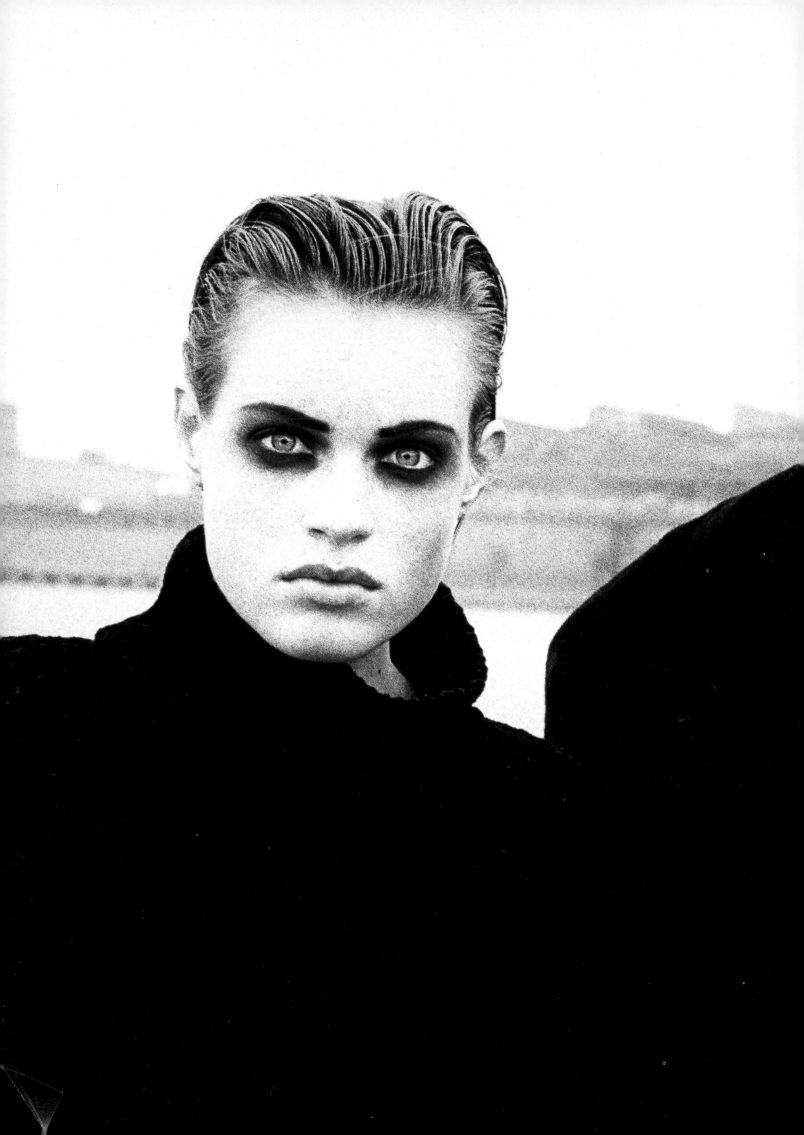

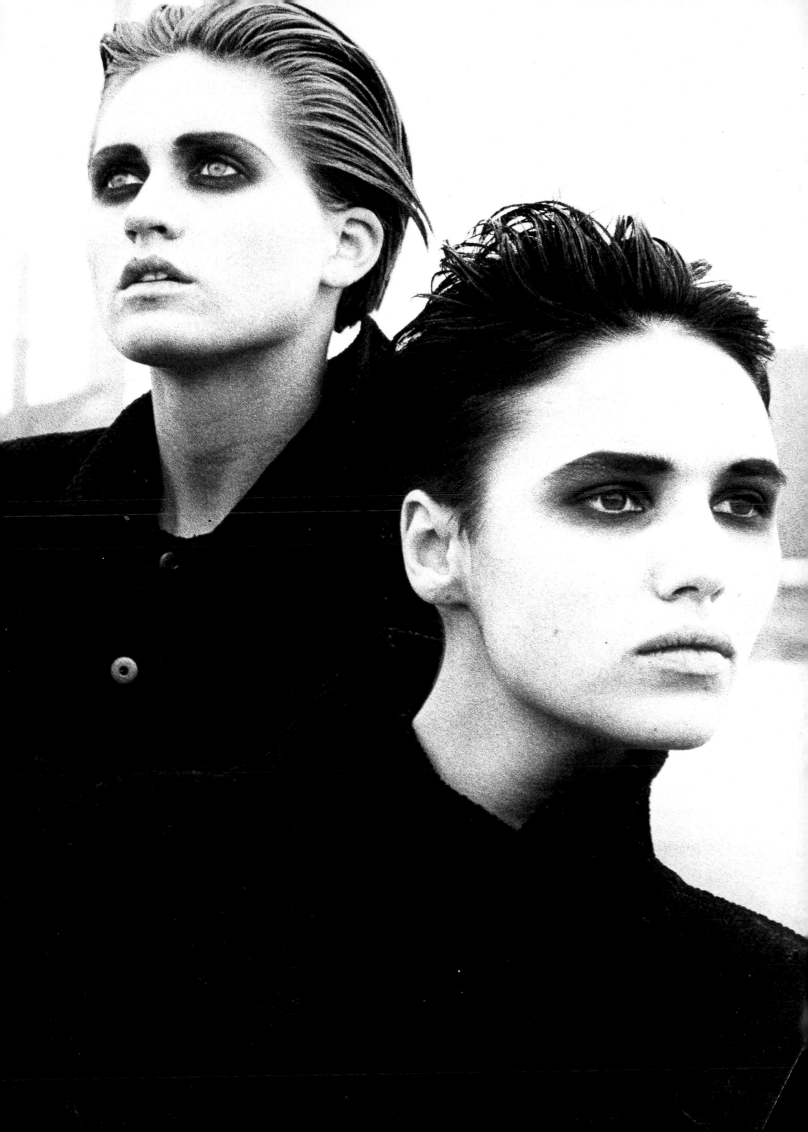

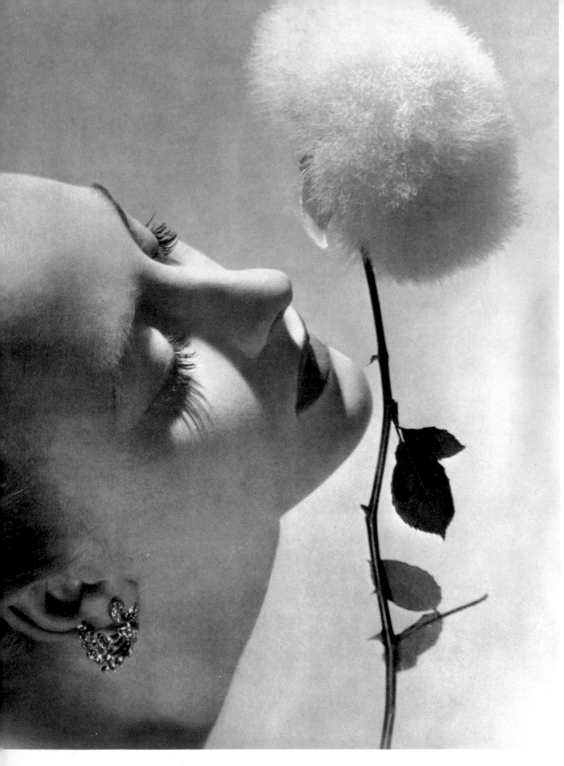

Above
Erwin Blumenfeld
1939

Right
William Klein
1956

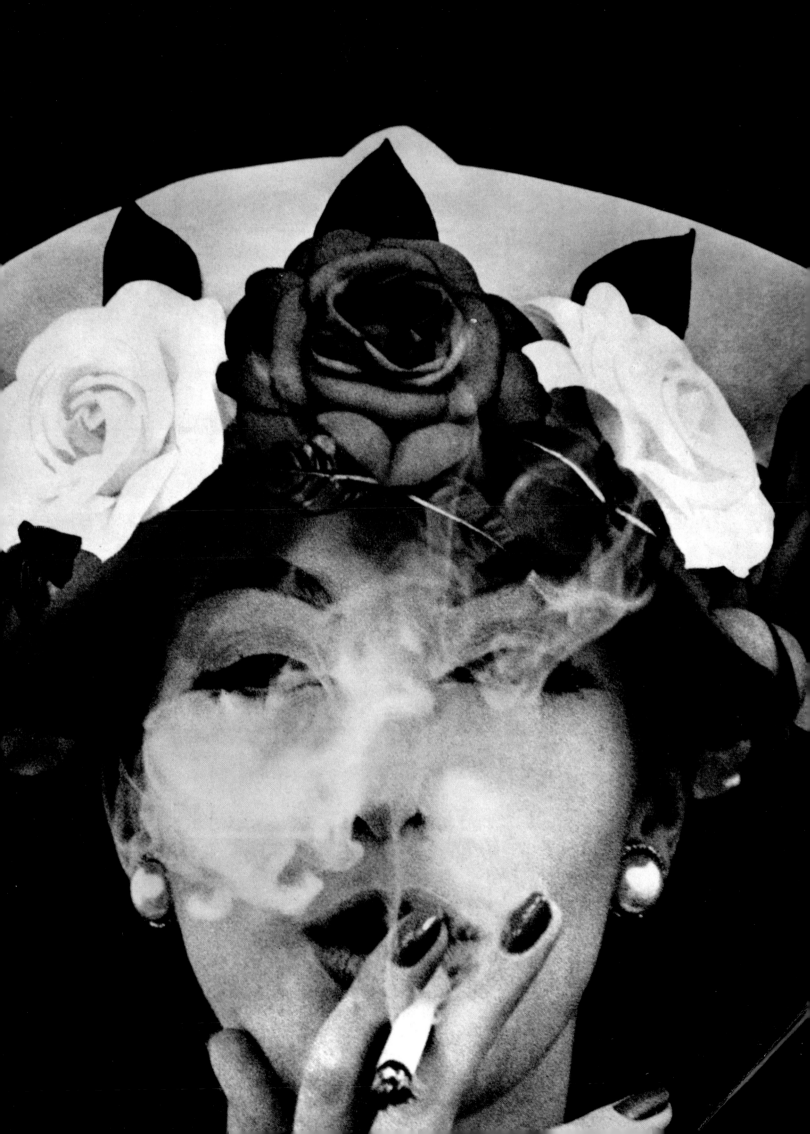

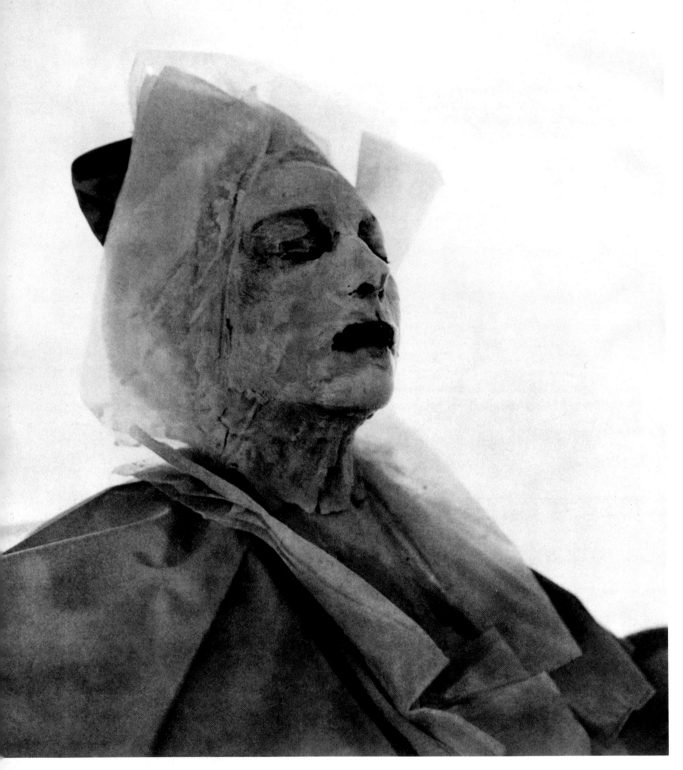

Above
Robert Randall
1951

Right
Clive Arrowsmith
1970

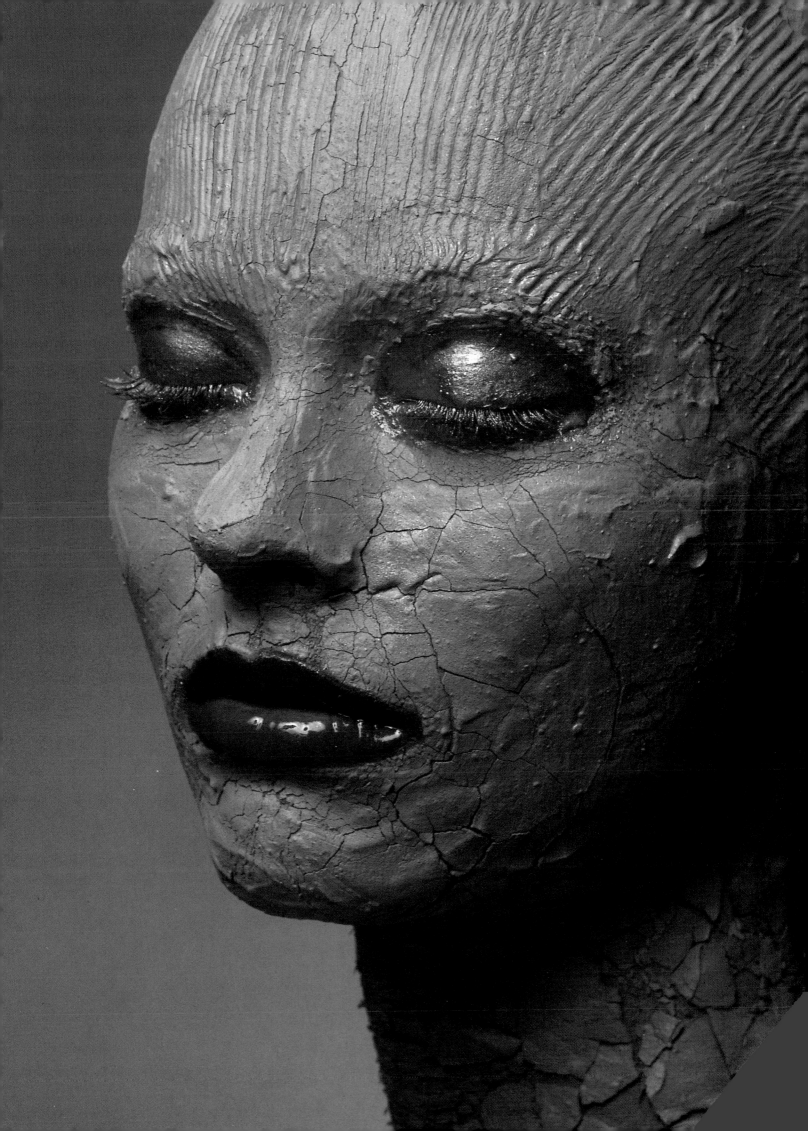

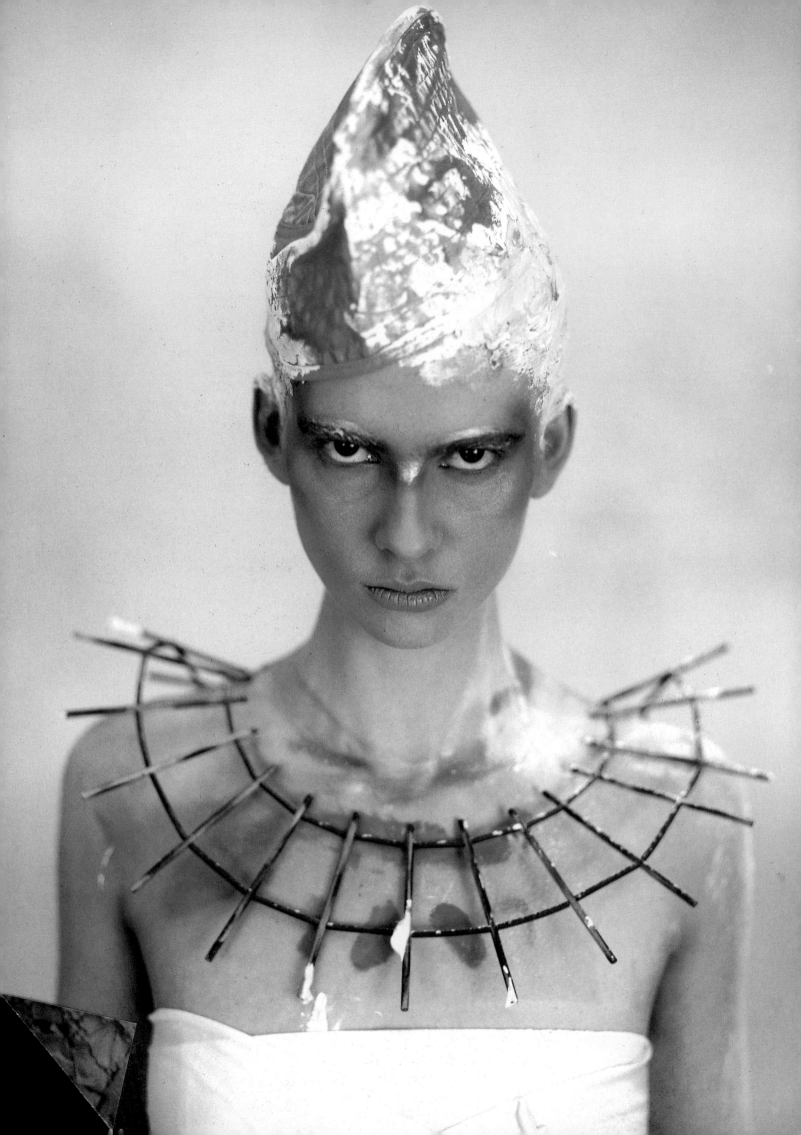

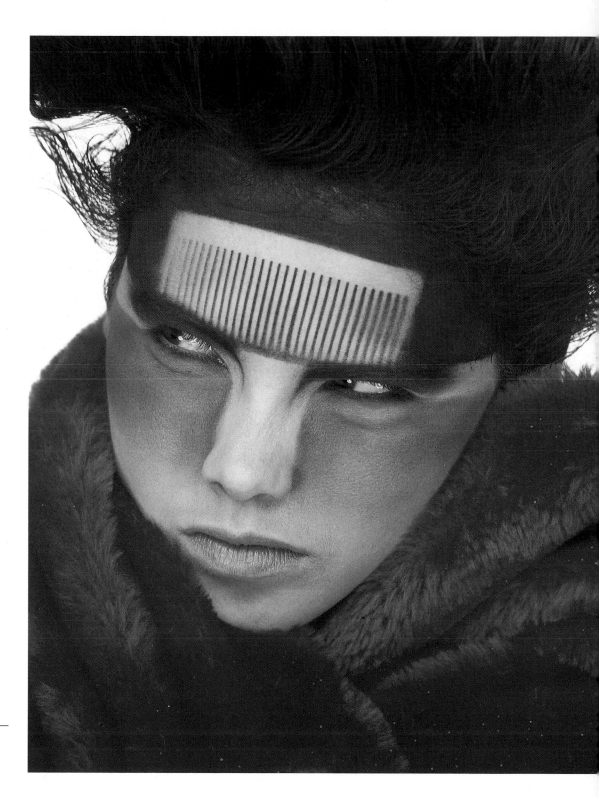

Left
Patrick Demarchelier
1985

Right
Albert Watson
1984

Right
David Bailey
1968

Overleaf
Sarah Moon
1971

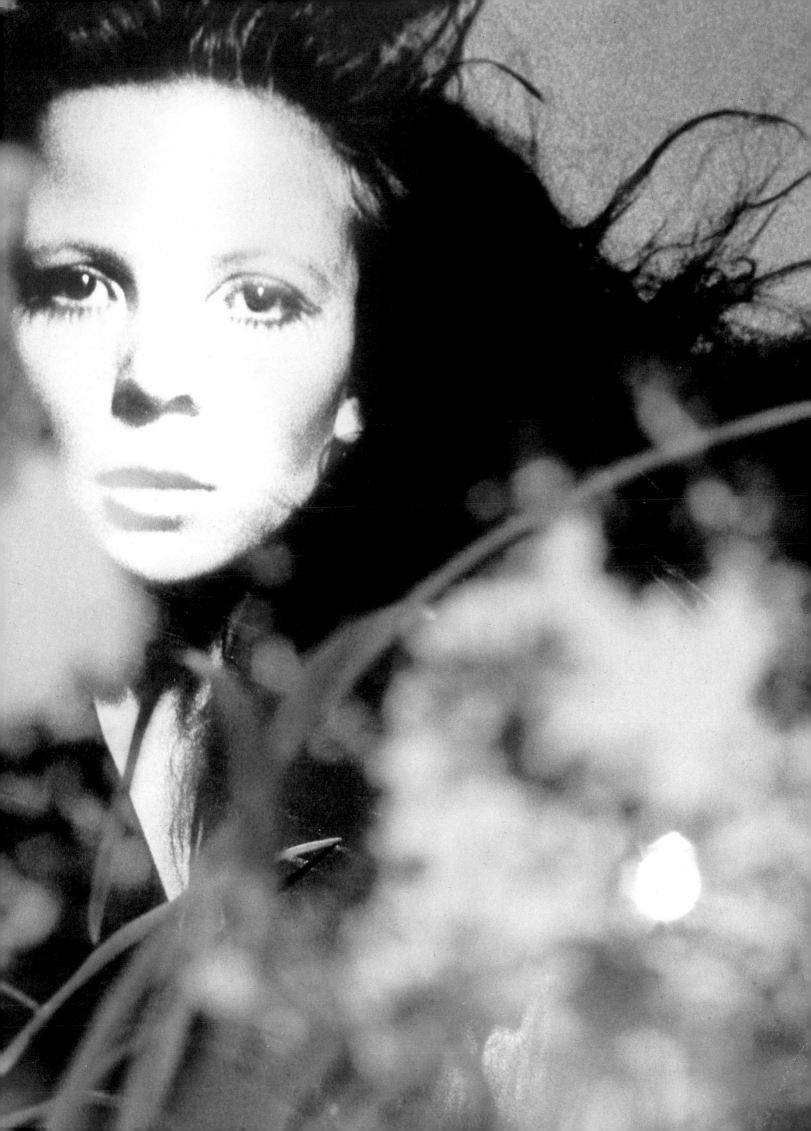

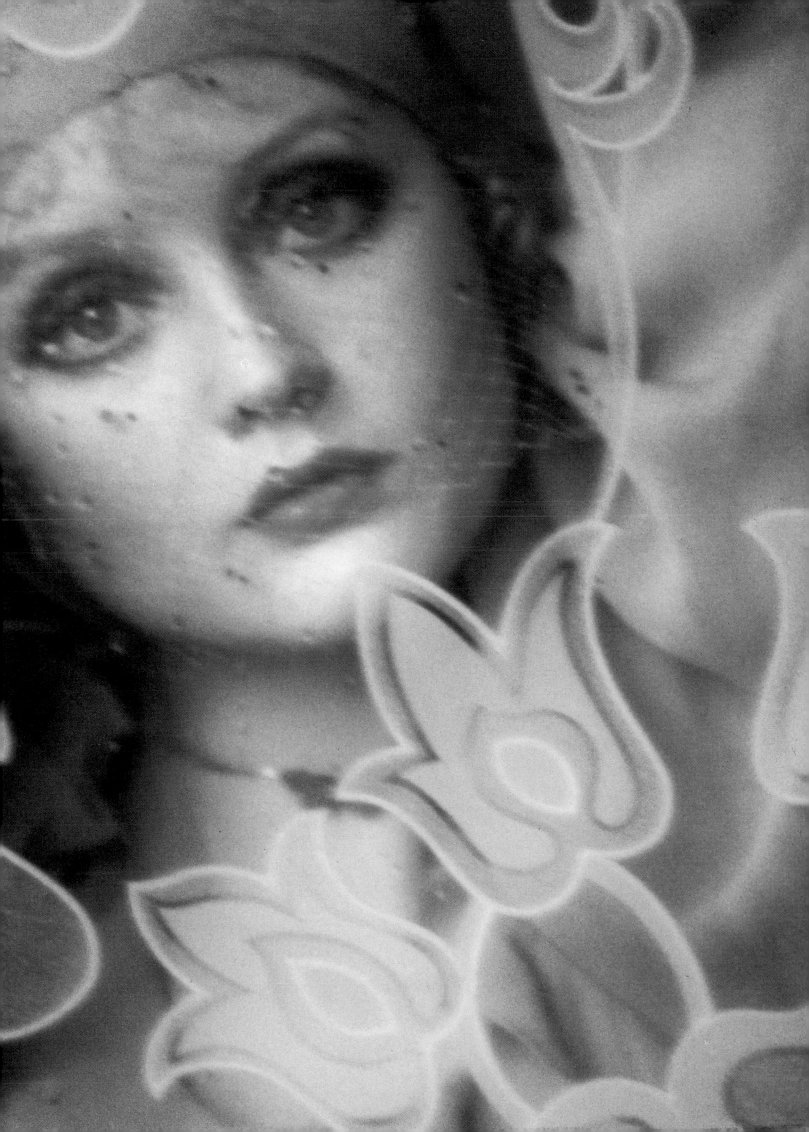

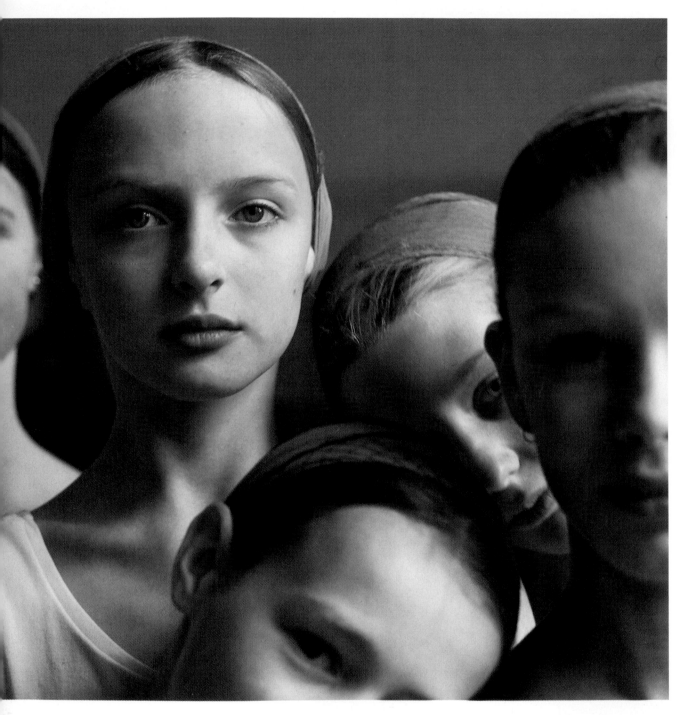

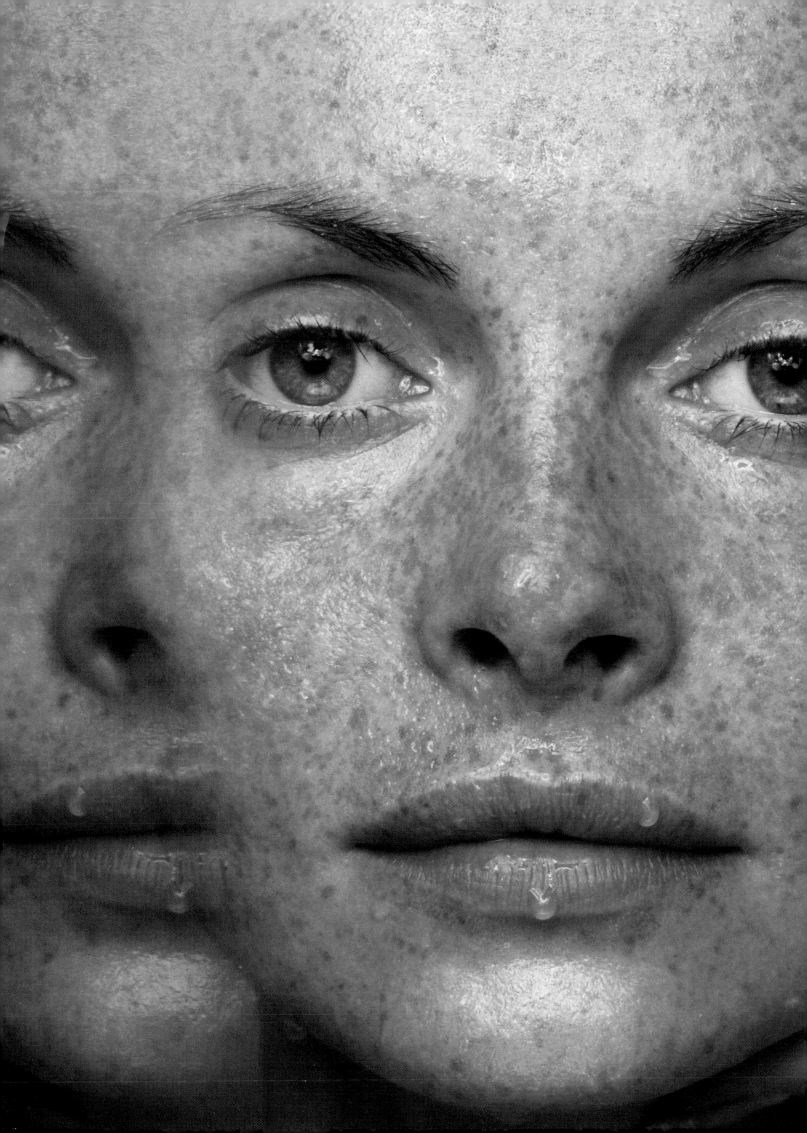

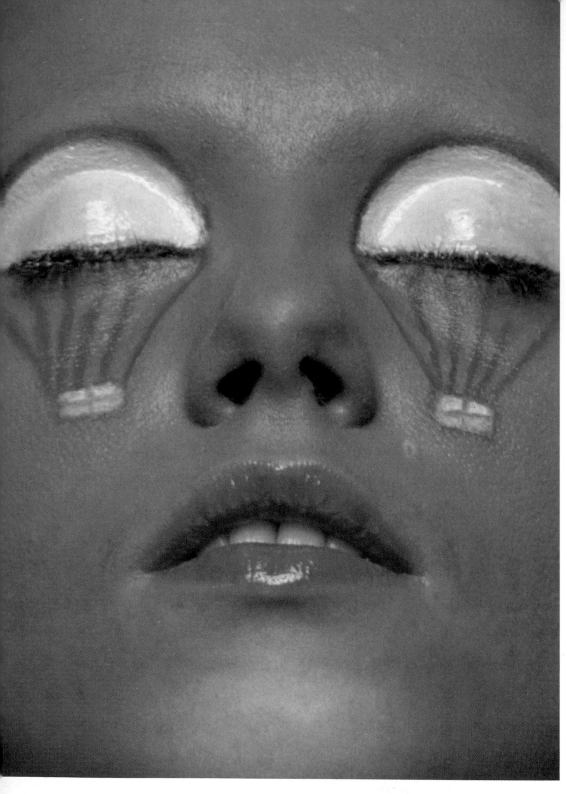

Above
Horst P. Horst
1967

Right
Horst P. Horst
1967

Overleaf
Deborah Turbeville
1987

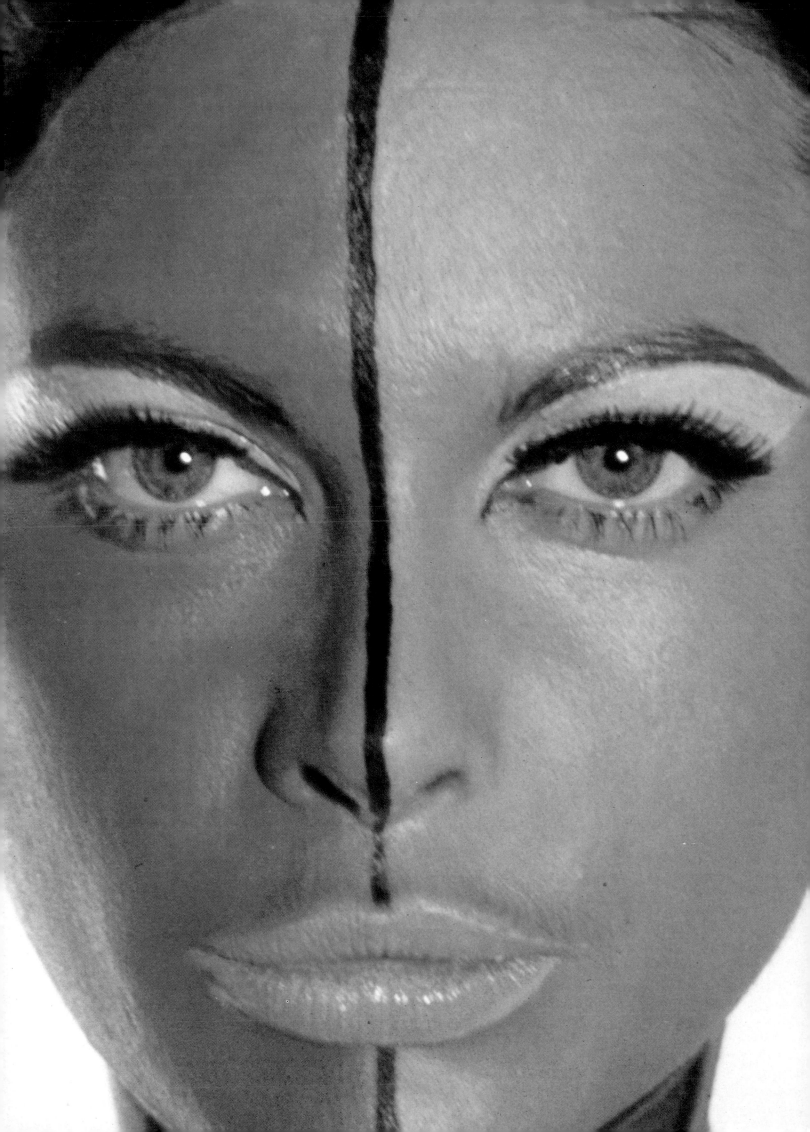

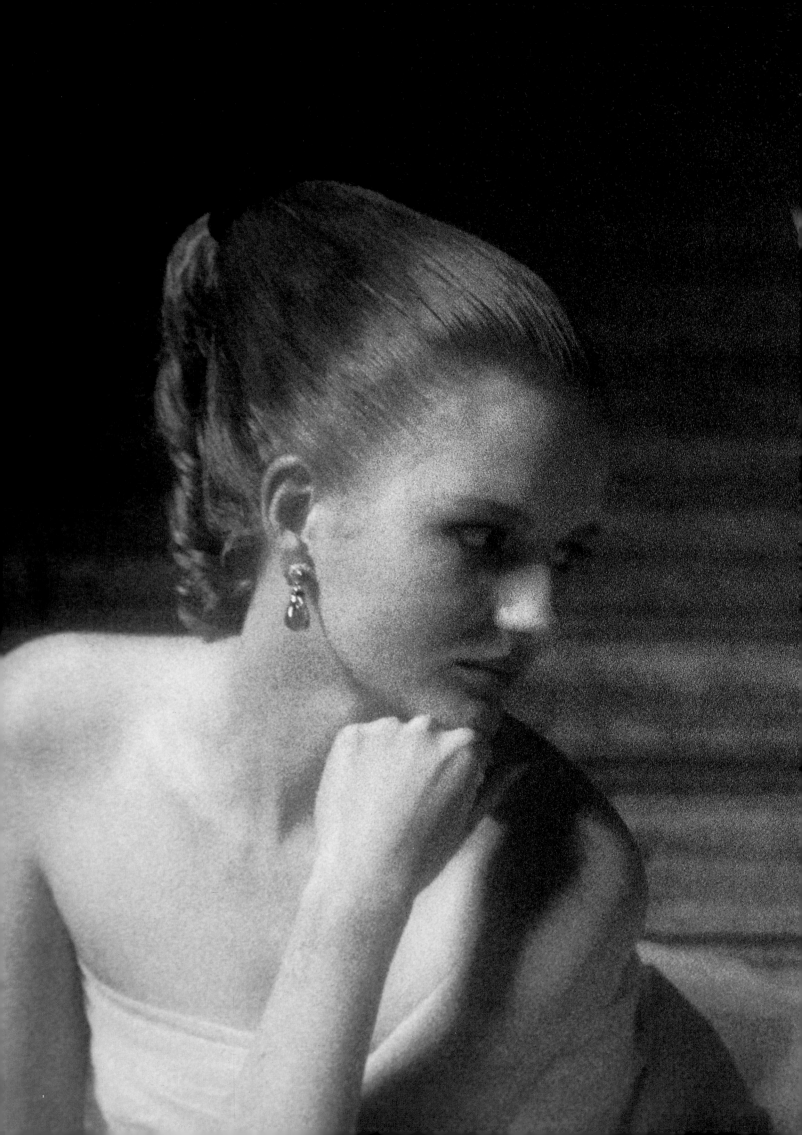

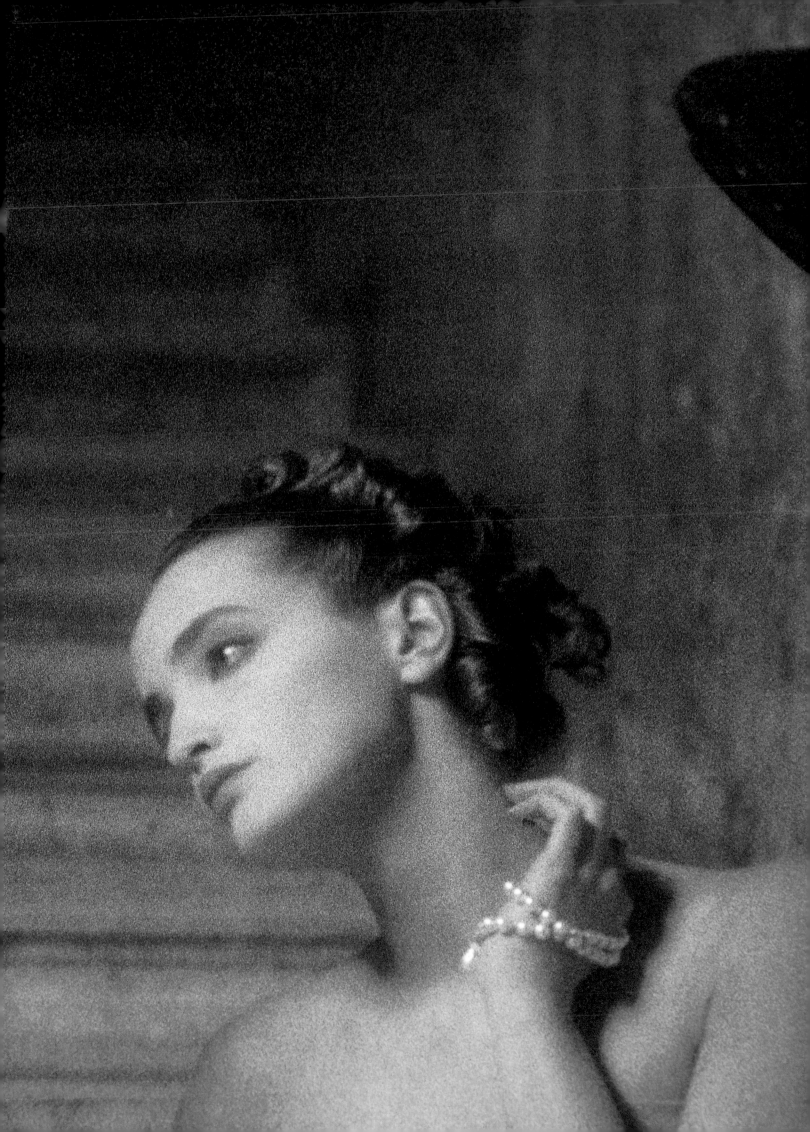

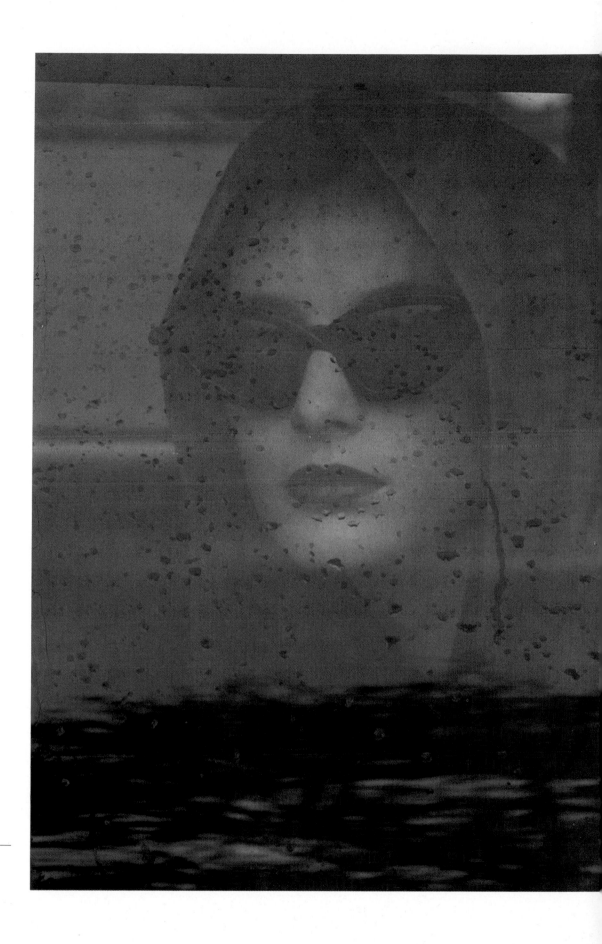

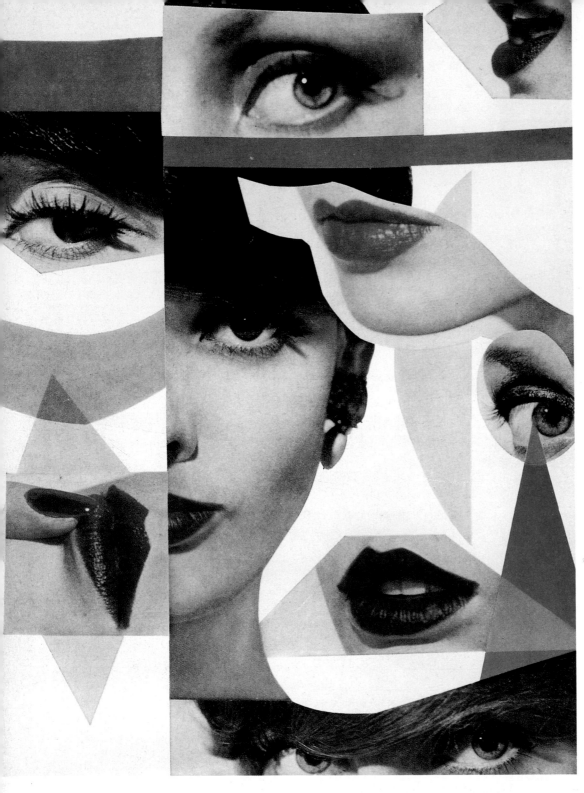

Above
Tom Palumbo
1961

Right
Serge Lutens
1980

Overleaf
David Bailey
1980

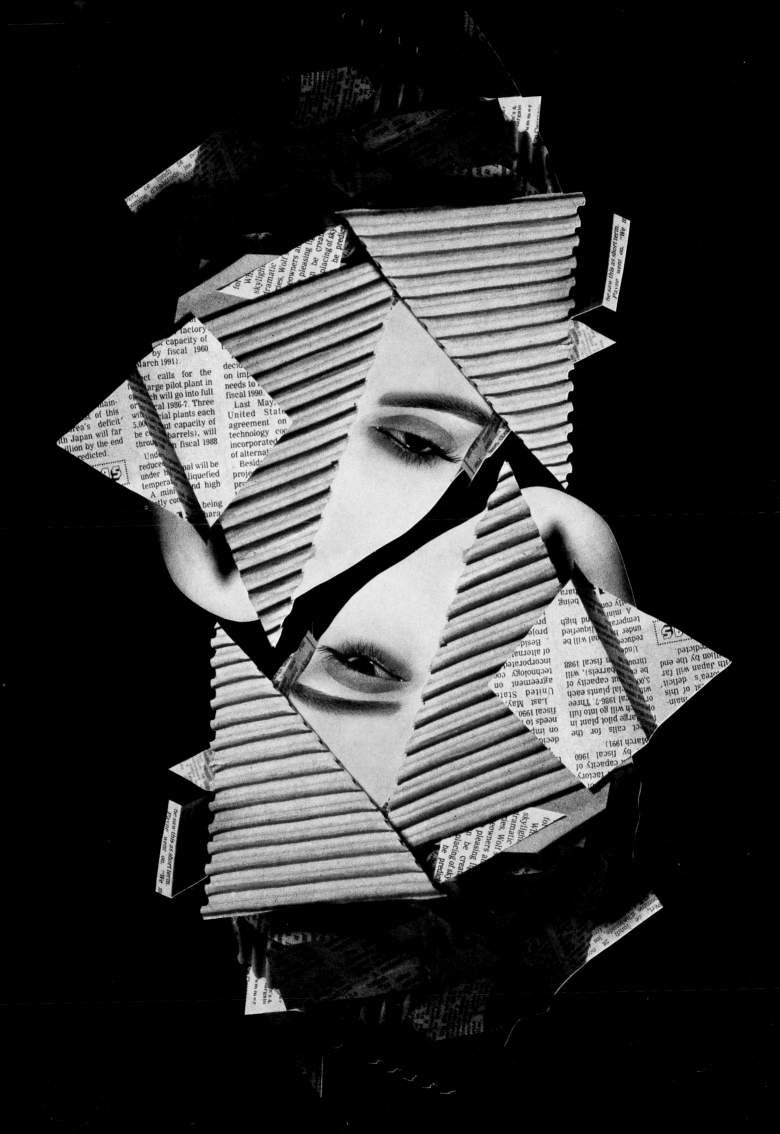

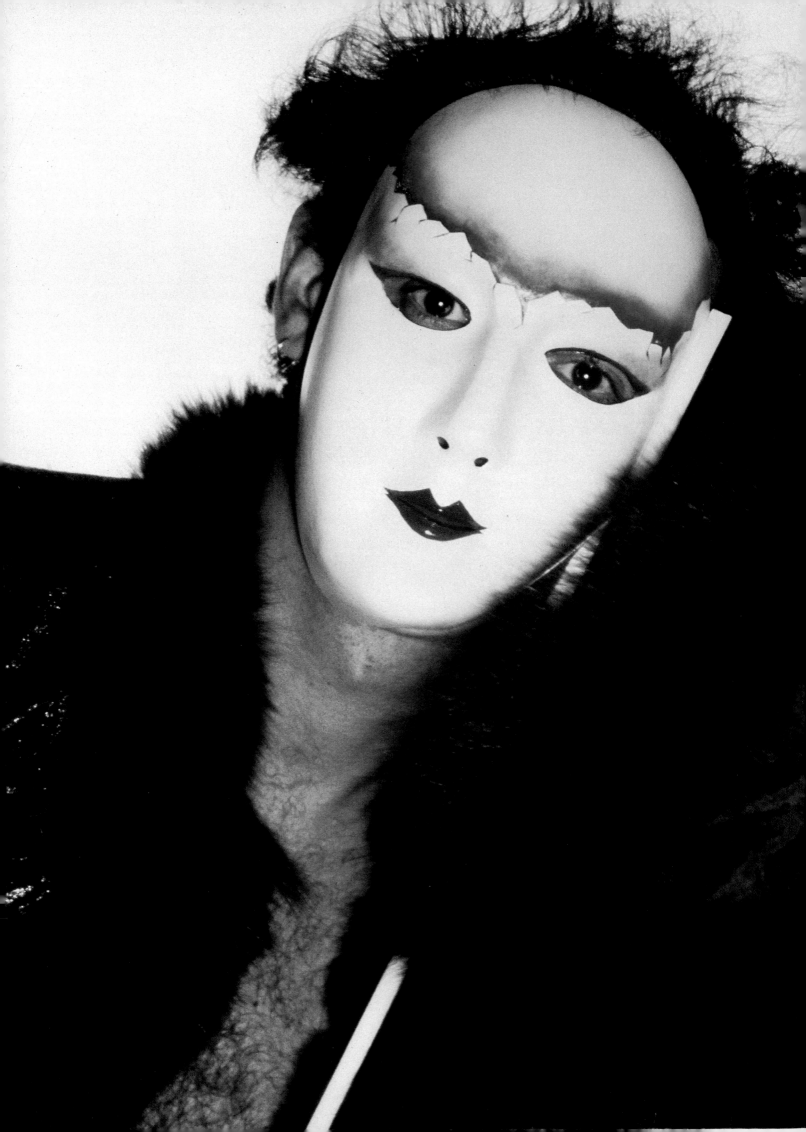

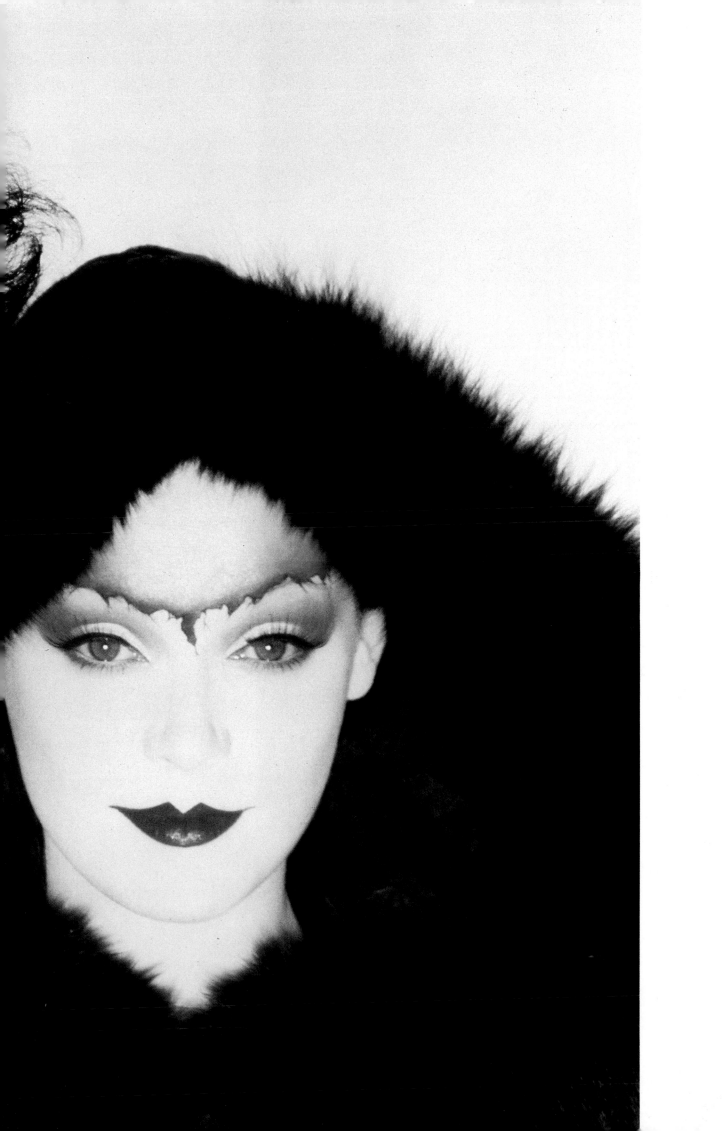

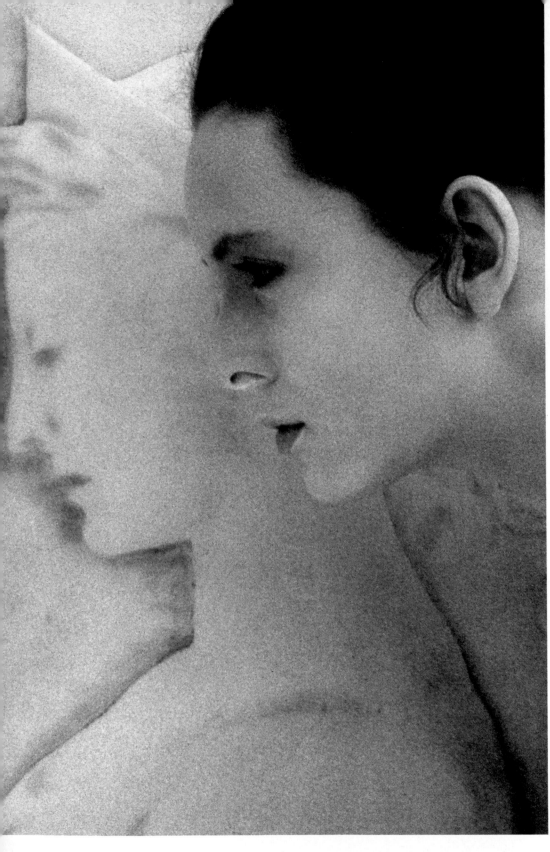

Above
Joyce Tenneson
1986

Right
Paolo Roversi
1984

182

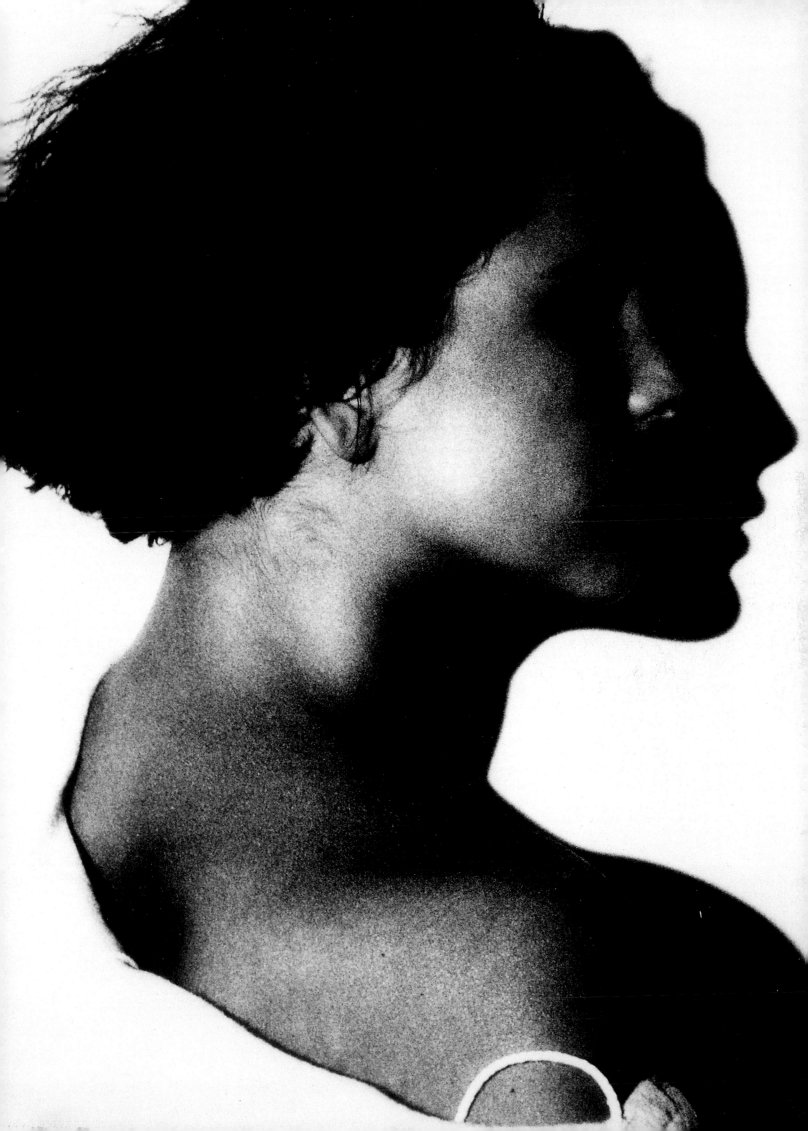

Biographies

CLIVE ARROWSMITH

Born in Wales and educated at Kingston-upon-Thames Art College. During the sixties Arrowsmith worked for Rediffusion as an art director for such programmes as *Ready, Steady, Go* and *This Week*. In 1970 he began his career as a photographer. Since then his work has appeared in a variety of publications in Europe and America including *Queen*, *Cosmopolitan* and *Vogue*.

RICHARD AVEDON

Born 1923. Lives and works in New York. There is general acceptance that Avedon is the greatest of all fashion and beauty photographers; despite this it is clear that he has often used his fashion pictures as a vehicle for his own ideas about society – illustrating dresses, though he does it brilliantly, is incidental. In these instances there is little difference between the aims of an Avedon fashion picture and a portrait. It is Avedon's need to show something more, about cultural values, the sitter's personality as evinced in the way he or she reacts to the camera, that has given his magazine photographs their edge. The son of a Fifth Avenue clothing store owner, Avedon was acquainted with fashion magazines as a child. Mukacsi was his boyhood hero, and Avedon understood well the lesson the older man's pictures taught about movement. Besides four books of portraits Avedon has also published a fashion and beauty retrospective, *Avedon: Photographs 1947–1977*.

DAVID BAILEY

Born 1938. Lives and works in London. It is instructive to recall that Bailey, who was thought to epitomise the more ephemeral aspects of the swinging London photographer of the 'Blow-Up' period, has now been working for the various editions of *Vogue* for twenty-seven years. More than any other photographer, Bailey was respon-sible for pulling British *Vogue* out of the shadow of its American counterpart; in doing so he helped clear the path for many other photographers to make telling contributions via British *Vogue*. Best known for his fashion and portraiture, he has in fact taken a considerable number of remarkable beauty photographs for *Vogue*, recent examples from Italian *Vogue* proving that he has not lost his rebellious streak. He has published eleven books since 1965, including an illustrated record of his 1960s photographs, *Black and White Memories*.

SIR CECIL BEATON

1904–1980. Author, photographer, diarist, artist, designer and decorator, Cecil Beaton shaped twentieth century taste and consciousness as few others could ever hope to. In 1928 the first of his photographs was published in *Vogue*, marking the start of an association with the magazine that would last over fifty years. He contributed portraits, wartime reportage and travel photography but it is likely that he will be best remembered, in this context, for his stylised fashion work of the 1930s. Its atmosphere of cultivated fantasy, studied theatrical posing and conspicuous use of props and artifice borrowed much from the Surrealist and Neo-Romantic movements, and captured the spirit of the times perfectly.

ERWIN BLUMENFELD

1897–1969. Born in Berlin, Blumenfeld emigrated to New York in 1941 and became one of the most influential of the wartime influx of European photographers. His involvement with avant-garde artists in Berlin, and later Amsterdam and Paris, brought to his photographs a breadth and seemingly inexhaustible ingenuity; his background in Dada and Surrealism ensured that his work was consistently unconventional. He had in fact already made startling fashion photographs for French *Vogue* in 1938, and in Paris was also a regular contributor to the surrealist magazine *Verve*. A retrospective book, *My Hundred Best Photos*, was published in 1981.

LESTER BOOKBINDER

Born 1929, New York City. Lives and works in London. Bookbinder trained with the photographer Reuben Samberg in New York, since which time he has become well known for his beauty, fashion and still-lifes. He has contributed to *Glamour* and American *Vogue*. His regular still-life contributions to British *Vogue* in the 1960s were one of the magazine's highspots, and proved very influential. More recently Bookbinder has concentrated on television commercials and, latterly, pop promos.

GUY BOURDIN

Born 1928. Lives and works in Paris. Bourdin's earliest photographs were landscapes shot on a whole plate camera, in the Edward Weston manner. He published these under the pseudonym Edwin Allan. A Paris publisher declined to make a book of these in 1955, but instead introduced Bourdin to French *Vogue*. He had already formed a friendship with Man Ray, which is illuminating in view of the surrealist inspiration for much of Bourdin's later work. The remarkable freedom he is afforded by French *Vogue* has enabled his fashion and beauty photographs to reflect more and more directly Bourdin's private obsessions and fantasies.

ANTON BRUEHL

Born 1900, in Australia to German parents. Bruehl studied as an engineer and moved to the USA to work for the Western Electric Company in 1923, but soon changed careers to take up photography under Clarence White. First worked for *Vogue* in 1926

Richard Avedon *David Bailey* *Cecil Beaton* *Erwin Blumenfeld* *Lester Bookbinder*

and later in collaboration with Fernand Bourges, who had developed a new colour transparency process resulting in engravings of a quality which has, in some ways, never been surpassed.

ALEX CHATELAIN

Born 1941 in France into a distinguished Russian family. He lives and works mainly in New York. Alex Chatelain revealed his leaning towards art at an early age, completing his first mural at eight years old. When his father, a journalist with *Il Figaro*, left for the USA Alex followed and completed his studies at the San Francisco Institute of Art. At first he trained as a fabric designer, before turning to photography and assisting the photographers Hiro, Avedon and Bourdin. From there he worked for American, British and French *Vogue*, *Marie Claire*, *Mademoiselle*, *Glamour* and *Seventeen*. He is equally well-known for his advertising work; among his clients are Revlon, Chanel and Calvin Klein. His work has been shown in exhibitions in Paris and New York at the Museum of Modern Art.

HENRY CLARKE

Born 1919. Lives and works in France. Clarke arrived in New York from his native California in 1948, taking up temporary work in the Condé Nast studios. While there he came into contact with leading photographers Penn and Horst, and this inspired him to take up photography himself. Around 1951 he signed contracts with the American, British and French editions of *Vogue* – much of that decade's portrait and fashion work for *Vogue* appears in the recently published monograph *L'elegance des années 50*. Now works primarily for French *Vogue*.

CLIFFORD COFFIN

1913–1972. Coffin was born in Pasadena,

California and educated at art college and UCLA. Studied photography under George Platt-Lynes (himself a Condé Nast photographer) and worked for a hotel chain, Texaco and MGM before joining American *Vogue* in 1944. Coffin was sent to British *Vogue* in 1946, moving to the Paris studios in 1948. He returned to New York in 1950, where he continued to contribute to *Vogue* and *Glamour* and opened his own studio to undertake an increasing amount of advertising commissions.

BRUCE DAVIDSON

Born 1933. Lives and works in New York. A leading documentary photographer, Bruce Davidson's period of working for *Vogue* was, by his own choice, very brief, lasting from 1960 until 1963. With no knowledge at all of the fashion business he treated *Vogue* sittings as he would a reportage assignment. The results were a great success – fresh and full of movement – but Davidson was never fully reconciled to working in this field: 'the pictures were my pictures, but I felt removed from the world they represented, and at the same time attracted to it. . . . I wasn't sure where I was being taken'. An excellent monograph, *Bruce Davidson Photographs*, was published in 1978.

JOHN DEAKIN

1912–1972. It was in portrait photography that Deakin really excelled, those of the Soho Bohemians of the early 1950s (whose demi-monde Deakin himself inhabited) being among the most penetrating and informative. He was nevertheless – during his short career with British *Vogue* from 1947 to 1955 – quite frequently called upon to photograph fashions and beauty, usually with less happy results than his portraiture. His irreverent attitude to photography resulted in many of his original prints being destroyed, but enough survived to enable a

retrospective exhibition to be mounted at the Victoria & Albert Museum, London, in 1985, and a book of Deakin's work for *Vogue* is currently in preparation.

PATRICK DEMARCHELIER

Born 1943. Lives and works in New York. One of the most sought after and consistently commissioned fashion and beauty photographers of the 1980s, Demarchelier is equally accomplished in other fields. His commercial clients include Revlon, Fabergè, Lancôme, Ralph Lauren and Calvin Klein while his cinema publicity campaigns include *A Chorus Line* and *Ishtar*. He has featured in the Universal Pictures documentary *Portfolio* (1985) and recently *Photo* magazine in France honoured him with a twelve page portfolio of his favourite photographs. His work has appeared in most of the leading fashion magazines, both in Europe and America, including *Vogue* (British, American, French and Italian), *Harper's Bazaar*, *GQ*, *Glamour* and *Mademoiselle*.

BARON DE MEYER

1868–1949. Moved from Paris to London in 1895 and acquired a reputation as premier amateur photographer of royal and artistic circles. A founder of the Photo-Secessionist movement in Vienna, de Meyer widened his audience through exhibitions at the Linked Ring in London, '291' gallery in New York and publication in Steiglitz' influential photogravure magazine *Camerawork*. Upon arrival in New York in 1914, he was hired by Condé Nast as the company's first ever staff photographer, contributing notable celebrity portraits to *Vanity Fair* and dominating American *Vogue* with his fashion and still life photography. He moved to *Harper's Bazaar* in 1922, but the flattering, soft-focus style gradually became outmoded and he was sacked in 1934.

Guy Bourdin *Anton Bruehl* *Clifford Coffin* *John Deakin* *Baron de Meyer*

TERENCE DONOVAN

Born 1937. Lives and works in London. Donovan, like David Bailey, 'emerged from John French's darkroom to cause such a stir in the 1960s' as Cecil Beaton put it. He was always more diverse in his operations than Bailey, shooting a lot of advertisements, men's fashions, commercials and ultimately feature films. A dedicated technician, he brings wit and a sharp intelligence to all his spheres of activity. A somewhat retiring character outside his profession, Donovan waited a long time before publishing a collection of his photographs, *Glances*, which appeared in 1983.

BRIAN DUFFY

Born 1934. Lives and works in London. Duffy, the third member of the so-called 'Terrible Three' along with Bailey and Donovan, was in fact the first of the group to work for British *Vogue*, having started on the magazine in 1958. Duffy favoured the *en plein air* approach and his pictures tended to be lively and informal. Cecil Beaton noted that the apparent influence of Foule Elia's photographs on Duffy's work, perhaps because Duffy's style was so well adapted to *Elle* magazine in the sixties, where Elia was well established. Increasingly preoccupied with television commercials and other activities, Duffy has drifted away from still photography in recent years.

ARTHUR ELGORT

Born 1940. Lives and works in New York. Elgort's original ambition was to be a ballet photographer, and his continued interest in ballet has proved a key influence on his fashion and beauty photographs. In fact he trained first with advertising photographer Carl Fischer and subsequently with fashion specialist Gosta Peterson. Peterson's casual approach to fashion shoots encouraged Elgort to adopt an informal/realist style in

his own work. This caused a revolutionary impact when he began to work for British *Vogue* in 1971, and before long he was a leading photographer at American *Vogue*. Alexander Liberman described Elgort's 1976 picture of Lisa Taylor as 'an extraordinary breakaway for traditional beauty photographs – a woman caught as if unobserved by the camera at a moment of intense personal involvement'. Some of Elgort's best work is included in a privately printed monograph, *Arthur Elgort: Personal Fashion Pictures*, published in 1983.

HANS FEURER

Born 1939. Lives and works from Switzerland. Feurer is another photographer who brought an art director's thinking to his photographs, which always possess immediacy and graphic economy. He first came to prominence on the new (and now defunct) magazine *Nova* in 1967 and has worked for *Vogue* since 1968. He has adapted his style to respond to changing trends but his pictures continue to retain their bold, sexy appeal.

TONI FRISSELL

Born 1907. Most of Frissell's fashion and beauty photographs for *Vogue* were made in a short period from 1934 until 1940, and after the war she worked occasionally for *Harper's Bazaar*. Although not the first woman photographer in this field she was undoubtedly the first to achieve real prominence and helped to pave the way for others. Very much a woman of action herself, her photographs consistently preached the advantages of a healthy active lifestyle, bringing a convincing air of realism to the pages of *Vogue*. Her documentary approach enabled her to work successfully for magazines such as *Life*, *Look* and *Sports Illustrated*, and she produced a film and book on life at the King Ranch, Texas.

PIERO GEMELLI

Born 1952 in Rome, Piero Gemelli trained as an architect before turning to professional photography in 1978. He specialises in advertising and still-life. In 1982 he settled in Milan, where he has contributed to Italian *Vogue*, German *Vogue*, *Vanity* and *Vogue Bellezza*, as well as continuing his advertising work.

ARNOLD GENTHE

1869–1942. Born in Berlin, Genthe emigrated to the United States in 1896. In 1911 Genthe became a freelance magazine photographer, specialising in dance and theatrical portraits, with a studio on Fifth Avenue, New York. His portraits appeared regularly in *Vanity Fair* from 1915 to 1926, and he occasionally supplied fashion and beauty photographs to *Vogue* and other magazines. He worked in a wide range of styles, from a soft-focus romanticism to sharply detailed modernism. No monograph on Genthe has been published so far.

MARCO GLAVIANO

Lives and works in New York. As a young man, obsessed with jazz, Sicilian-born Marco Glaviano emigrated to the USA in search of an opening in music. He toured with several other professional musicians and began to photograph as a hobby, never intending to take it up full-time. He worked for several years as an editor at *Rizzoli* before contributing photographs in his distinctive style to Italian *Vogue*.

HANS HAMMARSKIÖLD

Born 1926. Swedish-born Hammarskiöld became a professional photographer in 1948. After winning the prestigious annual Swedish Photographic Award in 1952, he spent some time in New York, meeting various prominent American photographers of the time.

Terence Donovan *Arthur Elgort* *Hans Feurer* *Toni Frissell* *George Hoyningen-Huené*

In 1954 he was joint winner in British *Vogue*'s photographic contest and for the rest of the decade regularly contributed fashion, beauty and still-life shots.

PAUL HIMMEL
Born 1914. Lives and works in New York. Although he gave up photography to practise psychotherapy in the 1960s, Paul Himmel has left some fascinating evidence of his experiments into recording movement in photography, though sadly little of his original material survives. Married to fashion photographer Lillian Bassman, he was a protegé of art director Alexey Brodovitch, and in 1954 published an intriguing book under Brodovitch's influence, *Ballet in Action*. His work was also represented in Steichen's *Family of Man* exhibition in 1955.

HIRO
Born 1930. Lives and works in New York. One of the few Japanese photographers to achieve international prominence in the world of fashion, Hiro emigrated to New York in 1953. He became assistant to Richard Avedon in 1956 and in 1958 art director Alexey Brodovitch commissioned Hiro's first still-life for *Harper's Bazaar*. The complete photographic technician, Hiro's talents were ideally suited to make him the leading modernist fashion and beauty photographer of the sixties. His powerful colour close-ups remain beauty classics. In 1982 he switched to *Vogue*, enlivening the magazine with some eye-catchingly surreal beauty pictures.

HORST P. HORST
Born 1906, East Germany. The most telling periods of Horst's education were his studies in Hamburg at Walter Gropius's Kunstgewerbeschule and his short spell at Le Corbusier's studio in Paris. This back-ground in architecture and design certainly appears to have helped Horst's fashion and beauty photographs infallibly achieve a great compositional rigour and clarity. Having arrived in Paris in 1930 Horst was befriended by Hoyningen-Huené and modelled occasionally for the senior man. By 1931 Horst was himself a *Vogue* photographer, at the start of a long and distinguished career. His long-time friend Valentine Lawford wrote a lavishly illustrated biography of Horst in 1984.

FRANK HORVAT
Born 1928 in Italy, but now working from Paris, Frank Horvat studied painting in Milan before taking up photography. He first achieved recognition as a reportage photographer and only later for his fashion work. He is well known for his innovative use of the 35mm camera which gave his fashion shots more spontaneity, a successful experiment he first carried out towards the end of the 1950s. He has worked for most of Europe's leading fashion magazines.

GEORGE HOYNINGEN-HUENE
1900–1968. Huené was born in St Petersburg, the son of a Baltic baron and an American mother. He moved to Paris in the 1920s, where he studied under the cubist painter André Lhote and became a fashion illustrator in the art deco style. In 1926 he began a nine-year stint photographing for *Vogue*, quickly establishing himself as a master of a cool, refined approach which was a fusion of modernistic and neo-classical elements. From 1935 he worked for *Harper's Bazaar*, until retiring from professional photography in 1945. Between 1938 and 1946 he published five books of photographs, of which the most significant is *Hellas, a Tribute to Classical Greece*, and in 1986 was the subject of a major monograph by William A Ewing.

JUST JAECKIN
Just Jaeckin worked almost exclusively for British *Vogue* in the sixties, when he emerged as a highly successful and versatile photographer. Apart from his fashion work, which is characterised by a lively, spontaneous style, Jaeckin also shot personalities, beauty features and covers for the magazine.

ART KANE
Born 1925. Having taken a degree at the Cooper Union School of Art, New York, Kane became, aged twenty-seven, the art director of *Seventeen* magazine. He left in 1959 to devote all of his time to photography. As such he was one of the first to bring to magazine photography what might be termed the art director approach, producing images which were directly tailored towards maximum graphic impact on the page. To achieve these ends he took William Klein's experiments with long and short-focus lenses even further, using focal lengths as short as 21 mm or as long as 2000 mm. After a long absence from *Vogue* his work can be found again in the Italian edition since 1983.

TONY KENT
Born 1941 in New York. Now lives and works in Los Angeles. Tony Kent worked as an actor in Paris before taking to photography in 1965, specialising in portraiture. Turning professional, he worked for French *Vogue* and *Marie Claire* and later American and Italian *Vogue*.

BILL KING
A former painter, American-born Bill King began his photographic career in the sixties, when he photographed the French collections in Paris. Since 1965, he has contributed fashion, beauty, personality and cover shots to a variety of major publications including *Harper's Bazaar*, *Elle*,

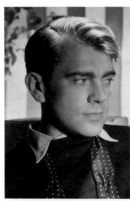

Horst P. Horst *Neil Kirk* *William Klein* *Barry Lategan* *Peter Lindbergh*

Cosmopolitan, *Tatler*, and the American and British editions of *Vogue*. He lives and works in New York.

NEIL KIRK

Born 1950. Lives and works mainly in London and New York. After film school and art college, Neil Kirk quickly established himself in the forefront of modern fashion photography. His advertising clients include many of the major fashion houses, while his fashion and beauty work has appeared in *Vogue Bambini*, *L'Uomo Vogue*, British and German *Vogue*.

WILLIAM KLEIN

Born 1928. The fashion and beauty photographs that William Klein took for *Vogue* between 1955 and 1967 were the single most important factor for change in the magazine's post-war history. His background in painting and graphic design, and lack of formal photographic training, left him with no inhibitions about camera technique. Consequently he felt free to exploit what were, on *Vogue*, radical innovations, such as the use of wide-angle and long-focus lenses, devices he utilised cleverly to create images of great impact and modernity. The books he published while contracted to *Vogue* were photo-documentary, not fashion, and the volumes on New York, Rome, Moscow and Tokyo have become important milestones in recent photographic history. Concurrently with working for *Vogue*, Klein was developing an interest in film-making, and in 1967 gave up photography to concentrate on films. After a long absence he has recently returned to fashion and advertising photography, still based in Paris, where he has lived since 1948.

BARRY LATEGAN

Born 1935. Lategan, who began working for *Vogue* in 1968, represented the second wave of sixties photographers. He is a quietly serious worker, dedicated to the highest technical quality of lighting and tonal gradation. His skills were especially in demand for beauty photographs and he excelled in this area for *Vogue* in the 1970s. More recently he has devoted an increasing amount of his time to directing television commercials — many of these for beauty products too. Currently he is compiling two books, a fashion and beauty retrospective and a volume of nudes.

PETER LINDBERGH

Born 1944. Lives and works in Paris. One of the most consistently exciting of today's fashion and beauty photographers, Lindbergh first worked as an advertising photographer on leaving art school in Germany. Since 1980 he has taken many of his best pictures for *Vogue*. Although his work has something in common with his fellow Germans, Helmut Newton and Chris Von Wangenheim, much of Lindbergh's inspiration comes from films, from sources as far apart as Fritz Lang's *Metropolis* and Jim Jarmusch's *Stranger Than Paradise*. In his preoccupation with establishing a narrative thread to his magazine spreads Peter Lindbergh is a stylistic inheritor of the tradition developed in the sixties by photographers such as Bob Richardson.

SERGE LUTENS

Born 1942. Lives and works in Paris. Lutens has worked in a wide range of media: between 1956 and 1968 he was involved in theatre and costume design, make-up and hairdressing, sculpture, jewellery, photography and films. In 1968, before turning to photography on a full-time basis, Lutens worked as a make-up artist in conjunction with Dior and created some of the most distinctive looks to appear in *Vogue* beauty photographs.

BARRY McKINLEY

Born 1943. Lives and works in New York. Born in New Zealand, Barry McKinley arrived in New York in 1972 by way of Italy, Paris and London. Since 1982 he has been a prolific beauty and fashion photographer for Italian *Vogue*.

FRANCES McLAUGHLIN-GILL

Born in 1919. Lives and works in New York. Born in New York but raised in Connecticut, Frances McLaughlin returned to her native city in 1941 to attend the Art School of the Pratt Institute, where she studied photography under Walter Civardi. Became a photographer with *Vogue* in 1943, remaining on staff until 1954, since when she has continued to freelance for *Vogue* and many other magazines. Since 1964 has also diversified into directing films and commercials. In 1948 she married the brilliant still-life and portrait photographer Leslie Gill, adding his surname to her own. Her work has a joyous, filmic quality and is characterised by a spontaneous naturalism which was particularltly effective in her beauty photography. Frances McLaughlin-Gill currently teaches photography at the New York School of Visual Arts and has been a prolific author.

BUTCH MARTIN

Born 1946. With degrees in Mass Communications and in Speech and Drama, Martin turned successfully to photography. He is probably best known for his fashion and beauty work for British *Vogue*.

HERBERT MATTER

Born in Switzerland 1907. Matter first studied as a painter, and in fact continued to divide his time between photography, design and graphics. He was a staff photographer for New York *Vogue* from 1946 until 1957. His combinations of photogra-

Serge Lutens *Frances McLaughlin-Gill* *Helmut Newton* *Norman Parkinson* *Irving Penn*

phy and graphics found less favour in New York than in Europe, but although he did not have the opportunity to apply these techniques to beauty photography it is his more unconventional work in this vein that has the most appeal today.

STEVEN MEISEL

American. Lives and works in New York. One of the newest star photographers for *Vogue* in both Italy and America, Meisel served, as it were, his apprenticeship on Italian *Vogue*'s junior magazine, *Lei*. Here he developed aggressive action fashion and beauty pictures which nevertheless preserve enough chic to be suitable for *Vogue*.

SHEILA METZNER

Born 1939. Lives and works in New York. The understated, poetic colour photographs Sheila Metzner makes for *Vogue* are splendid examples of the renewed contribution female sensibilities are bringing to fashion and beauty photography. Her home, with its collection of art nouveau and art deco objects, forms the backdrop for most of her pictures, which doubtless helps her achieve the air of ease and tranquility which characterises her photographs. A book of Metzner's work, *Objects of Desire*, was published in 1986.

GJON MILI

1904–1984. Emigrated from Albania to USA 1923, subsequently naturalised. Mili's background was in the field of electrical engineering, and from 1928 to 1938 he worked with the well known lighting research engineer, Harold E Edgerton. As a photographer for *Life*, *Vogue* and many other magazines since 1939 he specialised in applications of the high-speed photographic techniques he had developed with Edgerton. He published two books of photographs of Picasso; among films he has

made, besides a *Homage to Picasso* were others on Pablo Casals, Salvador Dali and Raoul Dufy.

SARAH MOON

Born 1940. Despite her name Sarah Moon is French, though she was educated in England. A former model, she took up photography in 1968, achieving instant success with her fin-de-siècle inspired romanticism which accurately captured the mood of the time. The grainy quality of her images too recalled the diffuse surface tones on photo-Secessionist pictures and the early colour process Autochrome. Allied to this were her considerable compositional skills and ability to direct her models to achieve the reticent mood she sought. She has worked for the various European editions of *Vogue* since 1970 and a monograph concentrating on her fashion and beauty work, called *Souvenirs Improbables* was published in 1981.

ARIK NEPO

Born c.1912. Died 1961. Russian, real name Arik Nepkoishisky. Nepo's parents moved to France when he was five, fleeing the Russian Revolution. He studied at a school of photography in Paris and became second assistant to the film director René Clair. He joined French *Vogue* in 1933, where he is especially remembered for his wide technical knowledge. This he developed further after emigrating to the USA in 1948, where he studied new printing and engraving methods. Nepo continued to work occasionally for American *Vogue*.

HELMUT NEWTON

Born 1920. Apprenticed to the fashion and theatre photographer Yva in his native Berlin from 1936, Newton emigrated to Australia in 1940, becoming an Australian citizen. His earliest *Vogue* pictures were

made in the 1950s for the Australian edition, but it was after establishing himself in Paris in 1962 that his individual style rapidly matured. Widespread interest in his fascinating images of sexual obsessions has tended to cause his fashion and beauty photographs of the 1960s and early 1970s to be forgotten. These however provide crucial pointers to later developments, many of his current themes being seen in embryo. Newton's most recent book, *World Without Men* (1984) is a compelling selection of his fashion photographs from the last twenty years together with revealing comments from the photographer.

JEAN PAGLIUSO

Born 1941. Lives and works in New York. With a degree in design from UCLA, she became assistant art director for *Vogue Patterns* and *Mademoiselle*. She turned to photography, and in 1970 won her first assignment, for Catalina Sportswear. In California she worked for *Seventeen*, *Mademoiselle*, *Harper's Bazaar*, *Vogue*, and in New York mainly for *Italian Bazaar*. Her advertising commissions include Bergdorf Goodman, Saks Fifth Avenue and Bloomingdales.

NORMAN PARKINSON

Born 1913. Lives and works from Tobago. Parkinson joined British *Vogue* in 1941, bringing to its pages an informality and joie de vivre and injecting new life into the magazine's presentation. More recently his colour photography has tended towards the epic and is perhaps over-glossy, but he continues to work in this manner for French *Vogue*, making him, with the exception of Horst, *Vogue*'s longest serving photographer. The National Portrait Gallery, London, mounted a large retrospective of Parkinson's work in 1981 and a visual autobiography, was published in 1983.

189

John Rawlings *Bob Richardson* *Richard Rutledge* *Jeanloup Sieff* *Edward Steichen*

IRVING PENN

Born 1917. Penn joined American *Vogue* in 1943, initially as an assistant to the art director Alexander Liberman. Finding that the established photographers were not receptive to his ideas he was invited to acquaint himself with studio camera techniques and realise his own ideas. In a short time he became *Vogue*'s leading photographer, a position he maintains today, and has been responsible during his career for many of the most memorable and influential beauty photographs ever made. In a sense the beauty photograph is the perfect vehicle for Penn's talents, combining elements of three areas in which he excels, fashion, portrait and still-life. Some of his early beauty pictures are reproduced in his book *Moments Preserved* (1960) and others featured in his major Museum of Modern Art (New York) retrospective in 1984.

DENIS PIEL

Born 1944. Lives and works in New York. A relatively recent *Vogue* recruit who has been particularly successful in America, and also with Italian *Vogue*. Born in Paris, Piel emigrated to Australia, where he studied architecture and graphics. His pictures have been described as combining a 'discreet voyeurism with tender sensuality'.

ROBERT RANDALL

1918–1984. Born in California, Randall's earliest enthusiasm was for films rather than photography. He first worked as a film laboratory technician and later as an assistant to John Ford's wartime film unit. After a short spell as a bit-part actor in Ford's movies he moved to Paris, where he worked for French *Vogue* from 1948 until 1955. Returning to New York he opened a studio concentrating largely on publicity photographs. He published a book, *Fashion Photography: A Guide for Beginners.*

JOHN RAWLINGS

1911–1977. Rawlings joined Condé Nast in New York in 1936, having served as a studio assistant to both Toni Frissell and Cecil Beaton. He was sent to the London *Vogue* studio in the same year, staying as their chief photographer until the outbreak of war. In 1945 he opened his own daylight studio in New York, the natural lighting making an important contribution to the freshness and elegance of his pictures. Rawlings continued to work for *Vogue* into the 1960s. He published two books of nudes, of which by far the better was *100 Studies of the Figure* (1951).

MIKE REINHARDT

Born 1938. Lives and works in New York. Reinhardt studied law before taking up photography in Paris. He has been a frequent contributor to British, French and American *Vogue*, *Life*, *Glamour* and, more recently, *Harper's Bazaar* and British *Elle*. Apart from fashion and beauty, Reinhardt is much in demand as an advertising photographer, perhaps best known for his Revlon, Max Factor and Ghinea commissions.

BOB RICHARDSON

Born 1928. Lives and works in Los Angeles. Richardson turned to photography from design and illustration, having attended the Parsons School of Design, Cooper Union and Pratt Institute in New York. His best work was done in the period 1963–1972, when he brought to fashion photography some of the more controversial aspects of sixties culture, although he has made several comebacks since. Contemporary films, especially those of John Ford, Visconti and Antonioni, clearly influenced his photographs' narrative content. In this, together with his seemingly casual way of working (he preferred a hand-held Nikon) and their

veiled sexual references, his photographs anticipated many subsequent developments in the medium.

ALBERTO RIZZO

Born 1931 in Rome, Alberto Rizzo trained as a classical ballet dancer. Moving to the USA in 1965, he worked in television before turning to full-time photography in New York where he worked for *McCall's*, *Mademoiselle*, *Glamour* and later *Harper's Bazaar*. He returned to Milan in 1971 to work for Italian *Vogue*, *L'Uomo Vogue* and in advertising, although recently he has tended to concentrate on television commercials. His work has been shown in Venice (1981) and in New York (Central Falls Gallery, 1983).

PAOLO ROVERSI

Born 1947. Lives and works in London. Roversi has worked for *Vogue* (and also *Lei* and *The Tatler*) since 1983, having previously worked for *Dépêche Mode* and *Marie Claire* in Paris. Over the last few years his mature work shows him to be a master of subtlety and understatement. Roversi's clever use of unusual lighting techniques gives his photographs a strength which acts as a counterpoint to their more delicate qualities. His liking for working direct from 10 x 8 inch Polariod colour prints has been widely imitated, as has his use of multi-coloured spotlighting.

FRANCO RUBARTELLI

Born in Italy. Lives and works there. Rubartelli's liaison with the striking model Verushka in the mid-sixties struck exactly the right note of exotica in *Vogue* at that time. Little has been heard of him since then, but if his photographs were largely derivative he was able to develop a style which perfectly exploited Verushka's leggy angularity.

Bert Stern

Joyce Tenneson

Deborah Turbeville

Albert Watson

Bruce Weber

RICHARD RUTLEDGE

1922–1985. Born and educated in Tulsa, Oklahoma, Rutledge moved to Los Angeles at the outbreak of World War II, working night-shifts in a war plant and studying photography at the Los Angeles Art Center by day. After the war he moved to New York where he was hired by Condé Nast Publications. He was posted to the Paris studio in 1949 and continued to divide his time between New York and Paris until his dramatic (and final) break with photography in the 1960s. Rutledge died in Paris almost completely forgotten, most of his work destroyed, and unrepresented in any of the recent fashion retrospectives.

JOHN SADOVY

Born 1925. Sadovy was born in Czechoslovakia and became an official war photographer in 1941 – at the age of sixteen. He moved to London after the war and was joint winner of British *Vogue*'s 1954 photographic contest. Announcing his success *Vogue* noted of Sadovy's work, 'There is seldom an attempt at the impromptu; more often an arranged effect, intellectual rather than instinctive' and they admired 'his careful skill with shapes and tone-weights, and his eye for balance and counter-balance'.

JEANLOUP SIEFF

Born 1933. Lives and works in Paris. Before working for *Vogue* in 1965 Jeanloup Sieff had ten years' experience in taking fashion photographs for magazines such as, *Jardin des Modes* and *Harper's Bazaar*. His atmospheric fashion and beauty pictures evoke a mood of subdued drama. They aroused great interest when first seen in Britain (in *Vogue* and *Nova*) in the mid-sixties, and Sieff has gone on to become one of France's most celebrated photographers, underlined by major exhibitions in 1986 at the Centre Pompidou and the Musée d'Art Moderne.

EDWARD STEICHEN

1879–1973. Born in Luxembourg, Steichen's family moved to the USA in 1881. Having been a leading member of the Photo-Secessionist movement Steichen made a radical change by signing a contract to work for Condé Nast in 1923. He continued as chief photographer for *Vogue* and *Vanity Fair* until 1938. A master of the large format camera and studio lighting, Steichen's forte was full-toned highly detailed photographs of a straightforward no-gimmicks dignity. For many years he set a high technical standard that was a yardstick for all other *Vogue* photographers. Published a visual autobiography, *A Life in Photography*, in 1963.

BERT STERN

Born 1929. Lives and works in New York. When Stern first worked for American *Vogue* in 1959 he was already a widely experienced advertising photographer. His pictures for the Smirnoff Vodka campaign of 1953 are regarded as a milestone in modern advertising photography. In spite of his considerable originality – evident in the pages of *Vogue* – in the 1960s Stern was unfairly characterised as an American archetype of the Blow-Up photographer. His vast studio and penthouse complex in Manhattan was legendary. It was short lived, but the myth continues to prevent a fair reassessment of Stern's talents. A monograph on Bert Stern was published in the *Masters of Contemporary Photography* series in 1974.

JOYCE TENNESON

One of *Vogue*'s most recent recruits, Joyce Tenneson's work has been frequently exhibited since 1972. She teaches and runs studios in New York and Washington. She describes her work as '. . . an attempt to penetrate and reveal emotional realitites.

Surface beauty is never my goal. What interests me most is to capture something compelling which speaks to the viewer – something enigmatic or elusive which continues to be interesting after the first glance'.

DEBORAH TURBEVILLE

Born 1938. Lives and works in New York and Paris. Deborah Turbeville started her career as a fashion editor, working for *Ladies' Home Journal*, *Harper's Bazaar* and *Mademoiselle*. In 1972 she turned freelance and also began to undertake photographic assignments. She had no formal training, but attended seminars run by Richard Avedon, Marvin Israel, and Diane Arbus. Israel has described her pictures as being like 'stills from a film you haven't seen but wish you had'. Perhaps the greatest compliment that can be paid to her photographs is that they read equally well when placed out of their original context on gallery walls. She has published several books, including *Wallflower* (1978) and *Unseen Versailles* (1981).

ALBERT WATSON

Born 1942. Lives and works in New York. Albert Watson has been established in New York for over ten years and has enjoyed so much success that he is probably thought of as being American. In fact he was born in Scotland and studied at a Dundee Art College and the Royal College of Art in London, where he took an MA in film studies. His fashion and beauty photographs are marked by a consistently high level of professionalism – strong and glossy.

■ *In spite of every endeavour, we have been unable to obtain biographical information on the following photographers: Saul Leiter, Tom Palumbo and Alan Turnbull.*

191

Index

Acknowledgements

I want to thank all the photographers, editors and art directors of the international editions of *Vogue* past and present and specially Alexander Liberman, editorial director of Condé Nast Publications who has been responsible for the look of *Vogue* for over four decades.

The staff of Condé Nast Publications have been more than generous in their help with this book. I should particularly like to thank Jane Ross who was responsible for the original picture research and Robin Muir for additional research. Special thanks also to Sian Dalziel, Sara Longworth, Lillie Davies and Elaine Shaw, to Diana Edkins and Cindy Cathcart in New York, Ute Mundt in Paris, Anna Zavka in Milan and Helga Colle-Tiz in Munich. Steve Kibble has been an especially sensitive collaborator in laying out the book and Alex Kroll an invaluable guide right from the beginning.